D0945895

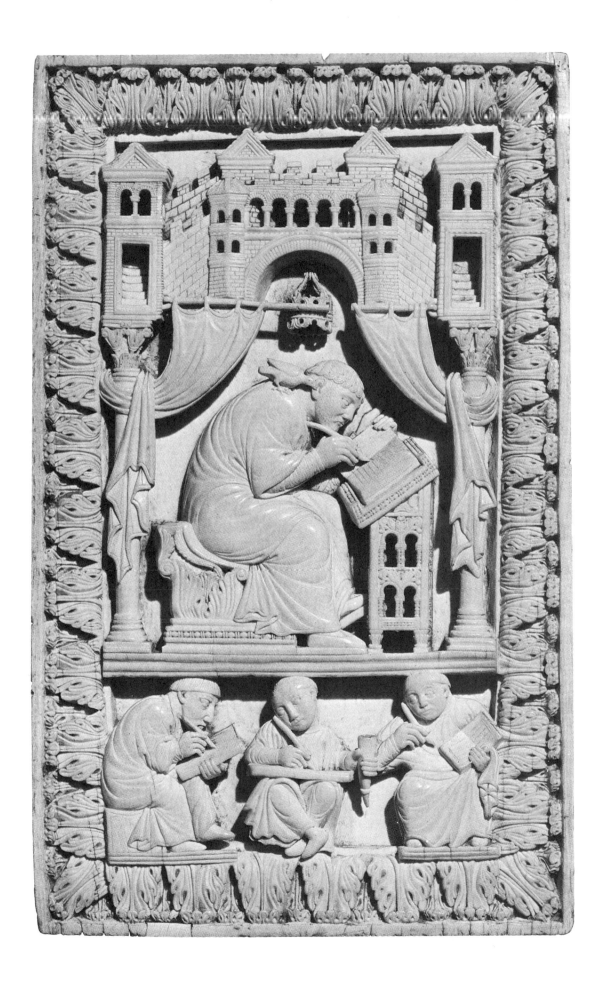

Frontispiece: [Vienna, Kunsthistorisches Museum, Der Hl. Gregor mit drei Schreibern (Elfenbeinplatte, Inv. Nr. 8399)] An avid writer on religious matters, St. Gregory the Great is shown at work on a manuscript in a 10th-century ivory carving that served as the central ornament of the cover of a Church service book.

Included are three additional scribes, suggesting that the words first penned by St. Gregory were then copied by many others and distributed throughout the Christian world. The dove whispering in St. Gregory's ear may be transmitting Heaven-sent guidance for the text in progress, as the gentle bird represented the Holy Spirit and was a symbol associated with the saint. [Original size c. 20.5 × 12.5 cm. (c. 5 × 8 inches)]

MEDIEVAL CALLIGRAPHY
ITS HISTORY AND TECHNIQUE

MARC DROGIN

Foreword
by Paul Freeman

DOVER PUBLICATIONS, INC.
NEW YORK

Copyright © 1980 by Marc Drogin.
All rights reserved under Pan American and International Copyright
Conventions.

Published in Canada by General Publishing Company, Ltd., 30 Lesmill
Road, Don Mills, Toronto, Ontario.
Published in the United Kingdom by Constable and Company, Ltd.

This Dover edition, first published in 1989, is an unabridged, corrected
republication of the work originally published in 1980 by Allanheld,
Osmun & Co., Publishers, Inc. and Abner Schram Ltd. (Allanheld &
Schram), Montclair, New Jersey. For this edition, the author has updated
some information in Chapter IX, "Materials and Resources," and made
other text corrections throughout the book. In addition, a few obvious
typographical errors have been silently corrected.

Manufactured in the United States of America
Dover Publications, Inc., 31 East 2nd Street, Mineola, N.Y. 11501

Library of Congress Cataloging-in-Publication Data

Drogin, Marc.
 Medieval calligraphy : its history and technique / Marc Drogin ;
foreword by Paul Freeman.
 p. cm.
 Reprint. Originally published: Montclair, N.J. : Allanheld & Schram,
1980.
 Includes bibliographical references.
 ISBN 0-486-26142-5
 1. Calligraphy. 2. Manuscripts, Medieval—Facsimiles.
3. Writing—History. 4. Paleography. I. Title.
Z43.D758 1989
745.6′197—dc20 89-17156
 CIP

To Martha, with love

I owe my achievements to her enthusiasm
and my concentration on things
no later than medieval to her assurance
that I am anything but a Renaissance man

. . . and to Eric, Anne, and Robert

CONTENS

❖ HISTORY ❖

❖ TECHNIQVE ❖

PLATES BY SCRIPT

Some common script names are included to simplify locating them. Subscripts and variations are listed by both names. Scripts appearing as marginal and between-the-lines notations are marked "gloss."

FOREWORD

The art and craft of calligraphy flourished for centuries until the invention of the printing press and type led it to an esoteric corner of man's endeavors. By the 19th century it flourished only in the most florid way on citations, scrolls, and certificates. At the turn of the century Edward Johnston reestablished calligraphy as a viable endeavor, returning it to its highest form, the manuscript book. Going to the archives of London's libraries and museums, he sought the historic manuscripts necessary as exemplars. Johnston spent those early years searching out a *Roman* here, a *Rustic* there, *Uncials* and *Gothic* forms, and modernizing and adopting them for practical use.

This book would have been a blessing to that dedicated giant. I think if he were with us today he would pore through these pages and hum to himself with joy. To find between the covers of one tome an enriching history of an age of calligraphic endeavor, illustrated with myriad useful, workable alphabets true to their creators, is a blessing that comes rarely to the practitioner and scholar of letter forms.

Calligraphy is perhaps the greatest juggling act in the graphic arts. One must master the skill to render letters in countless styles; learn to manipulate a flat-edged tool (quill, reed, steel nib, or fountain pen). As the letter forms are mastered one must also control the spacing between letters, between words, between lines. This leads to the layout and design of the full page. For in the end, it is not the individual letter one sees but the color and spirit of the page.

The medieval scribe used at most three or four alphabets. Today we are more eclectic, although we seem to prefer the *Italic* and *Roman*. However, this is only on the surface. Most scribes desire to learn every form and all the variations.

If you are a *scribat dedicatum*, you will cherish this book for the crucial period of historic alphabets brought together in a chronological sequence, thoroughly researched, and practical for use as a learning tool. Here you have the analysis and interpretation to help you understand the letter forms, and unstinting advice on how to do it yourself. If you are a paleographer, this book must tempt you to take up pen and ink and experience for yourself the joy that calligraphers have had for their own.

One must thank this author for the research and literary enthusiasm that resulted in the creation of a working book on this major period in calligraphic creativity.

Paul Freeman
Founding Chairman
of the Society of Scribes

PREFACE

This book was born of the frustration of looking for an answer and not finding it; or finding, after long search, an answer so elementary as to be inadequate or so complex as to be incomprehensible.

As more students pursue calligraphy, the number who advance beyond a desire to have finer handwriting increases. As I became interested in improving my own lettering, I became fascinated with the remarkable design and diversity of medieval lettering. I found that of the books available on calligraphy, some touch only briefly on the medieval period while others describe it in such scholarly detail that all but the most tenacious student is thwarted. Few books offer instruction in medieval scripts, and fewer indicate the original medieval methods or reproduce the sources of their versions of medieval alphabets. One finds part of an explanation here, the rest in another book, or does not find it at all.

I wanted a single comprehensive volume, easy to understand, to learn from, and to teach with. I wanted a book containing all the scripts that, to me, represent medieval calligraphy, complete with a history of the evolution of the alphabets, an approach that would enable the student to learn them just as his medieval predecessor did, and one that contained some background on the scribes, their world, and how the style of their writing changed over the course of a thousand years.

That is why I decided to write this book. As I gathered material, I discovered the existence in American and European libraries and museums of pages of carefully lettered alphabets and decorative embellishments produced by master calligraphers in the late Middle Ages. Seldom has one of these pages been reproduced—even as a curiosity—in the popular or scholarly instruction books available today. I feel it is better to study 13th-century *Gothic Textura Quadrata* from a 13th-century Gothic master calligrapher than from a 20th-century calligrapher's interpretation of that script. I have tracked down a number of these display sheets and have included as many as I could, limiting the variety to those I thought most unusual and useful. Some have never been reproduced. These sheets are the real "teachers" in the section *Writing Medieval Scripts,* my own lettering accompanying them serving only as a guide to how the pen was most probably moved by the scribes themselves.

I think you will find, as I did, once you learn something of the history of medieval scripts (the paleographer's domain) and then learn to produce them yourself, that enormous creativity was involved in their birth and that you can express as much creativity in working within them. It

was never my intention to learn how (or to teach others) to letter ancient scripts so authentically that the result appears a forgery of a particular medieval scribe's lettering, but rather to learn why and how he may have written so that I could express my own calligraphic feelings within the beautiful traditional form of each medieval script. My own writing in this book is easily distinguishable from any facsimile simply because it is my own. Many calligraphers of today are interested only in postmedieval scripts as a basis for their lettering because, as I have been told more than once too often, medieval scripts do not allow today's calligrapher to exercise any personal creativity. But I think that as you begin to capture the marvelous quality of the ancient scripts and create your own hands, you will discover a world of creativity opening.

What began with frustration has ended with much pleasure. I hope that your venture into the world of medieval calligraphy with its paleography firmly in mind will be every bit as enjoyable as mine continues to be, ink stains notwithstanding.

ACKNOWLEDGEMENTS

I suspect that if Mark Van Stone had lived during the medieval era it would have lasted a century longer on his enthusiasm alone. My former teacher, who introduced me to the rudiments of medieval calligraphy, Mark has long been a friend and companion in studying its history and technique.

I am grateful to Dr. Bruce Barker-Benfield, assistant librarian of the Bodleian Library, Oxford, for his patient assistance during the month I spent in the Bodleian studying medieval manuscripts and paleographical reference material. His endless consideration in obtaining for me precisely the right manuscripts and his suggestion of scripts to be included were extremely valuable. Hardly a morning or afternoon passed in which there was not some confusion he was kind enough to unravel, or some pitfall he was patient enough to describe and steer me safely around, such as his explanation of date references, to be found at the end of the Introduction. His graciousness will remain one of my fondest memories of my study there. And I am indebted as well for the many and kind services provided by Miss Cornelia Starks, Senior Library Assistant.

I must thank Barry McKay, Antiquarian Bookseller of that incredible paradise of books, Blackwell's, who went to considerable trouble in locating rare volumes, suggesting research sources, and in the process providing me with the pleasure of having a good friend in Oxford.

This book was made possible as well by the enthusiasm and direction offered by author and master calligrapher Alfred Fairbank, author and paleographer M. B. Parkes of Oxford University, and the extensive proofreading and translating provided by Miss P. R. Robinson, Lecturer in Palaeography at the Queen's University of Belfast.

I am also thankful to Prof. R. C. Latham of Magdalene College, Cambridge; Profs. A. G. Hassall and William Urry of Oxford University; Miss D. M. Callard of the Bodleian Library; Prof. and Mrs. Joan Gili and Mrs. Kathleen Kaye of Oxford; Miss Joan Hopkins of Cambridge; Mr. and Mrs. Alexander M. Salzberg of Norfolk; Prof. Werner Brandes of Phillips Exeter Academy; and Dr. Giesele Wilder and Mr. Alfred Olivetti of Exeter.

A great deal is owed to Martha Drogin. As each chapter was written, she edited with stoic determination, badgering and browbeating me in the cause of literacy. And I am most pleased with the section on *The Technique of Calligraphy* because it was written with her help and includes the excellent instructions she has given to students.

☧

❖ HISTORY ❖

I INTRODVCTION

Tenet insanibile multos scribendi cacoethes.

—Horace

[Many are possessed by the incurable itch to write.]

Calligraphy is the art of writing beautifully. It is the written letter, molded by one's concept of ultimate grace and perfect balance, a personal artistic expression as unique as the lines on the fingertips with which one holds the pen. It places one's soul at the tip of the pen for all to see.

The calligrapher can impose his artistic skill and personal expression on basic letter shapes in order to enhance the words so that they are more easily read and understood. A great abbot at the end of the Middle Ages looked back at the labors of the scribes of a thousand years and praised their calligraphy for the manner in which it induced generations to read. One can be more expressive in calligraphy and so ornament the written word that it is more awesome to behold than easy to read. Many medieval scribes penned holy works more to honor God than to educate his flock. Ultimately one can write with such calligraphic flair that the words are almost unreadable. In this way many a medieval court or palace scribe protected his temporal lord's power, shielding his meaning from the uninvited and preserving it from his enemies' forgers. Calligraphy is thus an art employed in varying styles reflecting different purposes.

Since historians do not agree on the period spanned by the Middle Ages, we are at liberty to select, from numerous alternatives, dates that are significant to our purposes. In this book the medieval era will be considered to begin in the mid-400s with the departure of the Roman legions from Britain signaling the twilight of an age dominated by ancient Rome. This was also the time in which the history of monastic orders began. We will consider the Middle Ages to

The Medieval Era

3

formata, and *textura,* may be difficult to define without exact descriptions. Remember that paleographers are equally without specific means of measurement. When they use these and other terms, they do so only after describing what they mean by them (as I have tried to do). But this may not be precisely what other paleographers mean.

One paleographer's *Early Gothic* is another's *Late Carolingian Minuscule,* and this often makes it difficult to talk to or to read the writings of two paleographers simultaneously. When I introduce a new script, I will include all the names I know it to have been given, so that you will have no difficulty in determining the script if you should find it referred to by a different name in another book. After I introduce the script and its variant names, I will refer to it thereafter by the name I feel is most descriptive.

Notes on plates

Facsimile Size

Margins

Translations and Transcriptions

Scripts and Sources

Several of the facsimiles shown have never been reproduced. Others have appeared only in obscure paleographical works, and several are from somewhat familiar manuscripts, but are of pages never before reproduced. In *Writing Medieval Scripts* the facsimiles are in their original size unless otherwise noted. In many cases original page margins were subsequently trimmed, so edge-to-edge page sizes should not be judged from the measurements of the plates. Where a facsimile is presented because the content of the text is important, the caption or text includes a translation. In *Writing Medieval Scripts,* where facsimiles appear for the purpose of studying letter design, a transliteration is included to simplify recognition of the letters. Words abbreviated in the text remain abbreviated in the transliteration.

Every facsimile is accompanied by the manuscript's source, shelf-mark, and *folio* (page) number. If you wish to locate all the examples included of a specific script, refer to the *Plates by Scripts.* You will find the addresses to write to in requesting photographs in *Materials and Resources,* as well as hints on international correspondence.

References to dates

When you wander afield to look up material, you are likely to discover the nomenclature regarding dates not only hard to calculate but impossible to comprehend. Should your wanderings lead you into, among others, the superb multivolume *Codices Latini Antiquiores* of E. A. Lowe, the following definitions of terms will be helpful:

SAEC. X	= the 10th century, i.e., 901–1000
SAEC. X IN.	= the beginning of the 900s
SAEC. X¼	= 901 to 925
SAEC. X$^{1/3}$	= roughly 900 to 935
SAEC. X¹	= 901 to 950
SAEC. X med.	= 951 or roughly the middle of the century
SAEC. X²	= 951 to 1000
SAEC. X EX.	= the going out or end of the 10th century
SAEC. X/XI	= the 10th or 11th century, or the turning point between the two, i.e., *c.* (about) 1000. X/XI does not mean the span 901–1100.

II THE SCRIBES

Scribite, scriptores, ut discant posteriores.

[Write, writers, so that posterity may learn.]

—Inscription in the scriptorium of Notre Dame de Lyre

"Il y a ung maistre en ceste bonne ville que par l'ayde de Dieu . . . moys apprent a bien lire, escripre, et de comptes et chiffres . . . Pour ce venes y tous bien prestament; car je m'esnuie de plus actendre, et suis tout las de le vous dire."

[There is a master in this good town who, by the aid of God . . . teaches how to read well, write, compute, and cipher . . . Therefore come ye all here and very quickly; for I am tired of waiting longer and quite weary of telling you so.]

—Advertisement by a mid-15th-century calligraphy teacher in Toulouse [69].

The history of calligraphy is contained primarily in the handwritten manuscript, which throughout the medieval era was most aggressively promoted by the Christian Church. The scribes of interest, at least from the onset of the Middle Ages, are therefore the monks who toiled in the monastery *scriptoria*, or writing rooms. While the Middle Ages was a period of enormous growth and change in the Church and in civilization as a whole, the manner in which the scribes worked, their attitudes about the work, and the tools they used changed relatively little.

The early medieval monks were either the sons of poor families who had sent them to the monasteries to be raised and educated to become monks, or they were men who joined because of religious conviction or to escape the instability of the outside world. In the simple life of the monasteries, the labor needed to make these communities self-sufficient was shared by everyone. Work in the scriptorium was an important obligation. To promote education, manuscripts had to be produced, and with the growth of the Church and the establishment of

new monasteries, there was a constant demand for the reproduction of many religious and classical works.

Depending on the design of the monastery, the scriptorium was either established safely above-ground in a somewhat attack-proof fortress tower [*Plate 1*]; a building unto itself within the walls of the compound; or separate work areas nestled beside cloister walkways. There the scribes labored during most of the daylight hours not taken up by religious services and other obligations. As the monasteries grew, some monks worked the land and assumed menial tasks, while those most adept at writing were allowed to devote themselves to work in the scriptorium. Skilled and willing scribes were much appreciated. Odo, the abbot of St. Martin's at Tournai in the late 11th century

> . . . used to exult in the number of writers the Lord had given him; for if you had gone into the cloister you might in general have seen a dozen young monks sitting on chairs in perfect silence, writing at tables carefully and artificially constructed. [Many important works] he caused to be transcribed. So that you would scarcely have found such a monastery in that part of the country, and everybody was begging for copies to correct their own. [15]

A scriptorium with a reputation for accuracy produced sought-after copies, and it was a matter of great concern that errors not be introduced accidentally into the copying, only to be copied again and again. So a scribe's work, proofread and corrected by the monastery's elders, was a thing of great value. The theft of such a manuscript was a high crime, and within the manuscript itself was occasionally inscribed a warning, such as the notation at the end of a late-medieval Bible:

> If anyone take away [i.e., steal] this book, let him die the death; let him be fried in a pan; let the falling sickness and fever seize him; let him be broken on the wheel, and hanged. Amen.* [20]

Some of this value may reflect the effort made in producing not only special manuscripts but also any of the monastery's written material. It was no easy task to work throughout the daylight hours and, despite companionship, almost silently. After morning services and general obligations were completed, each scribe would begin work at a desk or table with a stool offering no back support. No candles or warming fires were allowed, for the safety of the manuscripts. One may visualize the scribe at work with a quill pen in his right hand and in his left, a knife, used to sharpen the pen, to smooth out roughened areas of the parchment, and to scrape away errors, or hold the parchment in place. Nearby sat a pot of ink. Within sight of the scribe's hand-signals was the *armarius*, the monk who ran the scriptorium. He would supply the additional pens, inks, and parchments, all of which were probably prepared by either the scribes or the monastery's novices [*Plate 2*].

The scribe's daily task of copying a portion of an *exemplar*, or master copy, was decided by the armarius or the abbot. The scribe was not permitted to object to his labor or extemporize upon it. He could not exchange labor with another, nor could he let his mind wander, because he might well be questioned later about the material he had copied. He worked under the careful eye of the scriptorium's master [*Plate 3*]. If a scribe needed distraction, he could think about the wine or dinner waiting the end of the day's work, or he could encourage himself with the thought that each word he wrote was a blow against Satan and a mark in his favor

*Liber . . . quem si quis abstulerit, morte moriatur; in sartagine coquatur; caducus morbus instet eum et febres; et rotatur, et suspendatur. Amen.

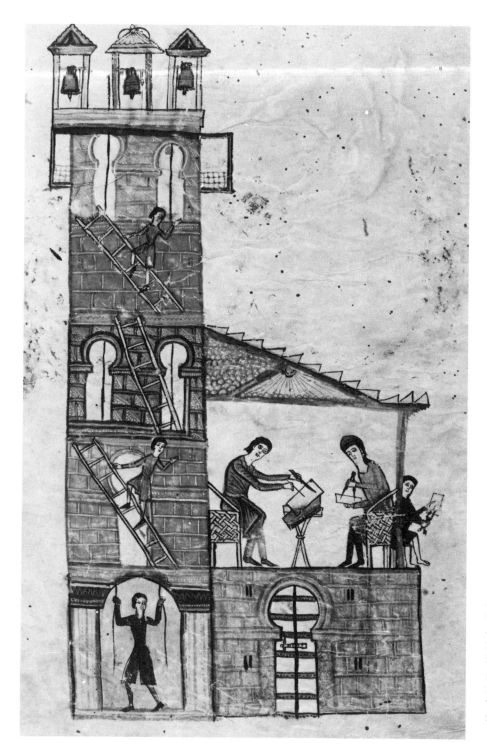

Plate 1. Scriptorium in monastery tower, c. 1220, Spanish. [New York, J. Pierpont Morgan Library, MS. 429, folio 183]. Copied from a similar illustration of 970, it illustrates a typical arrangement for safeguarding monks and scriptorium. Note removable ladders to foil assault and small windows to deter arrows. [Original height more than 42 cm. (16 inches)]

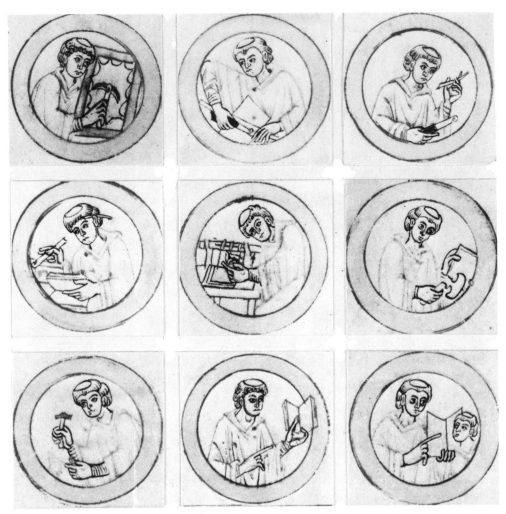

Plate 2. Monks producing books, c. 1100–1150, German. [Bamberg, Staatsbibliothek Bamberg, MSC. Patr. 5 (B.II.5), folio 1 verso]. Monks are shown (1) preparing parchment; (2) cutting it to size or scoring lines for lettering; (3) cutting a quill pen; (4) painting or trimming pages; (5) sewing the book; (6) making its cover and (7) its clasp; (8) displaying it and (9) putting it to good use.

Plate 3 (opposite). Scribe's self-portrait, c. 1150, English. [Cambridge, Trinity College, MS. R. 17.1, folio 283 verso] By Eadwine of Canterbury in the *Canterbury Psalter.* Text: "Scriptor s[c]riptorum princepts ego nec obitura deinceps laus mea nec fama quis sim mea Littera clama Littera te tua s[c]riptura quem signat picta figura. Predicat Eadwinum fama per secula vivum Ingenium cuius libri decus indicat huius quem tibi seque datum munus deus accipe gratum." Eadwine declared that he was the leading prince of scribes and that the glory of this manuscript was proof of his skill, assuring his fame forever. [Original size 40 × 28 cm. (11 × 16 inches)]

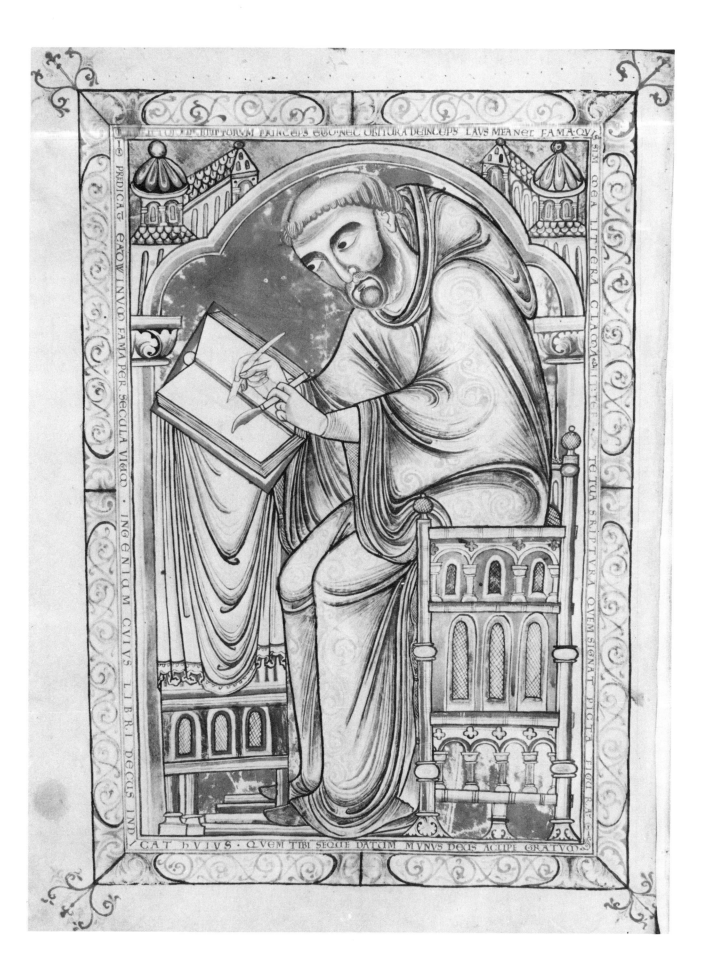

when the Day of Judgment came. He often began his work with a brief prayer in the upper lefthand corner of his first sheet of work [*Plate 4*].

Many scribes took great pride in their work, but the long hours of work could still chafe away at a carefully nurtured optimism. The scribe who had finished copying a lengthy Thomas Aquinas text in the 14th century, wrote:

> Here ends the second part of the title work of Brother Thomas Aquinas of the Dominican Order; very long, very verbose, and very tedious for the scribe; thank God, thank God, and again thank God.* [63]

The brief comments (or *explicits*) by the scribes at the end of their work reveal a variety of concerns—enthusiasm and religious feeling in furthering the word of God or in keeping the monastery's accounts in order, the desire for better materials, time for wine, a good meal, or a warm fire to restore feeling to their fingers. There were not above enjoying games involving the alphabet which occupied so much of their lives.

One example is the *abecedarian* sentence, from the medieval Latin *abecedarium,* meaning alphabet. An abecedarian sentence contains every letter of the alphabet. The most familiar to us today is "The quick brown fox jumps over the lazy dog." A scribe may have used one to "warm up" his fingers before beginning work each morning or to test his knowledge of a different script style when changing work assignments. These sentences were teaching monks' exercise when training the novice scribes. Two surviving sentences written about 790 contain every letter of the alphabet of that time [*Plate 5*]:

> Te canit adcelebratque polus rex gazifer hymnis.

> [The Hymn, oh treasure-bearing king, sings of you, and the (north?) pole also honors you.]

> Trans zephyrique globum scandunt tua facta per axem.

> [Your achievements rise across the earth and throughout the region of the zephyr.]† [50]

Plate 4. Insular Minuscule, c. 850, English. [Oxford, Bodleian Library, MS. Digby 63, folio 51 verso]. Note the *xb* in the margin, the abbreviation of *Christe benedic,* "Christ bless," an Irish habit adopted by this scribe.

*Explicit secunda pars summe fratris thome de aquino ordinis fratrum predicatorum, longissima, prolixissima, et tediosissima scribenti; Deo gratias, Deo gratias, et iterum Deo gratias.

†Because abecedarian sentences were usually nonsense phrases, both are very loosely translated.

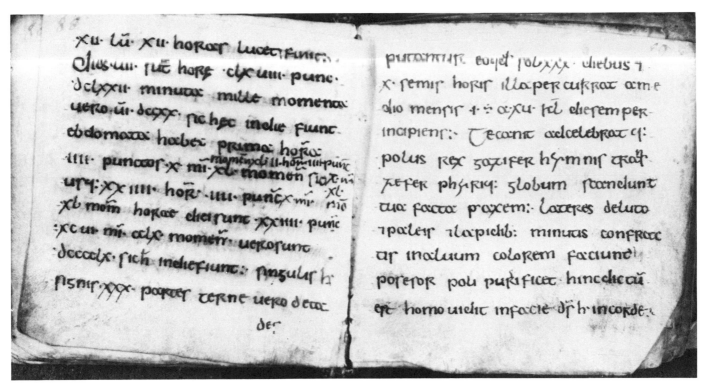

Plate 5. Insular Minuscule, c. 780–90, English. [St. Gall, Stiftsbibliothek St. Gallen, MS. 913, p. 89] A monk's personal notebook of miscellanea, containing two abecedarian sentences beginning on line 4, righthand page. Note error in *zephyrique* then corrected from point of error.

The increasing demand for manuscripts by the 8th century led to the more frequent appearance of the lay scribe. Taught in a monastery, cathedral school, or court scriptorium, he was not a member of a religious fraternity but instead worked for hire. The ranks of lay scribes increased as monasteries began to de-emphasize the scriptoria and cathedral schools became, or led to the establishment of, the universities of the 12th and 13th centuries.

Some lay scribes worked independently (a few particularly skilled ones gaining fame and fortune by their labors), but most gathered in workshops, later to become guilds. They worked in the neighborhoods of the universities to supply the great demand for textbooks. It is possible to get an idea of how the scribe fared economically by comparing some known records of his income with that of workers in other occupations. The salary of the average scribe of the 14th century, for instance, was equal to that of a common farm laborer, or half the income of an ordinary French farmer or English carpenter [14]. He may well have suffered the temptation to drop the pen and heft the sword, for by joining King Edward's army for a tour of duty in Scotland as a foot soldier, he might have earned in one day what he usually earned in three to seven.

Nevertheless the lay scribe toiled on through the Middle Ages and was the key source of calligraphy, along with another, later scribe, the itinerant writing master. The writing master was the product of the late medieval era's surge of interest in and availability of higher education, and the relative tranquillity of society. He traveled about a given territory offering his services, usually carrying with him a scrapbook or two [69] showing what he could do. We know something of his skill from the alphabets he lettered [88], although it is not known whether these were intended to be used in teaching or just in displaying his abilities. To let the

Beatus vir qui non abiit in consilio impiorum et in via peccatorum non stetit et in cathedra

Nottula

...vnde willighe beghehelichert vlitlich touerim Alle lieueste
in god heie vnde here wy bidden iw vnde ermanen im dusser
...wuardighen schrift dat gy den be ghonden krich willen aff laten
...doch ynsen willen den wy an ghe hauen hebben wyrt heren
...Rende erkest iw twene eida vnde van ku(n)sten riche wise
...wille wy of twene lesen de twissen iuwen quaden vnde syner
...chert to beiden siden em middel mogte vinden Des schal gans

Semiquadratus

Alium inuocauerim exaudiuit me deus iusticie mee in tribulatione dilatasti michi Miserere mei et exaudi orationem meam

Nottula

...ighebeth in lutter vruichert willichker beghelichert
...eme heren touerim steuen heren vnde besunderen fru(n)de
...gruuer...vnde ermanen vnde alle ghe
...lich dat in...naren rades...ghe
...vnsen moghen rede...wrstoren den...
...willighen leiten...herm beghert wy manne

...mei deus secundum magnam misericordiam tuam Secundum multitudinem
...anonim tuarum dele iniquitatem meam Amplius laua me ab in...
...mea est a peccato meo mundu vie Quoniam iniquitatem meam
...ose et peccatum meum contra me...Semper Tibi soli peccau et
...coram te feci ut iustificeris in sermonibus tuis et vincas cum iudi...
...Ecce enim in iniquitatibus conceptus sum et in peccatis concepit me...
...mea Ecce enim veritatem dilexisti incerta et occulta...tue

Sextus

...Wenceslaus van godes gnaden romischer konigh czu allen iden
...de de riches vnde konigh to bemen Allen vnde ghemeynlich
...luchtigen vorsten graven banner heren vnde allen edelen vnde
...der lande v ysen leuen ghetruwen vnsen lutteren grot vnd

Verba mea auribus percipe domine intellige clamorem meum Intende voci orationis mee

Versus

...vnsen lutteren grot mit vlitliker beghelichert alle tid touerim
...hocheborne vorste here vnde here wy bidden iwte hochmechtighen
...Richert vlitlichen in dussme jeghenwardigh breue dat gy wolden
...myt willen laten van deme lande dat gy an ghenomen hebben van
...heren all. Dat wir mit mibes Richert nicht dit dar vmme
...donen vnwilligen Rente wir to rade sint ge worden vnde besunderm
...mit wolbedachten rechtuerdighen rade vnser oldesten alle de sicherheit
...vnser lautkosten vnses richtes sud deme male dat wy nicht anders

Textus Rotundus

Quare fremuerunt gentes et populi meditati sunt inania Astiterunt reges terre et principes conuenerunt in vnum Aduersus dominum et aduersus

Argentum

...wr jaenanme vnde ghe beeren der lude to bodempeder Bekennen openbairliken
...in dusseme breue vor alle den de en sei horen eder lesen Dat wi higher dusses
...breues eider vromie dutseite eldern bi vns lest ghe hat Wente he erikken ghe horen
...de Wi bekenne vor dar de vorghenante ioh van ih th vnde sine eldern euch vnde
...vromelich vnde erlanch bi vns hebben ghe holden vnde nicht van eu andres
...wetten vnn alle god Hidde wi alle erlame vrome bedrnen Beide gheistliche
...vnde werlliken de wech vnsen willen willen eder laten Dat se sene vorghenanten
...ioh van h gunst mghn willen beuylen vnde ome be hulpen sin eder war he an
...en be gherende ist to sinem ghe schefte Dat wille wi gherne ieghen en vnde
...den oren willichlich vordenm Wo se dat ghebot an eyme ghe liken eder losken
...edder an eyme grotren Des to erner bekantnisse hebbe wi vnsen stad inghel

Nottula gelauata

...eme ghe strenghen edelen wol ghe borne miane Alie... wan g sy...
...nen vrymliken gruus sel desse breff...testra... Dusen be
...beghelichen truwen wetten in rechtem vlite touerim leue here her...
...vnde vuse eghentlike ghumer vns vnde den vusen to dusser tid eyns
...sunderlike wunnentlike vroyde vns eit sam ist Sint dar wy heb
...ben vor ware er uaren vnde vor nomen dat de ouerwynttlichste vorste

Argentum extra pennam

...olentes informari in diuersis modis scribendi Magistraliter et auisa
...aliter prout van scribitur in cuius dominorum. scilicet in literis
...teotibus et nottulis Venien eum ante et argento similiter aur
...oym metallo extra pennam venient ad me Johannem van
...haghen et informabuntur in breui tempore. spacio scni Blummer

public know he was available, he would post public notices at inns, on church doors, and at his temporary residence. Few such posters still exist [69], but what is probably the earliest known is a calligraphic specimen sheet written about 1400* [*Plate 6*].

These scrapbook pages and specimen sheets are the legacy of the end of the most diverse and prolific age of calligraphy. However, the age did not fade away quietly. Rather, the end was accompanied by the rising clatter of that novel apparatus, the printing press, which, between 1455 and 1500 produced more than 10 million books from 40,000 different handwritten exemplars. This was a task that would have taken all the scribes of Europe more than the thousand years that encompassed the Middle Ages [76].

Amid the noise of the press and the anticipation of what mass production of manuscripts could do for the world, one voice could be heard in praise of the old tradition. It was Johann von Trittenheim or Johannes Trithemius, the Benedictine abbot of Sponheim. In his famous *De Laude Scriptorum* (*In Praise of Scribes*), written at the dawn of the Renaissance, he reminded the new generation of the excellence of the scribes:

> The example of the informed scribes of bygone days may well serve as a guideline for the industry of our own scribes. We should look carefully at the ancient codices [books], written by well-trained scribes, and we should be guided in our dexterity and skill by their example. Among these scribes were many who took such extreme care in their copying that they not only wrote correctly but were also so well versed in designing attractive layouts by stresses, separations, divisions and illuminated initials that a mere look at their pages was inducive to reading. [3]

*Prof. James John has guided me to an early 14th century example penned by an Oxford liturgical calligrapher. The poster survives in fragments and is, compared to the above-mentioned Plate, extremely limited in varieties of style. See Van Dijk, S.J.P., *An Advertisement Sheet of an Early 14th Century Writing Master at Oxford*, publ. in *Scriptorium*, X, 1 (1956).

Plate 6 (opposite). Writing master's poster/specimen sheet, c. 1400, German. [Berlin, Staatsbibliothek Preussischer Kulturbesitz, MS. Lat. 2°, folio 384 verso] Believed the earliest surviving example of its kind. Johannes vom Hagen of Bodenwerder-on-the-Weser displays a dozen scripts and varieties of flourishes and decorated letters. [Original size before later trimming by bookbinder, probably 35×54 cm. (14×21½ inches)]

III THE PATRON DEMON OF CALLIGRAPHY

I am Cormac, son of Cosnamach, trying it at Dun Daigre, the place of the writing, and I am afraid we have got too much of the mischief of this ink. [40]

I am a poure dyvel and my name ys Tytyvyllus. [80]

Other crafts have their masters, other arts their patron saints, but only calligraphers can claim a patron demon. The following account of that singular medieval devil, Titivillus, is based on meagre scraps of written record pasted together with liberal amounts of presumption.

Titivillus was born in the minds of medieval monks [62]—created in jest to make a serious point. The repetitiveness of monastic life took its toll. Monks would occasionally cease to pay precise attention and words were mutilated, misspelled, and misplaced. Monks had to be reminded of the sin of inattentiveness. The earliest recorded mention of Titivillus by name appeared c. 1285 in John of Wales' *Tractatus de Penitentia* [43]. And the comment about him was repeated early in the next century when, in a sermon, Petrus de Palude, Patriarch of Jerusalem, commented, "Fragmina psalmorum / Titivillus colligit horum" [62] which, loosely translated, says that Titivillus collects bits of the psalms. Slipping about unseen [26] he listened for each and every verbal atrocity that occurred in the services [4]. But the monks deplored copying and writing errors as much as those in reading and singing. While no record of his interest in

scribal errors was found until the 15th century, it is logical to assume that he may have followed the monks from services to see what was amiss in the scriptorium.

What Titivillus did when he heard or saw an error gave him demonic status. John of Wales' early description added another fact [43] corroborated in several manuscripts (among them London, British Museum, Arundel 506, folio 46): "Quacque die mille / vicibus sarcinat ille." Titivillus, it explained, was required each day to find enough errors to fill his sack a thousand times. And these he hauled to the Devil below [4, 62] where each sin was duly recorded in a book against the name of the monk who had committed it, there to be read out on the Day of Judgment.

One might think Titivillus' search for mistakes was an easy task. *The Cloisters Manuscript*, as it is known today, was produced in 1325–28 with fifteen saints misplaced in the calendar and the names of more than thirty saints misspelled. Surely a sackfull in itself. But Titivillus' presence apparently had its effect. Monks soon took greater care, and by 1460 he was reduced to skulking about choirstalls, slack-sacked, in search of "Janglers, cum jappers, nappers, galpers, quoque drawers, momlers, forskippers, overenners, sic overhippers . . ." [9] (Janglers and jappers talk fast or jestingly, nappers fall asleep, galpers yawn, drawers drawl on and on, and momlers mumble. Foreskippers skip over things, overenners [over-runners] are simply faster foreskippers, and overhippers [over-hoppers] simply do it with bounce.)

Titivillus still came up or—more accurately—went down short on sins. By 1475 he was reduced to the drabbest deviltry:

> Titivillus, the dvyl of hell
> he wryteth har names soe to tel,
> ad missam garulantes [10]

—in other words, lurking in churches and taking the names of women gossiping at mass [49].

But the devil must have his due. At some point in the 15th century it dawned on him that a clever devil should be easily able to entice scribes into doubling, tripling, quadrupling clerical errors. And he wasted no time putting his plan to work.

Soon he was sacking sins as in earlier centuries. The scribes, overworked by the incredible

Plate 7. Rotunda, early 15th century, Italian. [Author's collection] Note the horned demon reaching from the abstract marginal leaf design. Many demons, among them Titivillus, inhabited the medieval imagination.

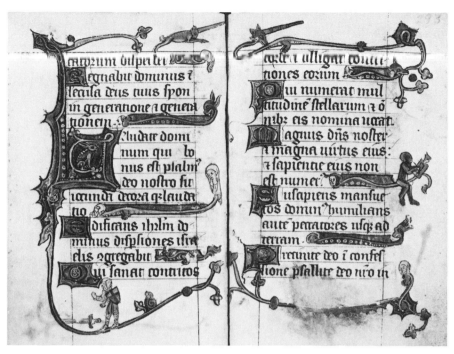

Plate 8. Gothic Textura Quadrata, early 14th century, Flemish. [Copenhagen, Det Kongelige Bibliotek, MS. GKS. 3384.8°, folios 292 verso and 293 recto] An ape takes notes on a horn-book in the righthand margin. Note the knight frightened by a snail; a familiar drollery in late medieval marginal illuminations.

demands put upon them by the universities' need for texts, disclaimed responsibility for the errors in the manuscripts they had to rush to produce. Titivillus, they said, had tempted them to err [38]. And Titivillus, acknowledged as the cause of their errata, became a patron rather than a pest since he absolved them of guilt.

A creation of the medieval era, Titivillus shied at the light of reason as the Renaissance dawned, and his name was soon forgotten. But no one had relieved him of his daily task. As printing increased in popularity and the wealth of calligraphy waned, he diversified his activities.

The pious monk who edited the manuscript *Anatomy of the Mass* in 1561 had to add to the slim 172 pages of text an errata fifteen pages long, a record for mistakes in so short a work. The errata began with the monk explaining that this dreadful situation was unquestionably the Devil's work. The manuscript had somehow been soaked in a kennel before reaching the printer who, after studying it while holding it gingerly, had mysteriously been induced to make this unsurpassed number of errors when he set it in type [22].

Sixtus V, pope from 1585 to 1590, apparently unaware of Titivillus, authorized a printing of the Vulgate Bible translated by Jerome. Taking no chances, the pope issued a papal bull automatically excommunicating any printer who might make an alteration in the text. This he ordered printed at the beginning of the Bible. He personally examined every sheet as it came off the press. Yet the published Vulgate Bible contained so many errors that corrected scraps had to be printed and pasted over them in every copy. The result provoked wry comments on the rather patchy papal infallibility, and Pope Sixtus had no recourse but to order the return and destruction of every copy. At least one, though, reportedly has been preserved [22] as a testament to Titivillus' handiwork. Since the Renaissance, books and more recently, newspapers have been flush with typographical errors which are always said to be

unaccountable. But it is obvious with whom the fault lies. Who else could have bedeviled the editors of the *Oxford English Dictionary* so masterfully: for the past half-century every edition of that eminent work has listed an incorrect page reference for, of all things, a footnote on the earliest mention of Titivillus.

Today's revival of interest in calligraphy surely pleases its patron demon. It must seem like the good old days to Titivillus. How else can we explain the mistakes we make?

(Pass the sack.)

Ⅳ THE SCRIPTS

In historical research we should not always wait until it is possible to solve a problem completely.*

—Prof. Aloys Schulte, 1919 [14]

For it is a comoun sawe, and soth it is, Worde and wynde and mannes mynde is ful schort, but letter writen dwellith.

—The Holy Bible. . . by John Wycliff and his Followers, c. 1395 [87]

The creation of the first alphabet was a result of adapting the pictographic and ideographic writing style of the Egyptians. Their style involved some 700 symbols, which may seem few in comparison to the 50,000 of the present-day Chinese [2], but it was cumbersome at best. Among the 700 symbols, some were repeated so often that the sound for the word they represented soon became recognized by that symbol. These initial sound-evoking symbols were used in a more humble, or bastard, quickly written form of hieroglyphics.

These phonetic symbols were adopted and adapted by the Phoenicians sometime before 1200 B.C. By building a set of 22 phonetic symbols representing all the sounds needed to speak their language, and through their use changing their shapes to abstract forms, the Phoenicians created the first alphabet [78]. This alphabet was borrowed and altered by the Greeks in the 8th century B.C., and it was officially adopted by that civilization in 403 B.C. [61] Well before that time, the nearby Etruscans, the first civilization to blossom on the Italian peninsula [29, 38], borrowed the Greek unperfected alphabet, changed it to suit their own needs, and gave their sixteen letters names, many of which we use today [21].

*In der Geschichtsforschung soll man nicht immer erst warten, bis es moglich ist eine Aufgabe vollig zu losen.

About 700 B.C. the Etruscans occupied early Rome and made it a city [38], and the Romans thus acquired the alphabet. Altering the Etruscan letters and adding to them alterations of desirable Greek letters, they applied calligraphic principles to their alphabet and adjusted it here and there until they had settled upon a collection of twenty-three [21, 28]: *A, B, C* (with the sound of *G* and *K*), *D, E, F, G* (a late addition since *C* had done the work), *H, I* (the vowel *I* and the consonant *J*), *K, L, M, N, O, P, Q, R, S, T, V* (always pronounced as *U*), *X, Y,* and *Z*. Missing were the letter *U*, which would not evolve from *V* until after 900; the letter *W*, which would not appear in Germany, for instance, until the 11th century, or in England until the 12th century; and the letter *J*, which would not proceed from *I* until after 1400 [60] [*Figure 3* and *Plate 9*].

No sooner had the Romans acquired their alphabet of fairly rigid capital letter forms, than the shapes began to change. Familiarity and the different demands for lettering led to less formal and to extremely cursive variations; from *Majuscule Cursive,* more closely mirroring the classical capitals, to *Miniscule Cursive,* a purely functional form [42]. All variations, though, were written with a stylus or other pointed instrument, the result being that all lines, vertical, horizontal and curves, were of equal thickness. The all-important change began about 200 B.C. with the adoption of the reed pen (known earlier in Greece and Egypt) and thereafter the creation of the quill pen. The reeds were cut with sharp points, producing monoline lettering. As time passed in the 1st century B.C., scribes gradually cut their pens with broader tips. The earliest datable clue to this popularity is 55–54 B.C., the date of a carved inscription [58] with variations in stroke width, obviously imitating a familiar written script style. This introduction of broad-point strokes in lettering gave an enormously calligraphic quality to the letter shapes, for lines and curves changed width and weight depending on the angle at which the pen point was held and the direction in which it was moved. This use of broad nibs and contrasting strokes thus began before 1 A.D. but probably achieved its greatest development during the early years of the 1st century [58].

The Serif

The other calligraphic step was the Roman adoption of the Greek serif in the mid-1st century B.C. (it, too, datable because of its appearance in the above-mentioned inscription). The serif is a brief perpendicular line ending most straight or curved strokes. The word, used by the English since about 1825, probably came from the Dutch *schreef,* meaning a flick of the pen [42]. Most scholars agree that its creation came about to solve a physical problem. One theory gave the scribe credit [17], while another honored the stonecutter [61] [*Figure 4*]. A modern theory [*Figure 5*] has, I believe, the more likelihood of being nearer the truth. What is most important is that the combination of stroke "weight" variation, thanks to the broad pen point, and the serif, resulted in lettering of unsurpassed calligraphic beauty.

This elegant lettering naturally was chosen for use on the imposing monuments so familiar throughout the Roman Empire. Scribes using broad brushes (exaggerated broad pen points capable of carrying sufficient pigment) painted the large beautiful letters on stone. Using these as a guide, stonecutters (often the scribes themselves) chiseled the letters into the stone, and the chiseled letters were then painted. Scholars today generally agree that the process of carving the letters was a means of recessing the painted letter to protect it from natural erosion. It was the paint, all of which nature has long since removed [2, 61], that gave them visibility.

The Trajan Column

We are more familiar today with this elegant lettering of the 1st century B.C. and 1st century A.D. on monuments than on papyrus or parchment. As it appeared in inscriptions it is called *Capitalis, Imperial Alphabet,* and *Littera Monumentalis,* the latter specifically referring to the Imperial and Augustan periods [42], *Scriptura Quadrata, Scriptura Lapidaria, Lapis Quadratus* and others. Palaeographers and calligraphers usually cite one particular example; the lettering on the column erected in Rome in 113 by the Senate and Roman people to commemorate the victories of the Roman Emperor Trajan [64] in what is now Rumania [23] [*Plate 10*]. Trajan died three years after his marble testimonial was completed, and his ashes were placed beneath

PHOENICIAN	GREEK	ETRUSCAN	ROMAN	MODERN
𐤀	A	A	Λ	A
𐤁	B	B	B	B
𐤂	Γ	C	C	C
𐤃	Δ	D	D	D
𐤄	E	E	E	E
𐤅	Y	F	F	F
			G	G
𐤇	H	𐌇	H	H
Z	I	I	I	I
				J
𐤊		K	K	K
𐤋	Λ	L	L	L
𐤌	M	M	M	M
𐤍	N	N	N	N
O	O	O	O	O
𐤐	Π	P	P	P
𐤒		Q	Q	Q
𐤓	P	P	R	R
W	Σ	S	S	S
T	T	T	T	T
			V {	U
	Υ	Y		V
				W
Φ	X	Φ	X	X
			Y	Y
	I		Z	Z

Figure 3. A simplified comparison of letter shapes, based on three studies.[2,61,86]

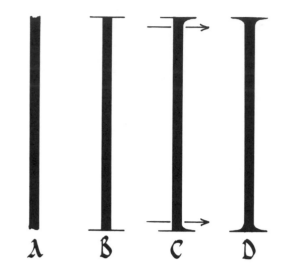

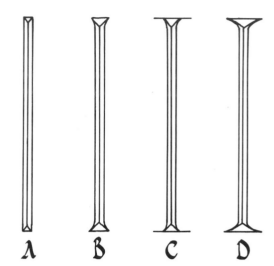

THE INKING THEORY

THE CARVING THEORY

Figure 4. Inking theory of the origin of serifs. A straight line (a) is difficult to begin and end with precision, and it appears more exact (b) with horizontal lines added. Pulling a pen or brush across a still-wet stroke can drag with it the extra ink (c), and repairing the accident by adding ink to balance the design (d) creates a calligraphically appealing figure.

Carving theory of the origin of serifs. A straight line (a) gives the illusion of bulging in the middle, which can be compensated for by slightly widening the ends of the line (b). To do this, it is easiest to start the horizontal cut a fraction away from the vertical line, and enter at an angle (c). In blending the horizontal cut with the vertical, the serif was created (d).

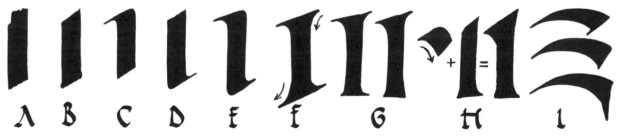

Figure 5. Another approach to the origin of the serif: (a) A line begins poorly if the breadth of the point is not fully inked, and (b) ends poorly when the point stops and ink flow continued momentarily. The solution was (c) to start with a quick edgewise motion distributing ink across the point, and (d) ending with a similar stroke pulling the pen quickly from the surface. A letter thus penned, (e) appears unbalanced, but (f) is improved by balancing each half-serif with its mirror image. (To this point I am indebted to the research by the Rev. E. M. Catich in *The Origin of the Serif*, Davenport, Iowa, 1968.) As time passed, scribes simplified the base serif by (g) producing a similar result by twisting the point clockwise; the shape varied depending on how far the point was pulled to the left in twisting, and how far pulled to the right at the finish. A single twist almost never, though, replaced the upper serif. But (h) scribes soon altered the procedure by making the first stroke the shorter one, and the second the major one proceeding directly into the letter shape. And (i) twisting strokes soon became commonplace in ending curved strokes, and led to increasingly greater exaggeration.

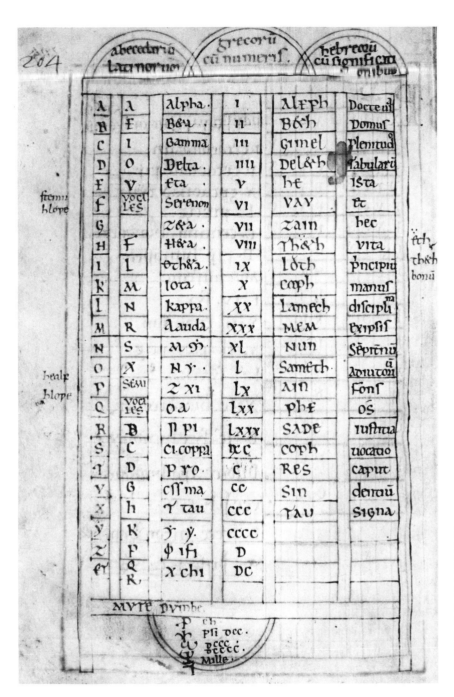

Plate 9. Latin, Greek, and Hebrew alphabets, 1011, English. [Oxford, Bodleian Library, MS. Ashmole 328, p. 204] Chart by the monk Bryhtferth, or Bridfertius Ramesiensis of Ramsey. Left to right: Latin alphabet in sequence, then by vowels, semivowels, and consonants; Greek alphabet and letters' numerical equivalents (added to at the bottom); Hebrew alphabet in sequence with Latin representation for each letter.

it. His enormous gilded statue later was pulled from the top and replaced in 1587 [23] by a smaller statue of St. Peter [8]. Ironically, what was erected to acknowledge a superb warrior, is primarily remembered as one of the most celebrated examples of calligraphy in history.

The script which the Trajan column represents in stone was, of course, for some time familiar to Romans as a written script, for no indecipherable and obscure variation would have been chosen to grace a monument whose purpose it was to make a public declaration. This highly calligraphic script of formal seriffed capitals has come to be known as *Roman Square Capital, Capitalis Quadrata,* and *Capitale Elegante* [42]. The essence of a majuscule script, *Roman Square Capital* letters were large and wide, so any text required maximum space. And the

ROMAN
SQUARE
CAPITAL

Plate 10. *Roman Square Capital*, A.D. 113, Italian. [Chicago, R.R. Donnelley & Sons, Inc.] Full-size replica of the Trajan Column inscription by Fr. Edward M. Catich. Translation: "The Senate and People of Rome to the emperor Nerva: Trajan Augustus son of the deified Nerva, conqueror of Germany and Dacia, in the seventeenth year of his tribunitian power, his sixth consulship, and sixth as commander, high priest, father of his country, in order to show the height of the mound and the extent of the area that has been cleared away for this project" [28]. Note customary lack of space between words; less frequent practice of dots separating words. [Original size, letters from 3.6 to 5.2 inches in height; marble slab 10 feet wide by 4½ feet high.]

letters were slow to write because of the need for precision. So only the finest manuscripts were deemed suitable for writing in *Roman Square Capital*; and these apparently were solely copies of the works of the great poet Virgil [29]. One of the earliest surviving *Roman Square Capital* manuscripts [*Plate 11*] is a copy of Virgil's work dating from the end of the 4th or beginning of the 5th century [74]. While in the lettering of the Trajan Column the broad strokes were in thickness one-tenth the height of the letters, and the thinner strokes one-half to one-third that of the heavier [60], the scribe responsible for the page in *Plate 11* employed some variations in custom with the time and in using pen on parchment rather than brush on stone. Using less height, proportionately, and a broader writing instrument, which he most frequently held slightly off from rather than exactly on the horizontal, he created letters in the script's style. But he did so with greater differentiation between thick and thin lines. The result was a more compact hand with stronger visual impact.

As was customary at that time, space was not left between words because it was believed

Plate 11. *Roman Square Capital*, 4th or 5th century, Italian(?) [St. Gall, Stiftsbibliothek St. Gallen, Cod. 1394, folio 7 recto]

Plate 12. Roman Square Capital, c. 816–35, French. [Epernay, Bibliothèque municipale, MS. 1, folio 19 recto] Revival of early script as display lettering, penned in gold. Note scribe's creativity in weaving together *I* of *Incipit* and *L* of *Liber*.

that such unevenly placed gaps destroyed the beauty of the carefully penned line of letters [82]. The separation of words was not to become a standard practice until the 8th century. Occasionally, as in monumental inscriptions, words were separated by dots, but this was the only break in the horizontal flow. And the only alteration in letter height was that of the *F* and *L*, which rose above their fellow letters [74].

Roman Square Capital, because of the space it required, the time it took, and its apparently restricted use, offered little promise as a popular script. It was revived intact later in the medieval era whenever the need arose for an important script for titles and headings [*Plate 12*]. But it was the basis for medieval man's scripts and, revived again in the Renaissance, survived to become the basis for our present capital-letter forms.

The premedieval scribes were not left, however, without a calligraphic script. The early capital-letter forms had not only been written stiffly but had been lettered with some cursive tendencies. They were, remember, the basis for *Roman Cursive* or *Minuscule Cursive,* which occasionally made the original (and as yet unseriffed) capitals so loosely cursive as to be indecipherable to modern eyes. Perhaps the increased interest in and appearance of

monumental lettering brought attention to it. By the 1st century scribes were lettering their cursive with more calligraphic tendencies, adhering somewhat more closely to the original capital shapes, and this more artistic development achieved considerable popularity. With the creation of *Roman Square Capital* the scribes of the 1st century if not slightly earlier had a beautiful book-script capital example to reflect. By tilting the pen away from the horizontal and making less frequent changes in the angle, they were able to produce each letter more quickly. By narrowing the width of some letters, they used less space in addition to gaining speed. One example [*Plate 13*], although written shortly before 494, may be representative of a far earlier way in which monumental lettering had been altered to become a less formal majuscule script. While this example is again a copy of Virgil's works [52], it is not an important copy but was probably written for school use [74]. The pen was held almost at 45 degrees, which considerably narrowed many of the letters. Such informalizing of the severe and stately capitals resulted in a script known as *Roman Rustic, Rustica* [42] or *Capitalis Rustica* [29].

ROMAN RUSTIC

By the 4th century *Roman Rustic* had become fairly standardized. In deference to speed the pen was held at a severe angle, and the scribe was less frequently inclined to change the angle for special touches. To conserve space the letters had become so narrow that most were only half the width of their *Roman Square Capital* form [58]. A particularly fine example [*Plate 14*] clearly shows that the effort to make *Roman Square Capital* easier to write quickly and in less space resulted in a highly calligraphic script. Similarly in *Roman Square Capital*, the *F* and *L* rose above their fellow letters, but in *Roman Rustic* the *B* and, in some manuscripts, *E* and/or *P* gained height. For capitals the scribes simply made the letter slightly larger than the others [2], using the same pen, for the entire script was comprised of capital forms.

Characteristics

Capital Letters

Roman Rustic, despite its bucolic name, was formal, remarkably graceful, and could require considerably more skill to produce than it would first appear [61]. Serving from the 1st century as the standard bookhand of the Empire [29], *Roman Rustic* had replaced the use of *Roman Square Capital* by the 5th century [60] and was a standard script as the medieval era began. Like *Roman Square Capital*, it was soon to vanish as a standard script, to return later when the scribes of the 9th-century calligraphic reformation searched for something special to add importance to portions of manuscripts. What cost it its popularity in earliest medieval days was the fact that, centuries old, it represented the old order. And that order was pagan. The medieval era brought with it a new order, Christianity, which began to sweep away not only the old concepts but also the scripts in which they had been written.

Plate 13. Roman Rustic, before 494, Italian(?). [Florence, Biblioteca Medicea-Laurenziana, MS. Plut. 39.1, folio 17 verso] [Size approximate]

AEQVORACVMMEDIOVOLVVNTVRSIDERALAPSV·
CVMTACETOMNISAGER·PECVDESPICTAEQVEVOLVCR
QVAEQVELACVSLATELIQVIDOSQVAEQVEASPERADVA
RVRATENENT·SOMNOSPOSITAESVBNOCTESILENTI·
ATNONINFELIXANIMIPHOENISSANEC·VMQVAM

Plate 14. Roman Rustic, 4th or 5th century, probably Italian. [Rome, Biblioteca Apostolica Vaticana, Codex Vaticanus Palatinus 1631 (P), folio 112 verso] Extremely beautiful and highly compacted hand. Note use of twisting stroke to widen vertical lines as they descend.

Christian Script

While one thinks of Rome as the focal point of this experimentation with and creation of scripts, the real action took place in the provinces. In the 2nd century, for instance, the greatest amount of writing was done in Egypt, where the small portion of the population who could read and write did so in both Latin and Greek [58]. Because of their bilingual ability a third script was to come into being—and it would become the first and foremost script of Christianity.

In the 2nd century the Church had not yet attained an official position of strength. Christians in Rome had few religious manuscripts, and these were primarily written in Greek. Latin had not yet become the official language of the Church in Rome. But it had for some time been the literary language of the Church in North Africa [58]. There the literate Christians had a variety of text scripts. The very earliest Christian writings may have been lettered in *Roman Square Capital, Roman Rustic,* or *Greek.* It is quite likely that, because of the considerable Greek influence, experimentation with a script that retained "importance" while permitting the scribe to work at a comfortable speed resulted in the adoption of some peculiarly Greek letter shapes. A particularly noticeable Greek touch, popular since the 3rd century B.C. [60], was the graceful rounding rather than squaring-off of letters. By the late 2nd or early 3rd century [74] a new Latin script emerged as dramatic and majuscule as, and springing from, *Roman Square Capital* and *Roman Rustic* [17]. This script also contained some of the graceful curves from the Greek alphabet, and since it was lettered with the pen held at an angle, it was rather easy to write quickly. By the 4th century it had become an established script for manuscripts of importance [52].

Adopted by the Church

The Church had meanwhile been gaining strength and growing enormously in membership. Latin had become the official language of Christianity in Rome, and the increased needs of the Church, plus the establishment of an official language, led to the next obvious step. One has to presume, though, how it developed. The Church fathers apparently saw about them a world in which almost all the manuscripts were pagan, written in *Roman Rustic, Greek,* or, in special and rare manuscripts, *Roman Square Capital.* Christian libraries now had to be established and an enormous amount of Christian writing produced. It was important this writing be in the now official Latin and distinctly different from the mass of pagan literature. But at the same time it must be recognizable to a flock both steeped in Greek and surrounded by pagan Latin scripts. The obvious answer was to officially adopt the provincial script. Its rounded Greek forms would be familiar to those used to Greek books and its *Roman Square Capital* and *Roman Rustic* origins would make it more acceptable to Christians whose background was Latin. So this

"new" majuscule script, already established among the Christians in Egypt, became the official script of the Christian Church. Its development was exclusively Christian. Of all the extant manuscripts, not a single scrap of any Bible exists in *Roman Square Capital* or *Roman Rustic* [82], and of the sizeable number of extant pagan manuscripts and fragments from those earliest centuries, few if any were lettered in this peculiarly Christian script.

I have so far mentioned no name in regard to this Christian script. We do have something specific to call it, but only because someone in the middle of the 18th century gave it a name based on what was probably a nasty remark by St. Jerome about fourteen centuries earlier.

Saint Jerome

St. Jerome, who was born in the year 340, was originally a desert hermit. In the desert he learned Hebrew and studied Christian literature. When he returned to Rome to teach, he was so repelled by its decadence that he retired to a monastery in Bethlehem. Jerome had been displeased with the existing Latin translations of the *Old* and *New Testaments*, so he began a new

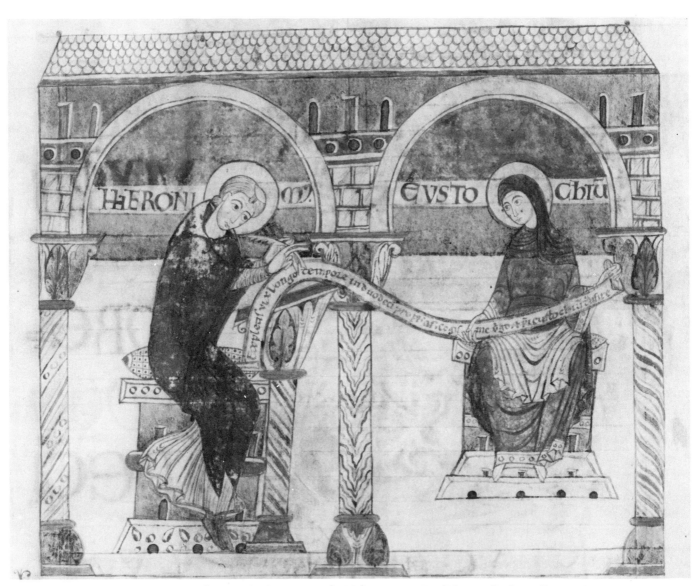

Plate 15. St. Jerome, early 12th century, English. [Oxford, Bodleian Library, MS. Bodley 717, folio VI recto] Illustration by monastery scribe and illuminator Hugo Pictor as the first page of a book whose size and extravagance would have miffed the saint.

translation based on what he considered the best Greek and Hebrew versions available to him. It took thirty years to complete and was to become universally accepted as the standard, common, or *Vulgate* text, from which word it gains its name [77]. The *Vulgate Bible* is still in Roman Catholic use today. Jerome was a powerful force in the establishment of profound Christian thought and was perhaps the greatest scholar of the early Church [*Plate 15*].

A man who thought Rome a Babylon and austerity a necessity, St. Jerome was one day horrified at seeing an ornate and expensively produced manuscript, and, in his preface to the Book of Job, damned such notions of waste and luxury:

> Let those who want them have ancient books or books written in gold or silver on purple parchment or in what is commonly called uncial letters— written burdens (I call them) rather than books.[52]

Now to be fair to St. Jerome, he was making a valid point. The finest manuscripts intended for the most important recipients, usually kings and popes, were occasionally executed on purple stained or painted vellum, in letters of gold or silver, the whole contained within ivory-carved and gem-encrusted containers or covers. St. Jerome, however, having reminded others that Christ had gone naked to the cross, was upset that so much ornament and wealth and pomp now seemed a necessary accoutrement to things Christian.

But what concerns us specifically is his use of that word *uncial*. Some paleographers [60, 61] theorize that he used that word because the script he saw was written an *uncia*, or Roman inch in height, or that the letters were *uncus*, or crooked [61], as they presumably were in comparison to *Roman Square Capital*. But another theory, which seems more in harmony with Jerome's lack of equanimity, is that while he was irritated at the size (and therefore either the seemingly careless waste of valuable parchment, or the suggestion that the words should need to be bigger in order to give them importance) he may have been glaring at *Roman Square Capital* or *Roman Rustic* [52]. Whatever he meant, he did not mean kindly. But the name *Uncial* was attached, fourteen centuries later, to the script an 18th-century author was anxious to have a name for, the beautiful Graeco-Roman script that St. Jerome may not have been referring to at the time.

(I have seen the term *Littera Romana* [52], or Roman letters, used to indicate *Uncial*, but also to indicate several Roman hands of the earliest Middle Ages, particularly up to the 6th century [42]. *Littera Romana* is further suspect because it has also been applied to the complicated charter or court hands used for papal bulls [52], although other sources state that such documents were written in a script called *Littera Bollata* [42]. I would suggest that *Littera Romana* is really a general term to indicate any and all scripts of the early centuries that one thinks of as Roman, even though they may have developed far from Rome.)

Uncial has been given several additional names in recognition of its appearance in variations. It is called *Square Uncial* to honor its *Roman Square Capital* parentage, and consists almost wholly of capital forms, all broad and majuscule. A *"b-d" Uncial* is one in which these two letters appeared much like the lowercase *b* and *d* of today. Another name, *ADEM, ADEM Alphabet,* or *ADEM Uncial* [42] originates from the fact that *A, D, E,* and *M* had forms so unusual that one recognizes the script by them. And *Natural Uncial* [42] refers to the script when the ascenders and descenders are equal in length to the minim stroke.

Jerome himself undoubtedly wrote in *Uncial* [74]. By the 4th century *Uncial* had become a fully developed script for books and, less than a century after St. Jerome's death in 420, reached its perfection. *Roman Square Capital* and *Roman Rustic* had fallen into disuse for all but titles. *Uncial*, from the 5th century [*Plate 16*] became, for important works, the major script of Western Europe as Christianity became the major influence. While it began as a majuscule script designed for speed, without the encumbrance of serifs (except for the occasional

Plate 16. Uncial, c. 450. Italian. [Oxford, Bodleian Library, MS. Auct. T.II.26, folio 82 verso] Extremely calligraphic example, rapidly written, with breaks in letters revealing the individual strokes. Notes in the left margin: Uncial of the same period, extreme left; later, more minuscule hand, to their right.

appearance of simple flicks of the pen [61], it soon began to show some changes. The letters *I, F, N, P, Q,* and *R* descended below the writing line; the letters *H, L,* and *D* ascended above it [2]. And while these ascenders and descenders were not so long as to make the script minuscule, they were a final departure from the rigid majuscule of earlier Roman writings [*Plate 17*].

Capital Letters

When the scribe wanted capital letters, he merely enlarged and, perhaps in so doing, also exaggerated one of the *Uncial* letters. Invariably he did so with the same pen used for the text [2].

Punctuation

More punctuation came into use at the time of *Uncial* writing, increasing the speed of comprehension. A point was used to indicate a brief pause, similar to a comma, and a colon or a colon accompanied by a dash for a more complete stop. A slanted line took the place of the point in the 6th century. At that time too the semicolon, drawn as a combination dot and slanted line, the appearance of the question mark, in the form of an *S*-shape drawn sideways, and another modern punctuation mark, the quotation mark came into use. The double quotation mark would not come into use until the next century [82].

Two important things then happened to this Christian majuscule script, which had been designed to be impressive, written rapidly, and understood easily. Its use as a vehicle in spreading the faith abroad made it more vital. And the importance it gained ironically predestined its death.

The Theory of the Rise and Fall of Scripts

Many of the medieval scripts rose and fell within the same inexorable pattern. It was a pattern that gave scripts a period of glory and, in their fall, forced the emergence of new scripts to repeat the same pattern. We can now see this pattern emerge in a broad context; particularly if we generalize for a moment.

Roman Square Capital was a script of unparalleled calligraphic excellence. It was a peculiar script because it seemed to have appeared at its peak, rather than rising slowly to it, although its origin was obviously in the earliest Roman capital and later cursive letter forms from which the monumental script was designed. Superb in appearance, *Roman Square Capital* was painstaking and time-consuming to form and, because of the demand for books, necessitated a more functional script. Whether a replacement came from the same original wellspring, as *Roman Rustic* did, or elsewhere, is not important here. But a simpler script had to come into use.

What then happened to the simpler replacement was to happen again and again. *Roman Rustic* became popular and talented scribes added calligraphic touches to it. As these became

Plate 17. Uncial, after 510, Italian. [Rome, Biblioteca Apostolica Vaticana, Basilicanus D. 182 (Arch. Pietro D. 182), folio 298 recto] Pen held almost horizontal. Note that extension of ascenders and descenders does not diminish majuscule quality; and mid-letter-height dots for pauses, above-letter dots for corrections, and horizontal bars indicating abbreviations.

popular and the script reached a higher calligraphic plateau, any use of it in simpler form became less acceptable to the discerning eye. The script, in effect, had nowhere to go but up. It could not stand still because the scribes' creative instinct could not be kept still. As one scholar put it: "The striving after beauty in handwriting is as natural to the accomplished penman as the striving after beauty in designing is to the artist."[74]

Inevitably *Roman Rustic* became more time-consuming to write rapidly. Since writing had to be done rapidly, and there was no willing *de*-calligraphying of a script,* another script had to take its place. This left *Roman Rustic* to fall into disuse as an extravagant art form. As we have seen, what emerged was a rounder and therefore more easily written Greek-flavored Roman script called *Uncial*. A graceful majuscule unencumbered with serifs, it was eagerly accepted by a Christian world desperate for manuscripts. As generations of scribes worked with it and expressed their creative abilities, the precision with which it was written became emphasized. The simple flick of the pen at the end of the strokes grew to a more artistic serif and, as this gave the script more importance, it was further honored by even more carefully penned intricate details.

In the 6th century some scribes began to letter *Uncial* with the pen held horizontally [*Plate 18*] instead of diagonally, in the fashion of *Greek Uncial* [60]. Once this technique became popular, *Uncial* could no longer be written as rapidly. This turn of the pen may have been added because speed was no longer important, previous additions having already slowed it down. Or it may have been the next creative step because a horizontal pen position gives a maximum contrast between horizontal and vertical lines. Once the scribes, intentionally or by default, dismissed speed as a factor, they were free to be as artistic as possible with every turn of each letter shape. By the 7th and 8th centuries [*Plate 19*] so much additional artistry had been added to the basic *Uncial*, so much embellishment lavished on its frame, that the script became what is called *Artificial Uncial*, or *Imitation Uncial* [52].† By the 9th century it had become so ornate that it was reserved only for special occasions; monumental manuscripts of the greatest importance [*Plate 20*], *incipits* (from the Latin for "here begins. . . ," the first sentence of a book or chapter),

ARTIFICIAL UNCIAL

*I do not believe an example exists of a script coming into being as the result solely of debasing a more calligraphic script.

†Some scholars, however, continue to use the name *Uncial*, your only clue to which form is meant being the period mentioned. If a period is mentioned.

Plate 18. Artificial Uncial, 6th century, Italian. [Durham, Dean and Chapter Library, Trinity College, MS. B.IV.6, folio 169*] Highly calligraphic example. Letters' righthand serifs are vertical and extended, a style indicative of European scribes. Symbol at line-endings (last line on the left) indicates omitted *M.*

and the like [35]. Similar names, *Uncialesque* and *Notarial Uncialesque* [58], reflect the *Artificial Uncial* letter forms of the 12th through 14th centuries. But at this late date *Artificial Uncial* was no longer a written script but a series of ornate decorative capitals to be used sparingly with the scripts of those centuries. While these capitals were sometimes used to letter phrases or statements, it is much as we might employ them today; for extreme emphasis and as rarely as possible [see *Versals*]. By the 11th century *Artificial Uncial* had, thanks to the scribes' care, risen above any functionality as a script [58]. And the same scribes had long since been forced to replace it.

As we follow the history of scripts, we find that most came into prominence to fill a need for functionality, flourished, became ever more calligraphic, and died of a surfeit of scribal exuberance. While *Uncial* was still the greatest script of Christian Rome, it led the history of calligraphy to a land that Rome forgot. Under the threat of destruction by heathens marching toward Rome in 410, the Empire recalled its troops from Britain, leaving that country to its own devices. A Christian land under Roman rule, Britain quickly began to crumble without Roman organization. Prey to the Picts attacking from Scotland, and the Welsh ravaging from the West, and unable to gain help from Rome, the Britons hired mercenary forces across the English Channel. Angles, Jutes, and Saxons (all commonly referred to as Saxons) came willingly. All too willingly. Soon the Britons were outnumbered by their rescuers and found themselves pushed from the land. The Saxons took Kent and turned it into a Saxon kingdom, and attacked much of the remainder of the Briton's lands, opposed most fiercely but unsuccessfully by a chief of Britain named Arthur, who was to become in legend the mighty King Arthur. The Saxons finally pushed the remaining Britons back into Devon, Cornwall, Wales, and the southwestern area of Scotland. By the dawn of the 7th century Anglo-Saxons ruled almost all of the land that became Angles' land, or England [83].

It was a land without record or literature, the Christian influence dissipated, the Roman glory a vague memory. Not one fragment of a single book or document of the days of Roman rule had apparently survived [52]. But England was not to be forgotten by Rome.

In the latter part of the 6th century, Gregory the Great planned to lead a mission to England, but the pope, or his court, refused to part with him. The plan had to be shelved [41], but it was remembered when Gregory himself became pope in 590, the first monk to be elected pope in

Anglo-Saxon Conquest

Gregory and Augustine

the succession to St. Peter [68]. Now unable to lead the mission, he chose the monk Augustine, who was prefect of his own monastery and experienced in supervision [54].

In 597, accompanied by thirty-nine other monks, laden with supplies, service books, bibles, lectionaries, lives of the saints, and possibly copies of monastic rules, Augustine headed north toward England. The writing in his finer and most impressive books was most certainly *Artificial Uncial* [52], and quite likely lesser materials were in more convenient, less space-consuming Roman styles, which could be called *Littera Romana* or even *Scriptura Communis* [42] (the term for any script used for normal everyday notations). One of the lesser scripts in Augustine's mixed baggage becomes of considerable interest in the near future.

Crossing the Channel, he encountered King Ethelbert in the countryside of Kent, the king suspecting that this Christian might employ magic spells and that they would be more easily dissipated if they were cast in the open air. Ethelbert decided not to convert, but he allowed Augustine to stay and try to convince any others who would listen [54].

Artificial Uncial to England

Housed in the partially ruined Roman church on the outskirts of Canterbury [83], which was to become the most important Christian seat in English history (unlike London, which was so pagan that Augustine had little success there [79]), Augustine began his work. Gregory had advised him to remove heathen idols but allow the altars to stand because heathens would gather there from habit [41]; let the old festivals remain, but dedicate them to Christian martyrs [34]; build new chapels in sacred heathen groves and celebrate Christ's birthday at the heathen feast of the winter solstice [68]. In short, his mission was meant to ease the Anglo-Saxons onto the True Path. (This was a traditionally effective approach that did not originate with Gregory. But the superimposition of Christianity over paganism could be a long while

Canterbury

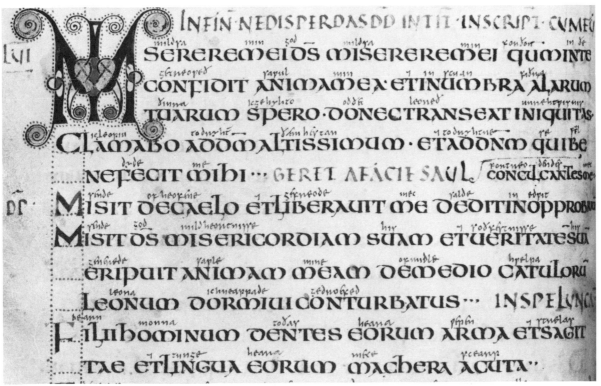

Plate 19. *Artificial Uncial*, c. 700–725, English. [London, The British Museum, MS. Cotton Vespasian A.I., folio 55 verso] Expert calligraphy. Important phrases penned in *Roman Rustic;* and *Roman Rustic G* (last line) replacing *Artificial Uncial* version. Note *Anglo-Saxon Minuscule* gloss, c. 850–900.

Plate 20. Artificial Uncial, late 10th century, German. [New York, Pierpont Morgan Library, MS. 23, folio 65 recto] Magnificent example in burnished gold on purple vellum, with difficult pen turnings and elongated ascenders and descenders so thin that majuscule quality is retained. Note numerous *NT* ligatures.

proving successful. As late as the middle of the 5th century, Pope Leo I had to chastise those who first bowed toward the sun before entering St. Peter's Basilica [24].)

Augustine succeeded in part, as Ethelbert agreed to be baptized [41], but he did not convert all England, only Anglo-Saxon Kent [79]. His attempt to gain unity with the remaining Church leaders of Western Britain failed because not only had he come from distant Rome, which had abandoned the Britons, but he was headquartered in the stronghold of their enemy, the Anglo-Saxons [54]. Yet Augustine's efforts were a major step. Christianity led to a semblance of order and tradition. But what is most important, he firmly established the use of *Artificial Uncial*. And in a land empty of records and devoid of books, *Artificial Uncial* bloomed as the faith spread northward. As this script increased in use and rose in artifice in both Europe and England, it soon began its decline toward obsolescence.

The script that was to replace it was also Roman and a close relative of *Uncial*, popular as early as the 3rd century [60] because it was easier to write, demanded less ability, and took up less space. It is known as *Roman Half-Uncial, Roman Semi-Uncial,* and *Minor Uncial* [58]. It is also occasionally given regional names when variations are discerned; one being *Burgundian Minuscule*, a somewhat more cursive version written in the 6th century [58]. *Half-Uncial* was probably represented in the written material in Augustine's baggage when he set out for England. Like all such early scripts that originated as cursive scrawls, this one was improved by the addition of *Uncial* characteristics [74] but it did not lose its cursive character, being free-flowing, small, and employing marked ascenders and descenders. One suggestion is that it appeared first in *Uncial* books when readers, familiar with *Uncial*, needed to insert notes in a small script that was nonetheless precise and readable. [74] Such notes, in the margins or between the lines of the original text, are known as *glosses*.

By the beginning of the 6th century, at a time when *Uncial* was already well on its way to becoming artificialized, the need for an alternative was obvious. And *Roman Half-Uncial* began to appear in minor manuscripts [46] that were not intended to be dramatic in appearance or expensive in terms of the amount of parchment used [52].

Uncial, a majuscule script, consisted of capital or uppercase letter forms. *Roman Half-Uncial*, heavy with ascenders and descenders, and maintaining its cursive heritage, acquired *Uncial* characteristics that were altered in order to increase lettering speed. While many letters were still recognizable as *Uncial* in origin, the entire script acquired an appearance we recognize as the beginning of lowercase letters. A minuscule script because of its ascenders and descenders, it acquired even more minuscule characteristics. The top loop of *B* disappeared, to be replaced

by the ascender-marked *b*; the rounded *S* became a flattened ascending and descending letter known as a *long S*. The *D* added another ascender in becoming *d*. The loop in the *e* became closed [60] and, among other things, the *Q* acquired a descender. The *N* generally retained its *Uncial* shape, however, because the lowercase *n* was too close in appearance to the new lowercase *r* [82] [*Plate 21*]. (The terms upper and lowercase are more modern, referring to the shallow trays or "cases," in which printers sorted the type, with separate compartments for each capital and small letter. The case of capital letters was always kept above that of the smaller ones—hence, uppercase and lowercase.)

From the beginning of the 6th century *Roman Half-Uncial* began to flourish. The lowercase letter forms that it popularized became calligraphic, were occasionally written as large as *Uncial*, but the basic lowercase shape remained. *Roman Half-Uncial* led a remarkable career. Facets of its style were adopted by many scripts that followed it. Its own lifetime lasted more than 500 years and came to an end only when a 9th-century reformation in writing introduced a clearer, more uniform script, called by one paleographer a calligraphic version of *Roman Half-Uncial*.

(We should look again at the terms employed. Beginning at this point all paleographers agree that the lowercase letter forms had arrived to stay; that they were a minuscule, as differentiated from the majuscule *Roman Square Capital, Roman Rustic,* and *Uncial* that had been in vogue; and that these qualities were epitomized by *Roman Half-Uncial*. But here the agreement on terminology ends. Some paleographers refer to the scripts that followed as *Minuscules*. Others prefer to use *Half-Uncial* in the script names. They also use the term *Majuscule* as part of script names and add *Quarter-Uncial* as another term for *Minuscule* in naming scripts, based on their reaction to the length of the ascenders and descenders and the formal roundness or informal compactness of the script. Since these terms are all relative, there is seldom total agreement. Simply speaking, none of the above words used by one paleographer is guaranteed to mean the same thing when used by another.

Roman Half-Uncial was carried out of Italy and across Europe. It probably accompanied Augustine to England and may very well have represented his *Scriptura Communis*. The English used it and, in turn, carried it back across the Channel and onto the Continent. Among the labors of the English missionaries traveling abroad was the teaching of *Roman Half-Uncial*. One of the most famous monks to make his way across was Wynfrid, an English Benedictine monk

Script Name Variations

Plate 21. *Roman Half-Uncial,* before 510, Italian(?) [Rome, Biblioteca Apostolica Vaticana, Basilicanus D. 182 (Arch. S. Pietro D. 182), folio 159 verso] Quickly written unsophisticated example typical of script's early appearance in books. Note elongated *s,* and minuscule *r, e, b,* and *d; Uncial N* prevents confusion with *n*-like minuscule *r*.

Saint Boniface

who by the age of thirty was already known in England as a rare teacher and scholar. In 719, at about the age of 40, he was given the name Boniface and consecrated as bishop for the German lands, where he began thirty-five years of service, commencing missionary work among the wild Thuringians [25]. It is evident that *Roman Half-Uncial* traveled with him [*Plate 22*]. St. Boniface later worked in Bavaria, Hesse, and Frisia and founded many Benedictine monasteries. He was a special example of those wise and dedicated missionaries who toiled against enormous odds and gained reverence among Christians everywhere. In 753 or 754, on a trip near Utrecht in the Netherlands, he and his companions were attacked by robbers. St. Boniface was among those killed [25].

The *Roman Half-Uncial* that had come to Europe directly from Rome or by way of England was to evolve into many new scripts. But a remarkable one began to take form long before St. Boniface's death. It occurred in Ireland; a wild and heathen isolated outpost a century and a half before St. Augustine left Rome.

To Ireland

At the beginning of the 5th century, Saccath, or Sucat [61], a Christian Briton boy of sixteen [42] was taken captive by an Irish raiding party in his native Severn area. Saccath arrived in Ireland a slave and was sold to a chieftain in Ulster [83], there to begin a lonely life tending sheep [61]. After six years, driven by a dream, he walked the two hundred miles to the sea. There a ship took him on the first leg of a journey that finally brought him home to Britain.

His religion inspired him to pursue missionary work. He studied first in one monastery and then another, motivated by a dream of returning to Ireland, but he was rejected by the authorities as leader of a mission. Although he spoke the language of the heathen, a rare asset, it was his Latin that held him back. His education was far surpassed by his zeal. Saccath's own writings indicate that he was familiar with and could comment clearly on and about at least one book—the Bible [18]. Those who were to make the decision found him too rustic for the task and appointed another. But when it was learned that the first mission had ended in disaster, Saccath was charged to lead another at once. Now almost fifty years old, he was appointed bishop to the Irish [25] and in 432 was at last on his way.

Saint Patrick

Given the name Patrick (the Latin equivalent Patricius bestowed upon him to indicate his nobility), he converted the Irish with a policy identical to that which a century and a half later Pope Gregory would urge upon St. Augustine. So the things Christian he brought did not replace the Celtic culture he found [34]. To a land where Latin was not spoken and the only alphabet, called Ogham, was hopelessly impractical, Patrick brought the language and the

Plate 22. Roman Half-Uncial, c. 700, probably English. [Oxford, Bodleian Library, MS. Douce 140, folio 59 verso] Formal appearance acquired by holding pen point horizontally. Marginal notation is believed to be in St. Boniface's hand.

Plate 23. *Insular Majuscule,* c. 790–830, Irish. [Dublin, Trinity College, MS. 58 (A.I.6), folio 146 recto] Superb example from the *Book of Kells.* Note majuscule quality given to lowercase letters, Irish style elongation of letters, and frequency of ligatures.

common script of Rome. Unlike Augustine, who would arrive in Britain bearing books in *Uncial* as the most important script to copy, Patrick came with books in *Roman Half-Uncial.* The script took on dramatic changes, penned by monks relatively isolated from outside influences and removed from the upheavals of war overwhelming England and Europe.

There is no way of knowing how much the radical change that occurred in *Roman Half-Uncial* was due specifically to the influence of St. Patrick (432–61) or to some calligraphic quality instilled by the artistic traditions of Celtic converts. But a new script, best referred to as *Insular* (from the Latin for island) *Majuscule,* emerged from the old in the 6th century. It is also referred to by paleographers as *Irish Majuscule, Irish Half-Uncial, Insular Round-Hand,* and *Irish Round-Hand.*

Insular Majuscule, at its calligraphic best, was breathtaking. When done with the greatest care, the pen was held at or near the horizontal. Distinctive characteristics include the curving *l* and *b.* The letters *A, D, R,* and *S* showed a mixture of both *Uncial* and *Roman Half-Uncial* forms [82] derived either from the beginnings of *Uncial* mixed with the *Roman Half-Uncial* of St. Patrick; *Uncial,* which had arrived later; or the *Uncial* tendencies brought across the Irish Sea by the Anglo-Saxon students. This last influence would have been the latest but was certainly a likelihood. Augustine's *Uncial* spread rapidly in England in the 7th century, as did word of the enormously respectable monasteries of learned scholars in Ireland. *Uncial*-trained Anglo-Saxon scribes flocked to study across the Irish Sea in the land referred to as *Insula Sanctorum* [49, 67], Holy Island or Island of Saints.

Insular Majuscule reflected other Irish innovations. Ligatures (the joining of letters) and creative stretching and shaping of letters is seen at its finest in the glorious script of the *Book of Kells* [Plate 23], the Latin gospel book considered to be the most beautiful manuscript ever created. Although the late 12th-century monk and historian Giraldus Cambrensis was describing another gospel book of the same era, his description mirrors the awe in which the *Book of Kells* was held [57]:

> Fine craftsmanship is all about you, but you might not notice it. Look more keenly at it and you will penetrate to the very shrine of art. You will make out intricacies, so delicate and subtle, so exact and compact, so full of knots and links, with colors so fresh and vivid, that you might say that all this was the work of an angel, and not of a man.

INSULAR MAJUSCULE

Characteristics

The Book of Kells

Paleographers disagree on precisely where or when the *Book of Kells* was begun and finished, but we can presume that it was the work of scribes between 790 and 830 [34]. A late example of *Insular Majuscule* of Irish origin, it was penned with a quill held just a few degrees off the horizontal [2], with the weight of the thickest strokes about one-fourth the height of the letters [60].

Wedged Serifs

The most outstanding innovation separating *Insular Majuscule* from its parents is the painstakingly drawn wedged or triangular serif, the earliest surviving example of which is dated about 561 [58]. How this characteristic developed is also a mystery.

One theory is based on the history of thick serifs as they appear in another art. No serif as such had ever existed in European calligraphy before the Irish scribes created it. But such a serif had, in rough form, appeared in the letters of the sculptured coins of early Rome and then of Byzantium [58]. At the time the Irish scribes were perfecting their *Insular Majuscule*, the most treasured arts of Europe were being produced in Byzantium or by Byzantine artists who had traveled to Rome. *The Book of Kells* is, in its decoration, heavily indebted to Byzantine art, and if the Irish scribes were impressed enough by Byzantine art to borrow it for manuscript decoration, why not the ornate serifs of the impressive Byzantine coin lettering in manuscript calligraphy? In truth there is no way of knowing where the Irish wedged serif originated, or why the Irish were so partial to it. They may have adopted or created it purely because it distinctively enhanced the new script for their new language [58].

The Book of Kells is the classic example of late *Insular Majuscule*, but that script was a distinctively decorative and ornate book hand of more than two centuries earlier. And even the manuscripts that preceded it by only a few years [*Plate 24*], or others written during the years of its own creation [*Plate 25*], show clearly that, had the *Book of Kells* not survived, the *Insular Majuscule* of the Irish, even in lesser works, was a unique tour de force.

INSULAR MINUSCULE

To enter glosses and to rapidly produce less important material, the Irish scribes in the 6th century had developed from the same cursive source a simpler, compact script with typically cursive emphasis on ascenders and descenders. The wedged serifs for *Insular Majuscule* found their way into this simpler script, and because the pen was held at a comfortable diagonal, the serifs were angled upward, giving the script a pointy effect. The script would have been more convenient without them, of course, but the Irish, perhaps admiring the serifs as a distinctive feature of their writing, kept them despite their inconvenience. This more compact script is known as *Insular Minuscule*, and it is referred to by some paleographers as *Irish Minuscule, Irish Half-Uncial, Irish Pointed-Hand,* and *Insular Pointed-Hand.* Both the majuscule and minuscule creations of the Irish scribes were taught to Anglo-Saxon students who traveled to the Celtic

Plate 24. Insular Majuscule, late 8th century, Irish. [Oxford, Bodleian Library, MS. Rawl. S. 167, folio 25 recto]

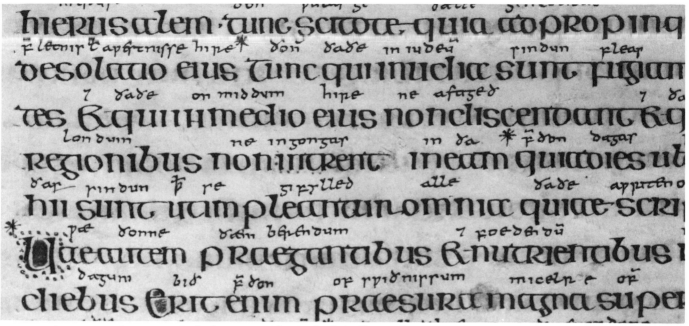

Plate 25. *Insular Majuscule,* before 822, Irish. [Oxford, Bodleian Library, Ms. Auct. D. II.19, folio 117 verso] Somewhat cursive version by Bishop Mac Regol, abbot of Birr. Note minuscule gloss by 10th-century Anglo-Saxon scribe, serifs suggesting his teacher was Irish.

land, leaving behind emphasis on *Artificial Uncial,* which emanated from southern England and was gradually taught further and further north.

About 565 the Irish themselves took their skill abroad. Beginning in Scotland and Northumbria, they began a trail of conversion and education southward across England [58]. The English or Anglo-Saxon scribes tutored by the Irish learned the newcomers' majuscule and minuscule scripts quickly [*Plate 26*] and copied them well. So similar was the Anglo-Saxon calligraphy to that of the Irish that late 7th and early 8th century examples are almost impossible to be categorized by nationality [52] [*Plate 27*]. After that period paleographers can more easily see differences because the Anglo-Saxon scribes tended to be more orderly and less whimsical in the way they allowed the letters to splash across the page. The Anglo-Saxons, by writing more clearly, allowing more space for their lettering, and being less inclined to add unusual flourishes, might even be said to have improved on their Irish teachers [52] (unless, as I do, you take more pleasure in seeing a more spirited individualistic hand at work). Paleographers have called work clearly Anglo-Saxon in origin, creating such script names as *Anglo-Saxon Majuscule* or *Anglo-Saxon Round-Hand,* and *Anglo-Saxon Minuscule* or *Anglo-Saxon Pointed-Hand.* One eminent paleographer makes constant use of the name *Anglo-Saxon Square Minuscule* [6] which may be his way of describing any hands between an obvious *Anglo-Saxon Majuscule* and *Anglo-Saxon Minuscule.* A few, however, prefer the safety of the generalized *Insular Majuscule* and *Insular Minuscule,* stating whether of Irish or Anglo-Saxon origin. A great variety is to be found in facsimiles of hands by Irish and Anglo-Saxon scribes. This is because of the differences in angle at which each scribe held his quill, and his ratio of letter height to the width of the quill nib. It is difficult, unless one is a paleographer, to discern between them, so it is best to consider the Irish and Anglo-Saxon scripts together as *Insular.*

By the middle of the 7th century, scribes most familiar with *Insular Majuscule* and *Insular Minuscule* converged with those using *Artificial Uncial* and *Roman Half-Uncial.* For a time all flourished harmoniously in Northumbria until a conflict between Celtic and Roman

Anglo-Saxons Taught Irish Script

Plate 26. Insular Majuscule, c. 750–800, English.[Oxford, Bodleian Library, MS. Arch. Selden B. 26, folio 34 recto] A late example by a scribe whose hand varied from majuscule to minuscule.

ecclesiastical practices occurred. The Celtic Christian Calendar and the Roman Calendar of Augustine differed in the date of Easter. It was a conflict of major importance to the people of that time, well worth argumentative hair-splitting. Equally hair-splitting was one of the lesser conflicts; Roman (and Anglo-Saxon) monks shaved the tops of their heads, and left a fringe indicative of Christ's crown of thorns, while the Irish monks shaved the sides of their heads, leaving a tuft at the top, possibly similar to that of their Druid predecessors [38]. To resolve these conflicts, the Synod of Whitby was held in 664. The Augustinian faction won and England thereafter followed Roman ecclesiastical practices. While writing style was not an issue, it was shortly after that date that the practicality of the *Insular* scripts won out over the *Uncial* [52, 66].

Insular Minuscule Succeeds

In the 9th century *Insular Majuscule*, ornate and expensive in terms of time and material, lost its popularity [82]. Into limbo therefore went the script's decorative touches that, in moments of creative enthusiasm, also had embellished the most calligraphic *Insular Minuscule* [*Plate 28*]. *Insular Minuscule*, however, continued in Ireland, and it remains today the script of Gaelic. *Insular Minuscule* remained in England [*Plates 29 and 30*], its use in Latin texts continuing until the 9th-century European calligraphic reformation influenced the English scribes in the 10th century. Thereafter Latin was written in a new script. Anglo-Saxon, however, continued to be written in a slightly altered *Insular Minuscule*, which employed three letter-forms from ancient Anglo-Saxon [*Plate 31*]. The Norman Conquest of 1066, however, brought new ideas from Europe, and, by the end of the 12th century, *Insular Minuscule*, whether for Latin or Anglo-Saxon, disappeared from England.

Insular Majuscule and *Insular Minuscule* had been scripts unique to Ireland and England, although they had originated with the scripts of early Rome. As we followed their evolution in the British Isles, much was happening behind us.

National Hands

With the establishment of the Byzantine Empire and the heathen upheavals in Europe, the power of Rome had been flickering. The Roman scripts that had been carried into Gaul and elsewhere were no longer backed by an all-powerful authority from home. Much as in Ireland, local influences adapted *Roman Cursive* and *Roman Half-Uncial* so independently that five distinct scripts, called national hands [21], could be discerned: *Italian* or *Lombardic* [35]; *Merovingian* of France; *Visigothic* of Spain; *Germanic*; and, most distant, *Insular*. The creation of national hands led the way to variations, one of which was *Beneventan Minuscule*, a strikingly calligraphic script of southern Italy from about 700 to 1200 [42]. Adding to the flavor and

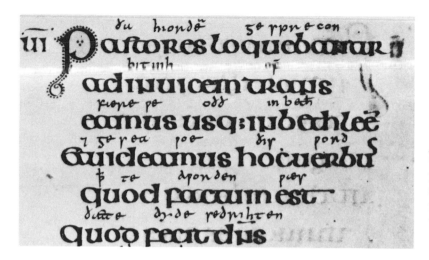

Plate 27. Insular Majuscule, c. 700, English. [London, The British Museum, MS. Cotton Nero D.IV, folio 143 verso] Beautiful example from the *Lindisfarne Gospels* by Eadfrith, bishop of Lindisfarne. Gloss is 10th century *Anglo-Saxon Minuscule* Anglo-Saxon translation (see *Plate 57*).

variation was the missionary invasion of Europe by the Irish and Anglo-Saxon monks in the 6th, 7th, and 8th centuries, who established monasteries at Luxeuil, Corbie, Reims, Tours, Wurzburg, Cologne, Reichenau, St. Gall, Bobbio, Fulda, Hersfeld, Lorsch, Echternach, Mainz, and elsewhere [52, 58, 82]. *Insular* calligraphy thus flourished in Europe along with various national hands and some scripts [*Plate 32*] that seemed unchanged from those brought from Rome 200 years earlier. There had been great movement across Europe, and just as Roman script need not have been written in Italy, so too an *Insular* script no longer meant that the scribe wrote it in Ireland or England [*Plate 33*]. Indeed, he may never have traveled beyond sight of his scriptorium in Switzerland or Germany. These *Insular* hands influenced the scripts of Europe and were to an extent modified by them. The result was that the Continent abounded in many variations.

However, when it came to the creation of a script in which to write legal documents, a special quality was required. A good charter hand or court hand was so ornate that one viewed it with awe, and so complicated that it not only resisted forgery but could not be understood by those who had no business reading it. Sometimes this succeeded too well. So skilled at the art of being importantly unreadable were the scribes of the pope's Curia that even a high prelate might have difficulty making it out. In 1075, for instance, Archbishop Ralph of Tours received a privilege but was hard-pressed to enjoy it, as it was written in the curious *Littera Romana* of the Curia and he could not make any sense of it [52]. It is not likely that he was awed. It is probable, though, that those within earshot of Ralph were.

[Whether called charter, court, legal, or documentary, the secretive secretarial hands of the

Court Hands

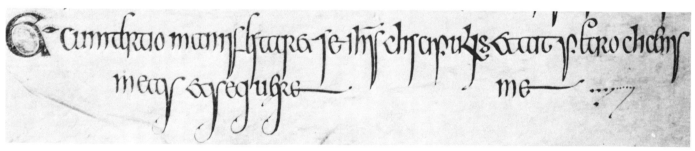

Plate 28. Insular Minuscule, c. 790–830, Irish. [Dublin, Trinity College, MS. 58 (A.I.6), folio 25 verso] Rare use of minuscule in the *Book of Kells*, made formal by use of majuscule decorative techniques.

medieval era are a field unto themselves, and their names can be as misleading as their appearance. *Littera Romana* may not actually be the name of a given script at a given time, but a reference to the kind of script used in the Roman Curia. It is also used as a general name for *Uncial* brought to England during the Roman rule [42]. As previously noted, it also served as a catch-all title for any script anyone presumed to originate in Rome. There was at one time a *Litterae Caelestiae*, which was reserved by law solely for the Imperial documents of Rome from 367, and which died out less than a century later. During the Middle Ages the scribes who taught court hands referred to them as *Notula Curiensis*, meaning a note by a member of the

Plate 29. Insular Minuscule, c. 800, English. [Oxford, Bodleian Library, MS. Lat. Bibl. c.8 (P), folio 105] Cursive hand retaining finely shaped serifs. Note numerous ligatures of *tall-e* with *p, n, t,* and *x.*

Plate 30. Insular Minuscule, c. 800, English. [Oxford, Bodleian Library, MS. Bodley 426, folio 76 recto] More cursive hand; narrower pen point, less regard for serifs, looser control of letter size. Note use of both *Uncial* and *Roman Half-Uncial d.*

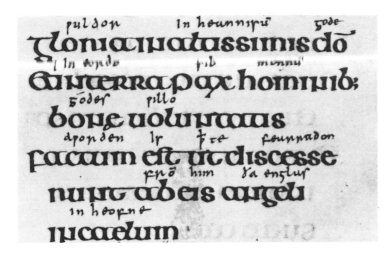

Plate 31. *Insular Majuscule, c.* 700, English/Anglo-Saxon Minuscule gloss, 10th century, English. [London, The British Museum, MS. Cotton Nero D.IV, folio 143 verso] Gloss contains three symbols added to Latin alphabet from early Anglo-Saxon when writing in that language: *Wyn* or *Wen* for *w* [110] (first letter above *voluntatis,* 3rd line); *Thorn* for the sound *th* (above *ut,* 4th line, with abbreviation symbol struck through it); and *Edh,* also for the sound *th* (first letter above *angeli,* 5th line).

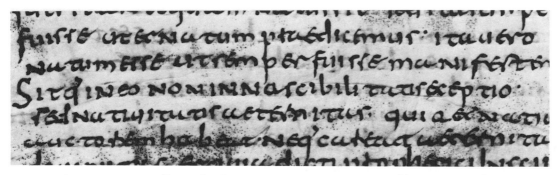

Plate 32. Roman Half-Uncial, 8th century, European. [Rome, Biblioteca Apostolica Vaticana, Basilicanus D. 182 (Arch. S. Pietro D. 182), folio 12 verso] Late example showing little evolution from that of more than two centuries earlier.

papal Curia; *Cancellaresca,* which means from the Chancellory; and similarly *Cancelleysch* and *Modus Copistarum,* or generally in the manner of a copyist [49, 69]. Another, *Diplomatica* [42], originated in the 12th century. In the late Middle Ages court hands ceased to be overly ornate and were no longer intended to be indecipherable to outsiders. Instead they became a style admired for its clarity and elegance. The legal hand that the Bolognese lawyers originated and used in the papal Chancery of the 13th and 14th centuries, for instance, was at the same time the script in which literary works appeared in Southern Europe. It is known as *Scriptura Bononiensis* or *Littera Bononiensis* and was distinguished by its tall unserifed letters with short ascenders and descenders [58]. The general name given to the new trend of readable writing was *Chancery Cursive. Cancellaresca Formata* [42] was a carefully lettered cursive form that, when used with greater speed and less formality, was called *Cancellaresca Corrente* or *Cancellaresca Corsivo,* the original name for *Italic* [42], anything but a complex indecipherable script.]

Charter hands began with a very cursive base and, instead of being raised to majuscule heights, the minuscule and cursive qualities were emphasized, which produced awesomely unreadable hands with multiple ligatures and seemingly frivolous ornamentation. So the national hands included important, readable, carefully produced scripts for books, and important but unreadable scripts for documents. At the same time there was also a need for a working script, a *scriptura communis* or better. Normally this would have been achieved by elevating cursive elements with book-hand characteristics, as was done in the creation of *Roman Half-Uncial.* In this case though, in some areas, the scribes created a more usable

Plate 33. Insular Minuscule, early 9th century, German. [Oxford, Bodleian Library, MS. Laud Misc. 442, folio 10 recto] Late example of an Anglo-Saxon hand. Clear, open letters and word separation suggest the influence of the calligraphic reformation growing in that area.

minuscule by borrowing characteristics from charter hands. National minuscule scripts often evolved from charter hands [52]. An example of this, certainly the strangest and one of the most short-lived medieval creations, occurred in the Vosges Mountains of eastern France. The earliest-known example was written in 669 [52]. The script reached its peak by 700 [56], and within a century it was on its way out. Its name was *Luxeuil Minuscule*, also known as *Luxeuil Script* or *Scriptura Luxoviensis*.

<div style="margin-left:0">LUXEUIL MINUSCULE</div>

Luxeuil had been the ruins of a Roman fort [25] or spa [34] until the Irish, led by St. Columban, arrived there from the Abbey of Bangor shortly after 590 bearing their own *Insular* scripts. However, *Insular Minuscule* (still too new to have been calligraphic [52]) and *Insular Majuscule* appear to have had little influence on what was to occur at Luxeuil. Unlike Patrick, Columban had an uncompromising attitude, antagonized the Burgundian royalty, and eventually was forced to leave about 610 [34]. His replacement generally held the same beliefs, but a new monk, Agrestius, with both a forceful nature and a more lenient attitude concerning asceticism, soon opposed the position of Columban's replacement and, as the result of a council of 625, was in a position of considerable influence at Luxeuil. Agrestius' more agreeable attitude regarding comfort and wealth set well with the royalty and other comfortable and wealthy folk. And some of the donations inspired by this approval likely allowed Agrestius to improve and support the scriptorium at Luxeuil [58].

Before becoming a monk, Agrestius had been secretary to the Burgundian king and was therefore familiar with the royal Merovingian chancery. It is no doubt for this reason that the *Merovingian Charter Hand* [*Plate 34*] was the one whose characteristics the monks of the scriptorium of Luxeuil overlayed on their cursive hands in creating their own *Luxeuil Minuscule* [58], probably Europe's first truly calligraphic minuscule [52].

At first glance it is as difficult to be impartial about *Luxeuil Minuscule* as it is to read it. The cursive traits of multiple ligatures and extended ascenders and descenders are as obvious as the charter traits of compactness and exaggeration [*Plates 35* and *36*]. The capital letters employed with *Luxeuil Minuscule* were based primarily on *Roman Square Capital* forms, but they also included some *Uncial* forms, appearing at first to be an unkempt design, or perhaps one about which no firm decision had been made [*Plate 37*]. But then so did the script. Yet *Luxeuil Minuscule* had a strange artistic grace and was clearly readable to the people of its time. Ample evidence of this is the fact that when the monks of Luxeuil founded other monasteries, *Luxeuil Minuscule* was seen and admired throughout France and beyond its borders. And other regional scripts soon showed evidence of its influence [52, 82].

<div style="margin-left:0">Luxeuil Capitals</div>

Plate 34. Merovingian Charter Hand, 696, French. [Paris, Archives nationales, K.3 No. 10] Royal diploma in letter form, the script an intentionally complex style clearly a parent of *Luxeuil Minuscule*.

Plate 35. Luxeuil Minuscule, early 8th century, French. [Verona, Biblioteca Capitolare, MS. XL (38), folio 65] Highly calligraphic example of a rather cursive heavily ligatured script.

As the 8th century came to an end Europe was in danger of sinking beneath the weight of national and regional majuscule and minuscule scripts. This would soon change as a calligraphic reformation spread throughout Europe and finally across the English Channel. For the first time in the history of calligraphy specific individuals are considered responsible for a script, one even giving his name to it—so perhaps it is understandable why so many legends and contradictory stories surround them. The two were an odd pair to reform the Western world: an illegitimate prince from the Continent, who never quite got the hang of proper spelling and could not write well no matter how much he practiced, and an Anglo-Saxon Benedictine monk, who was an inspiring teacher and excellent organizer.

The record of the birth of Carolus (c. 745) was evaded by his own court biographer, Einhard, but the supposition is that he was born two years before his father, King Pepin, married a duke's daughter, Bertrada [33]. Young Carolus grew up speaking the common

Charlemagne

debased Latin; he could converse and read in German and read classical Latin, but his spelling and writing were poor [33, 53]. In 768 he became king of the Franks and, on Christmas Day of 800, emperor of the west[53]. Late in his reign his court clerics unofficially entitled him *Carolus Magnus*, or Charles the Great, which in the common language of the area became the *Charlemagne* of legend. He lent sustenance to legend easily. Ruler, by 771, of France, Germany, half of Italy, and part of the Baltic region [2], he was a warrior of considerable repute, a supreme defender of the faith (his four concubines notwithstanding), and an able administrator. His concerns ranged from the preservation and advancement of Christianity and the improvement of society and the education of his subjects to the stamping out, if you will, of the custom of using bare feet to press grapes [38]. And one of his concerns was the poor level of calligraphy within his realm [17]. I do not suggest that this was engendered by artistic considerations. More likely he realized the value of communication not only in education but in ruling, for a good ruler must communicate his orders and know that they will be understood, and a realm peopled by diverse groups writing myriad scripts posed potential disaster.

Alcuin

Thus the importance of the Anglo-Saxon Benedictine monk Alchvine, Alcuinus, or Albinus [58], most commonly known today as Alcuin. Born in England about 735 [60] and educated at the Cathedral School of York, whose director he became, Alcuin was an undistinguished poet but, primed with good drink, an eloquent lecturer and that rare sort of teacher who can inspire in everyone a passionate desire for knowledge [38]. Charlemagne placed him in charge of his court's school and scriptorium. He gave him the responsibility for organizing the work and editing the texts involved in the emperor's program to revive knowledge by distributing classical and ecclesiastical writings throughout the empire. Alcuin worked at this faithfully for a number of years and was, in gratitude, made the abbot of St. Martin's of Tours in 796 [60]. He died about 806 [33], at about the age of seventy-one, a decade before his emperor died.

Charlemagne and Alcuin did not invent a new script, but their involvement was critical in terms of their influence on the styles coming into fashion in their time. To consider one such style, let us return to the French scribes of Luxeuil.

Plate 36. Luxeuil Minuscule, early 8th century, French. [Paris, Bibliothèque nationale, MS. Nov. Acq. Lat. 2243, folio 2 recto] Stronger cursive elements reduce this hand's calligraphic appeal. Note use of both forms of *n*, suggesting the style was in a state of flux.

Plate 37. Luxeuil Minuscule capitals, early 8th century French. [Rome, Biblioteca Apostolica Vaticana, XL(38) Reg. Lat. 317, folio 169 verso] Capitals of *Roman Square Capital* origin with an *Uncial H* mirror the elongated shape of the then-young script.

As the monastery of Luxeuil in the 7th century grew in importance and in personnel, some of its monks founded other monasteries. With them went *Luxeuil Minuscule*, which so impressed the scribes of yet other monasteries within and without France that characteristics of the unusual minuscule were adopted into their scripts. While *Luxeuil Minuscule* remained relatively pure in its native scriptorium, the scribes who left that chamber were affected by the scripts they met in the outside world. Some of the monks established a monastery at Corbie in the middle of the 7th century. There, somewhat removed from Luxeuil and again open to the influences of Irish missionaries, the variations of their own native scripts, and material arriving from Rome and Byzantium, their own predominant hand naturally began to change. *Luxeuil Minuscule*, at Corbie, became more formal, more controlled, and easier to read [52]. This "easier" characteristic may have been caused by an infusion of outside elements rather than a device created wholly by the Corbie scriptorium itself. What distinguished it was the elimination of the most cursive element of the script; its recklessly long ascenders and descenders.

New Script Develops

This probably occurred late in the 8th century because it was an important decision made at about the time of Alcuin, and one which some historians credit to Alcuin himself. Probably, over a period of time, it dawned on the scribes of the Corbie scriptorium that the most workable, pleasing, and readable proportion for a good script was one in which ascenders and descenders were equal in extension to the minim or regular body height of the letters. Letters were best contained within four equidistant horizontal lines. The descender of *p*, therefore, would be as long as the height of the bowl of the *p*, and the ascender of *b* would be as tall as the height of its loop.

Four-Line Design

The script was made even more readable when the separation of words became standard for the first time, making what was then called *Littera Gallica* or *Scriptura Francesca* even more appealing. Variations of it were employed in scriptoria of the latter 8th century throughout Europe [2], for Corbie's scriptorium was, in that century, the finest in all France, as Luxeuil's had been in the 7th century [52].

(It should be pointed out that the scribes of Corbie devised and worked in several script variations [52, 58]. While they all may have originated with the founders' *Luxeuil Minuscule*, they became so distinct that paleographers consider them under specific titles such as *Corbie a-b* and others using *Corbie* as part of the titles. Second, my description of the evolution that culminated in Charlemagne's favorite script gives the impression that *Luxeuil Minuscule* was the original factor. But had we moved toward Charlemagne directly from Britain or from Italy or Spain, the impression might have been that *Insular Minuscule* or the *Lombardic* or

Plate 38. Carolingian Minuscule, c. 800–900, origin unknown. [London, the British Museum, MS. Harley 208, folio 87 verso (large) and 88 recto (inset)] Uncalligraphic but more easily read than *Roman Half-Uncial* or *Luxeuil Minuscule*. Top margin has 11th-

Visigothic national hands were the original factors. I merely followed the trail we happened to be on at the time. In truth no specific script(s) can rightly be called the true path. But what is certain is that in the year 781 that path, and we upon it, reached the Frankish court.)

An ornate Bible was presented to Charlemagne in 781. Lettered primarily in the most majestic manner on purple pages, it contained a dedicatory page lettered in the far humbler *Littera Gallica.* The fact that this simple script was deemed suitable to set before a king indicates that Charlemagne, and Alcuin, apparently approved of its qualities [52]. At that period Charlemagne was already concerned with improving education and restoring proper Latin within and beyond the monasteries. He had already issued a royal memo in the nicest terms [33]:

> It has seemed to us and to our faithful councillors that it would be of great profit and sovereign utility that the bishoprics and monasteries of which Christ has deigned to entrust us the government should not be content with a regular and devout life, but should undertake the task of teaching those who have received from God the capacity to learn. . . . Doubtless good works are better than great knowledge, but without knowledge it is impossible to do good.

Charlemagne and Alcuin wanted classical texts, religious books, and educational material copied again and again and distributed far and wide. They wanted histories kept in detail (perhaps to authenticate Charlemagne's ruling position [11]) and court records fully maintained. Charlemagne liked this neat and easily read script (remember, he could not read very well), so it is believed that Alcuin took the *Littera Gallica,* approved the minim-height ascenders and descenders and the separation of words, and taught it in the court school and to the scribes of the court scriptoria. In 789 Charlemagne ordered all books, religious materials, and legal records henceforth written in this particularly serviceable script [60]. Within a short time it was known throughout the Empire and was being copied beyond its borders.

We know the script today as *Carolingian Minuscule, Carlovingian Minuscule, Caroline Half-Uncial, Caroline Minuscule,* and, because of its association with Alcuin's monastery, *Tours Minuscule* [70]. Late examples may be known as *Ottonian Minuscule* in deference to the rulers of that name after Charlemagne. Its spread was slowed only by the English Channel. The earliest English example known was produced in 956 [6]. Not until the 10th century did it become important enough in England to supplant *Insular Minuscule* (or *Anglo-Saxon Minuscule* to be more exact) as the script in which Latin was written [*Plates 38* and *39*]. And it was not until Europeans forcibly influenced the English by conquering them in 1066 that *Carolingian*

CAROLINGIAN MINUSCULE

century scribe's (student's?) alphabet with backward *b*, followed by symbols used in writing in Anglo-Saxon, and then the beginning of the *Pater Noster* (continued across the top of the right-hand page).

Minuscule made enough of an impression to take over, by the end of that century, the job of producing works in the Anglo-Saxon language. Paleographers can distinguish between the *Carolingian Minuscule* of Europe and England, or actually of English monks regardless of where they were, or even of European monks taught by English scribes. Individual hands are therefore occasionally described as *English Caroline* or *Continental Caroline*.

Characteristics

The immediate impression of *Carolingian Minuscule* is that it is *Roman Half-Uncial* well-lettered and pleasing to the eye. The proportion of ascenders and descenders to minims is comfortable, the separated words comprehensible, and the letters instantly discernible. Fewer ligatures are a hallmark of this new script, and those that are employed (*rt, st, ct*) are usually easy to understand. The letter *N*, until now a capital, soon acquired a lowercase *n* shape as *Carolingian Minuscule* progressed, although it is occasionally seen as *N* when forming the old *NT* ligature [82]. Something totally new to writing, however, was the *half-r* or *short r*, in which the minim stroke of an *R* is omitted when preceded by an *o*, since, in effect, the righthand bow of the *o* serves in its place (a technique which the scribes of Plates 38 and 39 ignored).

Hierarchy of Scripts

There is one more very important factor. Charlemagne had been vitally interested in retaining and disseminating the best of the past. Through his efforts and Alcuin's, this space-sparing, easily written, easily read script made possible the copying of thousands of early manuscripts that would have within a few centuries been wholly lost to mankind. In their

Plate 39. Carolingian Minuscule, early 12th century, English. [Oxford, Bodleian Library, Bodley 717, folio 5 recto] Highly calligraphic late example, with clear word separation, finely shaped letters, and controlled ascenders and descenders. Note use of *Roman Square Capital/Roman Rustic* capitals beginning sentences. What appears to be the early appearance of a *W* (bottom line) is actually overlapping *V* and *U*, the first two letters of *Vulnera*.

interest in the retention and revival of fine early works, the Carolingian scribes copied not only the texts but also the scripts of the past [*Plate 40*]. And they did so in a fashion first created by the much earlier scribes of the scriptorium of Luxeuil [58], known as hierarchically displayed headlining. *Roman Square Capital* was used for titles [2] and explicits, *Roman Rustic* for chapter heads, tables of contents, first lines, subtitles, and the beginning of paragraphs and sentences, and *Roman Half-Uncial* for prefaces and second lines of texts [2, 82]. Just as people today generally hold that the older a thing is the more important it is, Carolingian scribes calligraphed the most important part of a manuscript in the oldest script, and worked down in importance through later scripts until they reached the text itself in *Carolingian Minuscule*.

Charlemagne's empire had been dissolved by the 10th century, but his script reigned internationally until about the beginning of the 11th century, then declined over the following

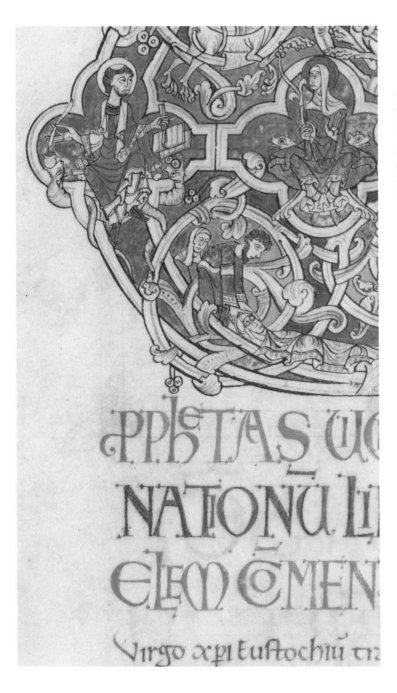

Plate 40. Carolingian Minuscule capitals, early 12th century, English. [Oxford, Bodleian Library, MS. Bodley 717, folio VI verso] Variations of *Roman Square Capital* and *Uncial* letters in the first paragraph, with both forms of *E* and *M* in the bottom line. *Roman Rustic V* and *E* are employed in the first line of the *Carolingian Minuscule* text. Hugo Pictor calligraphed this page and included, in the left center of the illuminated *E*, St. Jerome.

100 years [2, 21], its last stronghold the scriptoria of England, where highly calligraphic versions were produced well into the 12th century.

The next major redesign of medieval scripts was named by Renaissance scholars. They called it "Gothic," because they especially disliked the scripts and could think of no more contemptuous name for it than the word synonymous with the barbarian Goths [29, 82]. The "Gothic" epithet was ironic because the Goths had no script of their own, and the script that was invented for them [*Plate 41*] did not resemble Gothic scripts. If anything it resembled Greek, from which several letter shapes had been borrowed.

There was no abrupt point at which *Carolingian Minuscule* became Gothic in style, nor was there a juncture at which this interim style became specifically High Gothic in design. Designs change not by days or decades, but by generations and centuries. Some scholars apparently do not consider the transitional phase worthy of being called a script in itself, but those who do refer to it as *Early Gothic* or *Gothiques Primitives*, *Cistercian Script* (because that Order used it so frequently [48]), or *Late Carolingian Minuscule*.

According to some scholars, *Early Gothic* was first recognizeable in the 10th century [46], while others suggest the beginning [2, 58, 82?] or the end of the 11th century [29]. It is said to have become obvious in the 11th century [46], reaching its peak in the 12th century [29, 82]. There is even less agreement on the point at which it was no longer *Early Gothic* but one of the full-grown later Gothic scripts. When it became so formal that it was obviously *textura* in execution, there is no question but that it had reached maturity and could no longer be referred to as its former youthful self. Since *textura* was a hallmark of the 13th century and later, the most likely life span for *Early Gothic* was from the beginning of the 11th to the end of the 12th century [*Plate 42*].

Carolingian Minuscule was comprised of independent and clearly defined letters that formed words. The direction that calligraphy then turned was one that emphasized the uniformity of the word, with the letters and their design being subservient [52]. Specifically, demand for texts required that scribes write faster and use less space, thus reducing time spent, the cost of materials, and thereby the cost of books [58]. By attempting to write more quickly and to work more letters into a given space, the scribes had two choices: shorten the height of the letters in order to get more lines on each page, and use a narrower pen point in order to do so; or let the letters remain at their present height, not narrow the pen point, but narrow the width of the

<div style="text-align: right">

Gothic Period Begins

EARLY GOTHIC

</div>

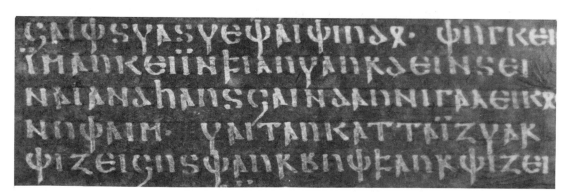

Plate 41. The Goths' Gothic script, 6th century, German(?) [Uppsala, Universitet-biblioteket Uppsala, Codex Argenteus Upsaliensis, folio not indicated] Bishop Ulfilas (311–81), perhaps a converted Goth, worked for forty years among the Visigoths and created a script for them based on Greek letters. With it he translated the entire Bible for them, except for the *Book of Kings* which, he decided, contained an emphasis on military endeavors—an inspirational material his warlike flock little needed [29]. The script never attained popularity. This is one of the few surviving examples, sumptuously rendered in silver with gold initials on purple colored vellum.

Plate 42. Early Gothic, c. 1100, French or Spanish. [Baltimore, Walters Art Gallery, MS. 10.17, folio 1] Good example of the transition of calligraphic *Carolingian Minuscule* into *Early Gothic*.

Characteristics

letters. We do no know why they chose the latter; but the first choice required two changes and the second choice only one. And the scribes chose the path of least revision.

When they narrowed the letters and, for the sake of speed, pulled their pens sharply around bends instead of making the slower and fuller curves, the lettering appeared bolder and more angular. The boldness made the letters more visible [58]. Soon what had been a functional necessity was appreciated and promulgated for its beauty [82] [*Plate 43*].

The characteristics of *Early Gothic*, a script bridging two periods, varied in arrival time in different countries. The *half-r*, created in Carolingian times as a letter following *o*, continued in use [*Plate 44*], occasionally also after other bowed letters. The *Uncial d* reappeared, as did the 8-shaped *s*, although only at the end of words. While the ligature *st* remained, the *ct* and *et* ligatures disappeared, and late in the period *ii*, confusing to read, was written as *ij* [82]. The scribes of England, northern France, northern Europe, and the Netherlands, because of excellent communication and a mutual affinity for calligraphic style, tended to make the same changes [74]. The letter *a* became "trail-headed," meaning that the beginning of the top loop extended just a bit further to the left than the lower loop. The letter *g* approached an 8-shaped configuration. The left leg of the *x* extended below the minim and curved back beneath the base of the letter preceding it. The cross-stroke of the letter *t*, as the final letter of a word, had a downward flick at its right hand end [47]. Several vertical minim strokes, instead of striking straight down to the base line and ending, began cutting to the right shortly before reaching bottom, ending with an upward flick of the pen, visible evidence that the pen was rushing upward to begin another stroke. But a different maneuver was becoming popular among English scribes (whether in England or elsewhere), who let several vertical strokes drop straight to the minim base line. The strokes then, with the corner of the pen, were filled in to create a flat foot [*Plate 44*]. This was sometimes done hurriedly by pulling the pen straight across, making a flat serif that was flush with the lefthand edge of the stroke but extended beyond it to the right [2]. Some scribes omitted the space between a letter bowing at the right when followed by a letter bowing at the left. Such duos often, if not actually, almost touched [56].

Soon scribes everywhere began to apply artistic touches to these characteristics, making what was initially functional more and more calligraphic. An obvious example is the care taken occasionally to decorate the ascenders and descenders by splitting their ends. With the

Plate 43. Early Gothic, early 12th century, English. [Baltimore, Walters Art Gallery, MS. 10.18, folio 175] Boldly calligraphic example with fanciful *Roman Rustic* first line of text. Note the several characteristics to become standard in this script: tucked-back leg of *x*, touching of bowed letters, narrowness of letter shapes, and split ascenders.

arrival of the 13th century, *Early Gothic* had already become, in formal application, a noble expression of medieval calligraphy.

The scribes of the *Early Gothic* period had also done much to change the form of capital letters used to indicate the beginnings of paragraphs or verses. Enlarged capitals had served the same purpose through previous centuries, but only from the late 11th century are they

Versals

Plate 44. *Early Gothic,* first half of the 12th century, English. [Oxford, Bodleian Library, MS. Douce 368, folio 54 recto] Excellent calligraphic style and extensive use of new form of capital created by building up *Uncial* shapes. Note such versals as the first *A,* rarely seen due to the popularity of the following one; and the uncommon *AE* ligature versal.

specifically referred to as *versals.* These versals were lettered in color, usually red (thus rubricated letters) or blue. They are sometimes known as *Lombardic Capitals* because of their appearance in Lombardy. Versals, for their use in the 12th through 14th centuries, are also occasionally referred to as *Uncialiesque* and *Notarial Uncialesque* [58] letters in deference to their origin.

What made the versal a new capital was that scribes took *Roman Square Capital, Roman Rustic,* or *Uncial* [58, 60] letters [*Plate 45*] and exaggerated the round strokes, the vertical strokes, and

Plate 45. Early Gothic capitals, c. 1150–1200, English. [Oxford, Bodleian Library, MS. Auct. E. Inf. 2, p. 262] Example of mixing styles harmoniously. Note *Roman Square Capital* and *Uncial M*s (third line), different *D*s in DAVID (three lines lower), and *T*s (second and third lines).

the serifs. The lines of the round strokes were made broader at their widest point [58]. The vertical strokes were narrowed in the middle or, if the letter was large, left hollow so they would not appear too heavy [46]. The serifs were stretched [58] so far that they were occasionally wider than the letter itself. Vertical serifs began to be extended too until, in some versal styles, they, with the horizontal serifs, stretched to enclose what had been open areas within the overall shape of the letters [*Plate 46*]. These enclosed areas soon were filled with pen decorations, while other decorations emphasized the outside shape of the versals, sometimes continuing the direction of vertical strokes far beyond the letters and turning them into decorative lines that flowed up and down the lefthand margins of the columns of text [*Plate 47*]. Some experts maintain that the basic letter shape was first outlined with a fine-point pen, and then filled in [2] [*Plate 48*], while others say that they were lettered with the pen that was used for the text, the exaggerated elements created by applying additional overlapping strokes [35, 46]. Probably both methods were used, time and skill being the deciding factors.

The result was a dizzying variety, each scribe moving beyond the basic exaggerated shape and enhancing it according to his own creative initiative. This resulted in as many decorative variations as there were scribes with the time, skill, and audacity to pen them [*Plate 49*]. From the last few years of the 11th century until the Renaissance, the versal, whether in blue or red or made magnificently with a raised coating of pure gold, became a working part of medieval book hands.

As time passed the scribes throughout Europe and England, enthusiastic about the economy in space and expense, delighted with the calligraphic possibilities, and pleased with the visual effect of the finished page, continued to adapt *Early Gothic* or, as they called it, *Littera Moderna* [1] or modern letters. Letters that were compact in *Early Gothic* became even more so. Ascenders and descenders that were becoming shorter, shortened further. In the early part of the 13th century, give or take a few decades, the working *Carolingian Minuscule* that had evolved into the more formal *Early Gothic* became the most ornate, artifice-bedecked calligraphy ever

Plate 46. Versals, c. 1490, French (?). [Author's collection] Displayed are versals closed by exaggeration (*E, U, C, M*), partially closed (*P* and *T*), enlarged and extending into the margin to indicate a beginning of a major section, or smaller to begin sentences or serve as initial letters. Note that exaggeration of curves and elongation of serifs does not destroy the recognition of the letter because the body of each is bold.

Italian and Spanish Gothic

known. This passion for what continued to be called *Littera Moderna*, most dramatically enveloped the scribes of northern France, Flanders, England [52], and Germany. Only the scribes of Italy and many of those in Spain and southern France [42] remained half-enraptured. The Italian scribes hesitated to part with so many curved strokes, and they did not compact their letters. The result, in the 13th through 15th centuries, was easily distinguishable from their northern neighbors' calligraphy by its roundness. Its variations are known as *Rotonda, Rotunda,* or *Gothic Rotunda* [42], *Half-Gothic* and *Round-Gothic* [60], *Littera Textualis,* (specifically used by the French for secular works [42]), *Semi-Gothic, Spanish Round-Hand* (called *Redondilla* in the 16th century [42]), *Southern Gothic* [42], and occasionally *Semi-Quadratus* or *Textus Semi-Quadratus* (half- or partially-quartered or four-sided). The latter name is sometimes occasionally used to denote another script favored by the northern scribes. The late-medieval round Italian and Spanish scripts were especially beautiful [*Plates 7* and *49*]. Italian Renaissance calligraphers referred to the variations as *Lettera Formata* [42]. To add to the confusion, the rounded Italian Gothic minuscule has also been called *Littera Moderna* [58], the same title northern scribes used for the script the Italians disliked.

The hesitancy of southern scribes to follow these extreme Gothic tendencies led to their rejection of things Gothic in the 15th century. Looking back for a simpler style, one that reflected their ancient heritage, they mistook *Carolingian Minuscule* for their ancient Roman script and called it "Antique Letters," an excusable error, since most of the oldest surviving manuscripts were known only in the form of Carolingian copyists' work. Upon their own beautiful 12th-century *Carolingian Minuscule* they based their scripts of the Italian Renaissance, and this was the source of the popular *Humanist Book Hands,* among them *Italic (Cancellaresca*

Plate 47. Versals, c. 1400, English. [Cambridge, Magdalene College, MS. 2981] From a scribe or illuminator's copybook, showing unadorned versals, *E, F, G, H,* and *I,* and *F, G, H, I, K* so surrounded by decoration that they are known as *boxed versals.* Note the thin "moat" keeping the decoration at bay, and the bold letter shape to retain recognition.

Corrente or *Cancellaresca Corsivo,* by which names *Italic* was first known [42]), which resulted in the familiar letter forms of the present day.

While the Italians, Spanish, and southern French were resisting drastic changes in design, scribes of other areas, from the end of the 12th century onward, were following a design concept that so exaggerated angularity and uniformity of line that the individual letters became subordinate to the design of the word itself. This was emphasized by the discovery that with exaggerated letter forms the identifying characteristic of a letter was usually in its upper half. If the lower halves of the letters were free to appear almost identical, it would help to create a uniform pattern for the entire word, and the individual letters would remain recognizable. This can be seen rather quickly by covering the bottom half of a word in one of these scripts: While 20th-century eyes may at first glaze with confusion, they should perceive the word, whereas a late-medieval reader would more easily if not instantly grasp it.

Once the pattern was adopted, the words could truly form individual designs, the letters woven together to form a whole. Thus the terms *textus, textur,* and *textura,* meaning weaving or woven in Latin, are frequently used as a description. Done with any degree of competence, a word penned in *textura* forms so graceful a unit that, if the manuscript page is turned upside down or even sideways, the word will still remain a balanced artistic design.

The scribes applied their individual calligraphic skill to push this style to its peak, and individual creativity resulted in a sizeable array of unusual hands. But this bewilderment of hands can be generally divided into two scripts because of one particular factor: Either the

Textura

Fancy Foot-Work

variations were based on a script in which the majority of vertical strokes ended with flat bases lacking any additional strokes, or "feet" [*Plate 50*], or the majority angled off before reaching the base line or were decorated with flourishing serifs that, in effect, served as "feet" [*Plate 51*]. The question of which style came first seems rarely asked—or answered—by paleographers. I believe it is suggested that the "footless" version occurred first in England, and it spread abroad and inspired the "footed" version, probably in Northern France.

If the scribes were creative in their separate footloose calligraphic camps, they were equally creative when it came to naming the resulting scripts. We are today burdened with the names independent writing masters used to refer to the scripts they practiced and taught. Added to these are the names paleographers have created from Latin roots in order to indicate the scripts' heritage. Because early printers used the finest handwritten manuscripts of their day as the bases for their type designs, those names given to typefaces have also come down to us as representative of the handwritten scripts. In 1507—9 Leonhard Wagner, a scribe at the Monastery of St. Ulric and St. Afra in Augsburg, in his *Proba Centum Scripturarum Una Manu Exaratarum*, showed samples of and listed the names for 100 different scripts or hands employed from the 11th century onward. While some of them were neither Gothic nor *textura* in form, it is an indication of how vast the variety was almost 500 years ago. Fortunately only a few names have survived to modern usage. At least twenty-two names are not only in use but occasionally used interchangeably. So it is best to place them in order and then choose one for each of the two basic Gothic *textura* scripts.

General Gothic Script Names

The two are titled most simply either by their period, *Gothic* [21], by their location, *Northern Gothic* [42], or their strong impact, *Blackletter* [35, 60] or *Black Letter* [21, 58]. They are titled by their formality, as in *Lettre de Forme*, a name used in France in the 15th-century library of

Plate 48. Versals, c. 1400, English. [Cambridge, Magdalene College, MS. 2981] Copybook instructions for initial outlining of boxed versals to be then filled in, the alternative method to penning versals directly with overlapping strokes. Note that while *A* is almost closed, and *C* is closed, recognition is not lost because elongated serifs are no thicker than the body's thinnest part.

psequeris. Scribis enim
contra me amaritudine.
7 consumere me uis peccati
adolescentie mee. Posu
isti in neruo pedem meum. 7
obseruasti omnes semitas me
as 7 uestigia pedum meo
rum considerasti. Qui quasi
putredo consumendus sum. 7
quasi uestimentum qod come
ditur a tinea. R. Libera me
dne de uiis inferni qui porta
ereas confregisti 7 uisitasti in
fernum 7 dedisti eis lumen ut
uiderent te qui erant in penis te
nebrarum. V. Clamantes et
dicentes aduenisti redemp
tor noster. Qui por. Lc. ix.

Homo natus de muliere
breui uiuens tempore. replet
multis miseriis: qui quasi
flos egreditur 7 conteritur 7 fu
git uelut umbra 7 nunqua
in eodem statu permanet.
Et dignum ducis super

Plate 49. Versal and *Rotunda*, c. 1320, Italian. [Author's collection] Decorative creativity: versal *H* made elaborate by fine-line leaf design extending beneath it, and exaggerated serif serving as the perch for a stork or crane above it.

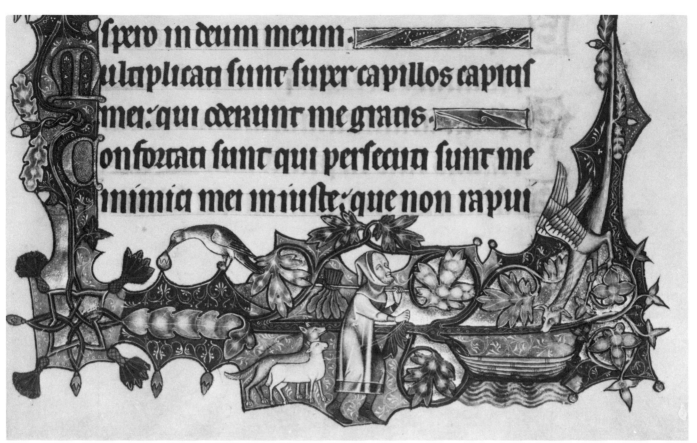

Plate 50. *Gothic Textura Prescisus vel sine Pedibus*, c. 1300, English. [Oxford, Bodleian Library, MS. Douce 366, folio 89 recto] A page from the *Ormesby Psalter* showing highly calligraphic form of the script and superb "marginal illumination," containing a well-known riddle. Note the country fellow, with a bundle of turnip tops on a stick, leading a wolf and a lamb. How can these animals and food be taken across the river in three trips to the opposite shore, landing only one at a time, and at no time leaving the wolf alone with the lamb, or the lamb alone with the turnip tops? [15] Solution appears at the end of References.

Plate 51. *Gothic Textura Quadrata*, 1323, French. [The Hague, Koninklijke Bibliotheek, MS. 78.D.40, folio 124 recto] Note the precursor of today's dotted *i*, the stroke allowing one, for instance, to read correctly as *ini* what would appear to be *uu* (end of next to last line).

Charles V and by Jean, Duke de Berry (1416) [45]. They are referred to by period and heritage as *Gothic Minuscule* [17], and by the fact that they formed designs: *Textur, Textura* [60], *Littera Textualis* [56], and *Littera Textualis Formata* [56]. The German typeface imitating the letters' "broken" shape gave them the name *Fraktur* [60]. Those who think of anything faintly resembling them as not only English but also old, call it *Old English*. And in many modern printshops where they are chosen as fussy enough for a nuptial announcement they are called *Wedding Text*. The Italians, who disliked so angular and fussy a script, must have despaired as they watched it spread across Europe. Much in the manner that later generations were to blame a social disease on the misconduct of some other nation's people, the Italians therefore called the styles *Lettere Francese* [38]. Since none of the above is specific, it is best to avoid them all.

Names specifically indicating the Gothic *textura* script notable for its absence of feet are *Textus Abscisus* [69] (a cut design), *Mancherley Notteln* [69], *Textus sine pedibus* [45] (without feet), *Textus Prescisus* [2] (precise or exact), and a combination of the last two, *Textus Prescisus vel sine pedibus* [69] (woven exactly and especially without feet). There is something marvelously overdone about the latter, and overdone the script certainly was. Since German writing-master Johannes vom Hagen used the name in 1400 [*Plate 52*], I would change *Textus* to *Textura*, specify its period, and call the script without feet *Gothic Textura Prescisus vel sine Pedibus*.

The script with feet has been specified as *Textur* and *Textura* [45], *Textura Quadrata, Textus Quadratus* [2, 45], *Textus Semi-Quadratus* [45], nothing more than *Quadrat* [45], and *Missalschrift* and *Monchschrift* [45]. The most definitive name for a Gothic script with words woven and letters angled to form feet would be *Gothic Textura Quadrata*.

GOTHIC
TEXTURA
PRESCISUS
VEL SINE
PEDIBUS

GOTHIC
TEXTURA
QUADRATA

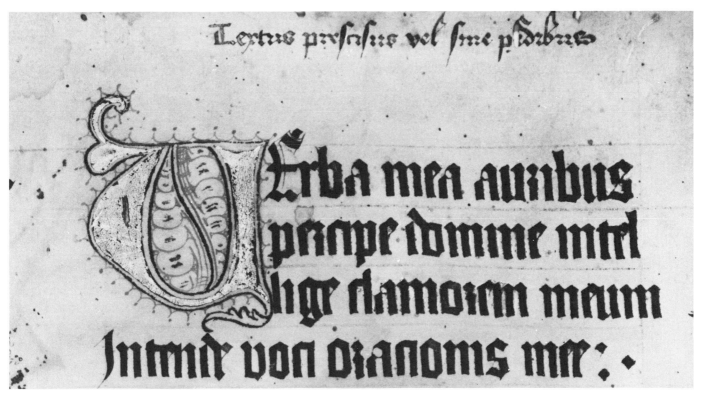

Plate 52. Gothic Textura Prescisus vel sine Pedibus, c. 1400, German. [Berlin, Staatsbibliothek Preussischer Kulturbesitz, MS. Lat. 2°, folio 384 verso] Writing master Johannes Vom Hagen's hand contains many more "footless" forms (for instance in *a, c d, e*) than that of the English scribe's approach to the same script (see *Plate 50*).

Given the basic difference between the two scripts and the scribes' affinity for or feelings against feet, the characteristics of *Gothic Textura Prescisus vel sine Pedibus* and *Gothic Textura Quadrata* were similar: shortening of ascenders and descenders, forked endings of ascenders, narrowing of letters, and the "heavier" aspect of the entire page as lines were compressed [2]. A perfect Gothic *textura* was achieved when the space between vertical strokes was exactly the same width as the vertical stroke, and the space between words was twice that [60]. Another factor important in achieving the finest *textura* quality was in the *conjoining* of letters. In *Early Gothic* the tendency was to leave only a minimal space or no space between a letter bowed to its right (like *b*) and a following letter bowed to its left (like *d*). In *textura* scripts all such combinations (such as *bo, po, og, oc,* and *be*) not only touched but overlapped precisely. They shared a stroke between them [52, 82] or, rather, shared the vertical portion of the stroke between them, for we are dealing with bows that now are composed of straight lines instead of curves.

Other characteristics: The *g* closed its lower loop. The *long-S* became common at the beginning of and within the word, but a final *s* took on an 8-shaped appearance. The letters *w*, *y*, and *z* were permanently added to the alphabet, bringing the total to twenty-five. (The total reached twenty-six with the addition of *j* after 1400.) The letter *t* acquired a pointed top [52, 82]. The *half-r*, which originated in *Carolingian Minuscule* following the letter *o*, was used in Gothic *textura* scripts in place of *r* when it followed every vowel, particularly so by the 14th century [52, 82]. So familiar had the *half-r* become in the latter Gothic period that, in the hands of some scribes, it replaced *r* completely. And the *Uncial* form of *d* became customary [52]. It was soon obvious that an identifying stroke was needed to set apart the letter *i* and so a somewhat vertical flick of the pen was used at first [60], which became a dot in the 14th century [82] [see *Plate 51*]. In the 13th century the letter *u* appeared as a *v* at the beginning of a word but remained *u* within a word. In the 15th century, to distinguish *u* from *n* in Germany, a hook was penned over the *u*. Throughout northern Europe and the British Isles the ligature *st* remained, ligatures of *et* and *ct* became rare, and *ae* no longer appeared, having long since become *e* [82]. Upon all these characteristics the scribes heaped their favorite ornamental creations of hairline strokes and hooks [82] [*Plates 53* and *54*].

In all this flourish it should be remembered that the two Gothic *textura* scripts were wholly minuscule. For important letters, as in *Early Gothic*, versals were used, and they followed the style of the day by becoming more ornate. Where a capital was needed, but the time required and the attention created by a versal was not called for, scribes began to use larger versions of the minuscule letters, or variations of *Roman Square Capital* with decidedly *Gothic* pen turnings. They were, though, of no particular importance, but rather the beginning of something unusual to come.

Gothic Textura Quadrata and *Gothic Textura Prescisus vel sine Pedibus* continued calligraphically onward and upward, through and beyond the medieval era, to die of exhaustion in the rarified atmosphere of the Renaissance—except in Germany, where the pro-*pedibus* script survived well into the 20th century.

From the moment the *textura* scripts outstepped *Early Gothic* enough to be conspicuous as independent scripts, they were the most formal examples of calligraphy. Since they had been too cumbersome for all-around duty [*Figure 6*] right from the beginning of the Gothic period (c. 1200), a more functional script was needed. Having used the term *textura*, one would assume that a more functional variation of the same script could be produced by writing it in a *cursive* (wholly functional) or *formata* (aspiring to calligraphy) manner. But in the Gothic period the characteristics of the two *textura* scripts were so severe and distinct that less formal application was necessarily so different that it was recognizable as a separate script.

This more functional script, in a pattern familiar to us throughout the medieval era, was created by taking a cursive *Scriptura Communis* and adding to it facets of the monumental script(s) of the day—in this case the two *textura* scripts. The resulting script, encompassing a

Plate 53. *Gothic Textura Quadrata,* late 15th century, German. [Author's collection] Excellent control with exaggerated "feet," use of hairlines, exacting spacing between strokes. The overall effect is so well woven that it is as fine a design seen upside down. Why a page of such script is called *Black-Letter* is obvious.

Plate 54. *Gothic Textura Quadrata,* c. 1450, French. [Author's collection] Fine calligraphic work, size not deterring the scribe from penning distinct angles, splitting ascenders and adding delicate hairlines.

Plate 55. *Gothic Littera Bastarda,* c. 1480, French. [Author's collection] A neatly produced version called *Lettre Bâtarde.*

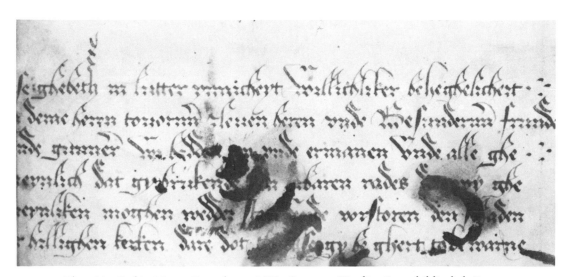

Plate 56. *Gothic Littera Bastarda,* c. 1400, German. [Berlin, Staatsbibliothek Preussischer Kulturbesitz, MS. Lat. 2°, folio 384 verso] By Johannes Vom Hagen. A *Nottula Fracturarum* version requiring care and skill.

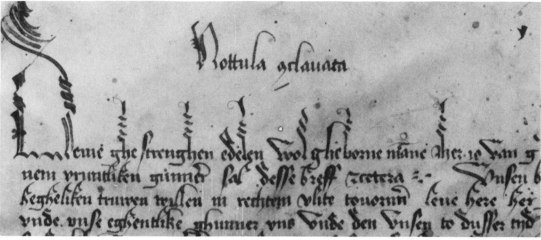

Plate 57. *Gothic Littera Bastarda*, c. 1400, German. [Berlin, Staatsbibliothek Preussischer Kulturbesitz, MS. Lat. 2°, folio 384 verso] Vom Hagen's *Nottula Conclavata* version. Note unusually decorative ascenders.

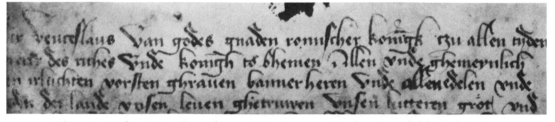

Plate 58. *Gothic Littera Bastarda*, c. 1400, German. [Berlin, Staatsbibliothek Preussischer Kulturbesitz, MS. Lat 2°, folio 384 verso] Vom Hagen's *Nottula Simplex* version.

Plate 59. *Gothic Littera Bastarda*, c. 1400, German. [Berlin, Staatsbibliothek Preussischer Kulturbesitz, MS. Lat 2°, folio 384 verso] Vom Hagen's *Nottula Acuta* version.

Plate 60. *Gothic Littera Bastarda*, c. 1400, German. [Berlin, Staatsbibliothek Preussischer Kulturbesitz, MS. Lat. 2°, folio 384 verso] Vom Hagen's *Separatus* version.

wide variety of versions, is referred to by paleographers as *Gothic Cursive* [60], *Gothic Book-Hand* or *Gothic Book Script* [48] (a poor choice since the *textura* scripts were also book hands), *Current Cursive* [60] (doubly emphatic since it translates as "running running"), *Notula* [56, 60], *Bastarda* [2], *Bastarda Minuscule* [56], and *Littera Bastarda* [56, 82] (bastard letters). The most appropriate general name for the script is *Gothic Littera Bastarda*, keeping in mind that nothing illegitimate is meant by the term. Bastard merely meant lowborn, or not aspiring to nobility.

Within the general script of *Gothic Littera Bastarda* paleographers have been able to recognize variations sufficiently distinct to be called scripts in themselves, and medieval scribes provided additional examples, to which they themselves gave names. Together they include *Bâtarde* or *Lettre Bâtarde* [60] [*Plate 55*], the French translation of our general script name but, when referred to in French, meaning that variation unique to France; *Brevitura* [69], meaning small or short; *Nottula Fracturarum* [69] [*Plate 56*], meaning broken notes; *Nottula Conclavata* [69] [*Plate 57*], meaning set close together or appearing rough; *Nottula Simplex* [69] [*Plate 58*], meaning simple, lowborn, and unembroidered; *Nottula Acuta* [69] [*Plate 59*], meaning sharp or slanted; *Littera Parisiensis* [82], a 13th-century script apparently found in Paris; *Separatus* [69] [*Plate 60*]; *Bastardus* [69] [*Plate 61*]; *Secretary* [56, 63], the English 15th-century version of *Lettre Bâtarde*; *Charter* [2], a curious name to choose until one remembers that many late-medieval charter or court hands were meant to be readable rather than mysterious; *Bastard Secretary* [63] [*Plate 62*], a more calligraphic version of *Secretary* devised by English scribes for more formal matters in the 15th century; and *Coulée*, a French official and business hand originating in part from *Bâtarde* [42].

A remarkable work of scholarship in this decade has added to the list with the creation of the term *Anglicana* [63] to indicate *Gothic Littera Bastarda* written specifically by English scribes from the middle of the 13th century. The establishment of *Anglicana* then allows for recognition of

Variations

Figure 6. Among the amusements of scribes of the Gothic era was the creation of verses employing a minimal number of letters. Some surviving examples are based on the use of *i, m, n,* and *u* and *v* (both of which were represented by the *u* letter shape). It has been suggested that these verses were created as an example of the script's unreadability. I have seen them offered, though, only as an exercise in making a comprehensible statement with the fewest possible letters. But the purpose may have been dual. This example concerns a letter of complaint by short actors, sent to the Senate in Rome, pointing out their desire to continue distributing to the actors wine acquired from particular vineyards near the walls.

In English the letter reads: "The very short mimes of the gods of snow do not at all wish that during their lifetime the very great burden of [distributing] the wine of the walls to be lightened."

In Latin it reads: "Mimi numinum nivium minimi munium nimium vini muniminum imminui vivi minimum volunt."[82]

No explanation is offered for the addition of *l, o,* and *t* at the end.

Plate 61. Gothic Littera Bastarda, c. 1400, German. [Berlin, Staatsbibliothek Preussischer Kulturbesitz, MS. Lat. 2°, folio 384 verso] Vom Hagen's *Bastardus* version. His different scripts in this and preceding Plates show both the similarity between variations of a script and the similarity that can occur when any single scribe is the source of different scripts.

Plate 62. Gothic Littera Bastarda, c. 1415, English. [Oxford, Bodleian Library, MS. Bodley 596, folio 2 recto] Beautifully penned *formata* version called *Bastard Secretary*.

Plate 63. Gothic Littera Bastarda, c. 1450–75, English. [Oxford, Bodleian Library, MS. Rawl. G. 398, folio 49 recto] Excellent *formata* version called *Bastard Anglicana*, employed in documents, special manuscripts, and for display purposes in texts of baser scripts.

Plate 64. Gothic Littera Bastarda, c. 1500, English. [Oxford, Bodleian Library, MS. Laud Misc. 517, folio 126 verso] Interesting calligraphic example of *Bastard Anglicana* version by Carthusian monk William Darker, because he used ideas from several different scripts to create his own hand [86]. This attempt to simulate *textura* while remaining functional has so altered the style that it is considered a variation within itself, called *Fere-Textura* [86].

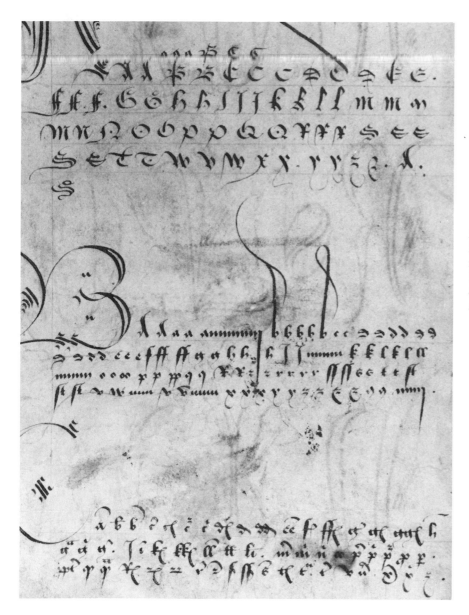

Plate 65. Gothic Littera Bastarda, c. 1450–1500, English. [Oxford, Bodleian Library, Ms. Ashmole 789, folio 4 verso] Perhaps by the scribe Ricardus Franciscus. Displays rapidly written capitals, lowercase alphabet, abbreviations, and ligatures.

variations named *Anglicana Book-Hand, Anglicana Formata,* and *Bastard Anglicana* [*Plate 63*], a 14th-century attempt to raise *Anglicana Formata* even closer to *Gothic Prescisus vel sine Pedibus.* The English scribes of the late 15th century made a similar attempt, the name now given it being *Fere-Textura* [63] [*Plate 64*].

Since many of the distinctions among these scripts or hands cannot be discerned by nonscholars, it is best to hold to the general name of *Gothic Littera Bastarda*, within which all of them fall.

Gothic Littera Bastarda occurred in so many variations over such a long period of time that it is not possible to cover everything in a detailed set of characteristics. In general, the object was to imitate the textura scripts in appearance but not in effort and time. The stroke(s) that in *Carolingian Minuscule* had been rounded, only to be broken into angles in the textura scripts, regained some, if not all, of their curves. The line began straight and then angled off into a curve. Those angles that remained, having been produced in the textura scripts by halting the

Characteristics

pen at the end of one straight line before proceeding with the next (or lifting the point at this juncture before proceeding), were produced in a single stroke in the more functional script. The result was a slightly softer appearance. Even in *Gothic Littera Bastarda* variations that attempted to approach textura, some angles might be very carefully copied while others were not; i.e., elaborate feet on the first two strokes of *m*, but not on the last, or on the first but not on the second stroke of *n* or *u*. The hasty, jagged track of the pen resulted in the overextension of some strokes that became exaggerated as admired characteristics, such as the pointed top of *e, o,* and occasionally other letters, referred to as a *horn* and seen most often in *Lettre Bâtarde.* *Half-r* sometimes followed only *o,* but it might be seen following every vowel and occasionally every righthand bowed consonant. *Long s* and *s* were sometimes used independently and in other script variations appeared together. The rules for which was to be used where fluctuated. Ascenders, marking the cursive element, were lengthened considerably and bent so that the vertical space limitations did not hinder their growth. Any *Gothic Littera Bastarda* hand is a collection of variations, and it is difficult to create a rule. It is therefore possible to look at one hand and, from it, create a formal or informal hand, or to combine the two and end up closely imitating the original.

Gothic Capitals

The subject of capitals of less-than-versal eminence has been touched upon. The sudden explosion of *Gothic Littera Bastarda* was important to the history of capital letters. Paleographers point out that the Gothic period was the first in medieval history in which a script acquired its own capital letters, most likely referring not to the ornate versals that inhabit the *textura* manuscripts, perched here and there like precious gems, but to the simpler penned initial letters that begin sentences and proper names [see *Plate 63, 64, 65,* and *66*].

There are also highly creative patterned capitals that were known, in the English of that day, as *cadels.* A beautiful example is the inscriptional page penned by Jean Flamel that begins *The Grandes Heures of Jean, Duke of Berry,* completed in 1409. Flamel, one of the period's finest calligraphers [73], as secretary to the duke, wrote and signed the page with remarkable flourish [*Plate 67*].

Such capitals are an exaggeration of the *Gothic Littera Bastarda* imprimatur of long, sweeping strokes and jagged calligraphic touches familiar in the text, applied to the capital as a means of giving the capital the importance of a versal [*Plates 68* and *69*].

Profusion of Styles

Because of the growth of universities [*Plate 70*], schools, religious orders, court systems, and business operations—and the general increase in literacy among the population—the demand for books [*Plate 71*], the need for documents, and the reliance of society as a whole upon paperwork was tremendous during the late medieval era. The ranks of scribes increased

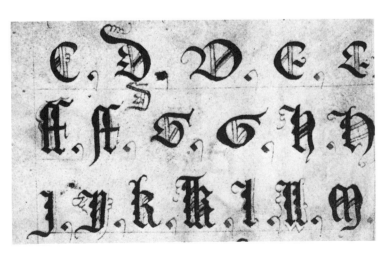

Plate 66. Gothic capitals, c. 1400, English. [Cambridge, Magdalene College, MS. 2981] From a copybook. A formal variety, not skillfully penned. Such letters require overlapping strokes as in the production of versals. (See *Plate 117* for complete alphabet.)

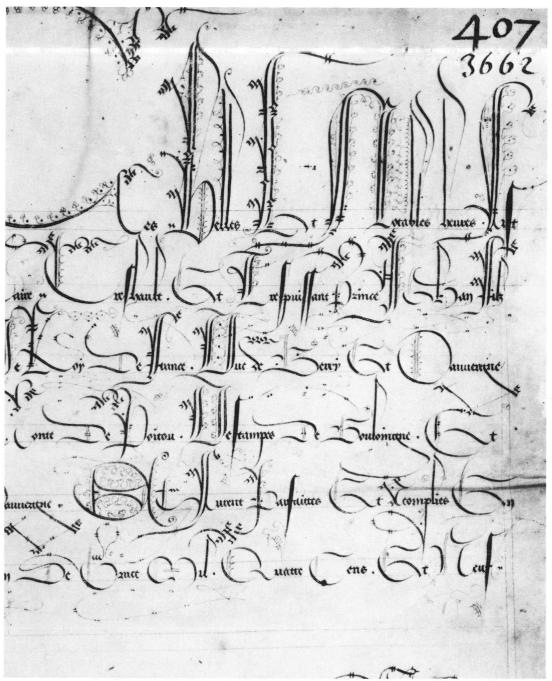

Plate 67. Gothic Littera Bastarda/Cadels, 1409, French. [Paris, Bibliothèque nationale, MS. Lat. 919, frontispiece] The ex-libris of Jean de Berry in the *Grandes Heures of Jean, Duke of Berry,* by the Duke's secretary, Jean Flamel. Text: "Ces belles et notables heures fist/ faire tres hault et tres puissant prince Jehan filz/ de roy de France, duc de Berry et d'Auvergne/ conte de Poitou, d'Estampes, de Bouloingne et/ d'Auvergne. Et furent parfaites et accomplies en/ l'an de grace Mil quatre cens et neuf." Transl.: "These beautiful and noteworthy Hours were commissioned by the high and mighty prince Jean, son of the king of France, Duke of Berry and of Auvergne, Count of Poitou, of Estampes, of Boulogne and of Auvergne. And they were perfected and completed in the year of our Lord, 1409. [signed] Flamel [98]. Note how elaborate decoration lends importance to an informal script. [Original size of text 30 × 25 cm. (12 × 9¾ inches). For full-size reproduction, see *Plate 141.*]

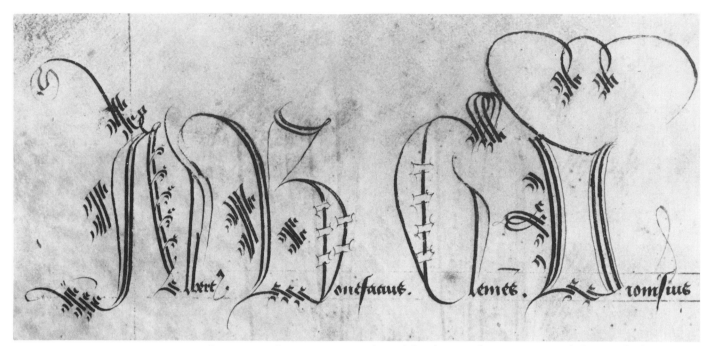

Plate 68. Gothic Littera Bastarda/Cadels, late 15th century, English. [Oxford, Bodleian Library, MS. Ashmole 789, folio 3 verso] Perhaps by the scribe Ricardus Franciscus. An alphabetical list of names to display elaborate capitals. Note patches on *B* and *C*, perhaps a cursive suggestion of a ribbon wound around the vertical strokes.

Plate 69. Gothic Littera Bastarda, c. 1475–1500, English. [Oxford, Bodleian Library, MS. Ashmole 764, folio 100 verso] Excellent *formata* script. Note three of the four forms of Gothic period capitals: the late form of ornate versal, the highest form of Cadel capital (*C*), and, throughout the text, simpler shorthand forms of the versal. Missing is the formal capital of *Plate 66*.

accordingly, each group adapting the scripts at hand to best suit its own purpose. As an example, clerks in judicial courts faced with mountains of rulings, orders, writs, repeals, etc., would be inclined to write in the *Gothic Littera Bastarda* of their region and period. But while they penned the presentation copies of the documents in an impressive variation of that script, known as an *engrossing* hand [63], the file copy or copies of the same document were dashed off in a more cursive variation.

Also, earlier in the Middle Ages there had been a certain degree of freedom within which a scribe might add ornament to the few scripts with which he was familiar, or from force of habit bring characteristics of his native script into the script of the monastery hundreds of miles away. But the different monastic sects' major scripts at a given time were rather few. In the latter part of the medieval era the majority of writing was outside the Church or monastery's jurisdiction, and no such constrictions held this greater and more varied flood of scribes now at work. In these last centuries it is far more difficult to follow the trail of specific letter forms because so much variation existed, so much splitting of styles occurred, and so much overlapping created new subvariations that the grand scheme of calligraphy seems all at loose ends. The time frame, too, becomes warped. So much interaction occurred between countries, so much awareness existed of what other scribes were doing elsewhere, that we who are used to variations in scripts occurring in spans of hundreds of years find it difficult to cope with styles that appeared and disappeared within decades. One becomes accustomed to seeing a humble script rise to eminence and force, in the vacuum created beneath it, the emergence of a newer and more functional script. Now in the late Middle Ages, as the clerks have shown, scripts were simultaneously raised and lowered. In the earlier days a script—and there were few of them—existed as representative of the work of hundreds of scribes of an entire nation or empire. At the end of the Middle Ages, in the flood of scripts, one script or one variation might represent only a few scribes engaged in a single job in only one city.

Glance casually at the dozen or so examples of *Gothic Littera Bastarda* variations on nearby pages, which only begin to represent what the scribes of the period offered. Then turn back to the *Carolingian Minuscule* facsimile [see *Plate 39*]. If your eyes find it refreshing and pleasing, you have begun to grasp the enthusiasm with which Italian and other late-medieval or early-Renaissance scribes sought to escape to it from the Gothic influence [*Plate 72*]. You can then understand the energy with which they partook of a Renaissance of new concepts and new scripts so different from the past . . . but which could never have existed without the scripts we have been studying.

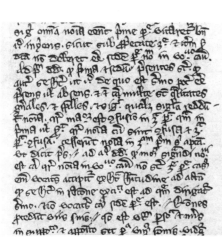

Plate 70. Gothic Littera Bastarda, c. 1285, English. [Oxford, Bodleian Library, MS. Digby 55, folio 146 recto] Typical appearance of a university textbook of its period; the script at its most functional.

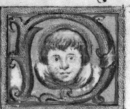

er fignum fanctæ crucis & inimicis noftris
líbeza nos Deus nofter.

Omine labia,
mea apezies.et
Et os meum
annunciabit.
laudem tuam.

E. us in adiutorium,
meum intende.

R. Bomine ad adiuuandum me feftina.

Gloria Patri,et Filio,z
Spiritui fancto.

Sicut erat in principio,zc.

Patris fapientia,veritas diuina Deus lxomo captus eft

Plate 72. Humanist Bookhand, c. 1600–20, Italian. [Author's collection] Representative of one of the forms of the script as it appeared in the twilight of the medieval era. The script was created by Poggio Bracciolini in Florence in the early 1400s, based on the Italian 11th-and 12th-century Carolingian Minuscule. Humanist Bookhand (also Humanistic Bookhand or Scrittura Umanistica [55] it was called Littera Antiqua [1], Lettera Antica, and Scriptura Antiqua [55] (a form of the latter in the 15th century being Littera da Brève [55] by the 15th-century scribes. A cursive form emerged in that century; Cancellaresca Corrente or Cancellaresca Corsivo, the origin of today's Italic [55].

Plate 71 (opposite). Gothic Littera Bastarda, c. 1410, English. [San Marino, The Huntington Library, MS. El 26.c.9, folio 153 verso] A page of the Canterbury Tales from the Ellesmere Chaucer, with a portrait of the author. Not particularly calligraphic, but large and bold. [Original size 40½ × 26 cm (10¼ × 16 in.)]

❖ TECHNIQVE ❖

V THE TECHNIQUE OF CALLIGRAPHY

Writing is excessive drudgery. It crooks your back, it
dims your sight, it twists your stomach, and your sides.

> —Translation of a note penned by an unknown
> medieval monk at the end of a manuscript.[20]

For on booke he skrapith like an hen,
That no man may his letters know nor se.

> —Colyn Blowbols Testament, c. 1500 [87]

One of the earliest Christian martyrs acquired his place in the *Calendar of Saints*—and in history—after a peculiar episode in the 4th century. St. Cassien was teaching pagan children in a Christian school in Germany's Tyrol, when, impassioned by an apostate uprising, the little barbarians attacked him with what was handiest. St. Cassien died—by the pen.

Today's calligraphy instructor may never be confronted with such treachery, but he is far less fortunate than his medieval predecessors, the teaching scribes and writing masters. Their students began instruction having never held a pen, but you have years of bad writing habits behind you, and oddly enough it would be easier to begin with calligraphy if you had never been taught to write.

In learning to write in the calligraphic style of the medieval era, you are entering a course that has a long and noble tradition. Calligraphy approached in the traditional manner has

considerable mystique, and this can act as an impediment to one's initial learning, which should be made as trouble-free as possible. Medieval scribes were accustomed to sitting upright without support, a position we find uncomfortable today. They held their writing materials at a steep angle, which we're unaccustomed to. The quills they used had to be recut after every page and frequently refilled. We have fountain pens to prevent such distractions. The medieval scribes' papyrus and parchment posed problems our modern papers solved centuries ago. I suggest we make the initial learning process as trouble-free as possible. Once you have a firm grasp of the technique, by all means add all the traditional elements you desire.

But from the very beginning two things must be traditional: the use of the broad-tipped pen, and the method in which the medieval scribe moved the broad tip to form his letters. This *ductus*—the direction and sequence of each stroke—is a valuable skill, yet it is relatively easy to acquire. If anything, it is the "secret" of medieval calligraphy, and it can be learned directly from those scribes. In practice, to find your own convenient niche in calligraphy, you may want to adjust this *ductus* by using some of your own variations. But you should begin with the knowledge of how the letters were formed originally.

To begin, you need the most convenient materials, an understanding of the best writing position, and some knowledge of basic techniques. (For specific materials and their sources, see *Materials and Resources*.)

What To Work On

The best paper to work on is a pad of smooth and thin sheets the size of this page or larger. A grid sheet with squares the same size as those used in *Writing Medieval Scripts* should be placed under the paper. The lines will serve to keep your rows of lettering perfectly horizontal, and your vertical strokes truly vertical. Keep your work sheet attached to the pad to cushion your working surface, and place a board or a large thin book beneath the pad to serve as a rigid backing. Use a clip to hold the pad to the board or book.

What To Write With

Write with a fountain pen so that your attention (undistracted by constant refilling and uneven ink flow) can be devoted to practice. Lefthanded writers should use pen points cut oblique left. Righthanded writers may use points cut straight or oblique right. Select a pen point the width of the one in which the *ductus* of each script is lettered in *Writing Medieval Scripts*. Use ordinary fountain pen ink; it flows smoothly, will not dry on the point when you pause, and washes off easily in case of accidents.

Sit on a chair that offers some back support. If you are sitting at a table, slide a few books under the end of the board so that it rests at an angle. If you are working without a table, cross your legs or set one leg across the other so that you can rest the board at an angle. The angle should be less than 45 degrees, but one that will help you avoid having to hunch over the paper (which creates tension). Your writing arm should be unrestrained in motion, resting on the heel of your hand and supported by the side of the first joint of your small finger. Place your paper in front of you, straight or slightly tilted to the left. If you are lefthanded, tilt it to the right about 45 degrees. By keeping your elbow near your side and resting the heel of your hand on the paper, your arm and hand will be in the best position to achieve the smoothest lines and arcs.

How To Position Yourself

When you take the pen in hand, do not let it lie all the way back between your thumb and first finger. This would place the pen at an angle of about 45 degrees to the writing surface. Let it rest further forward against the side of the first finger, so that it stands almost upright—at an angle of 65 degrees or more to the writing surface. Rest your hand on the paper below where you will be writing. If you try to write level with and to the left of your hand (or, if you are left-handed, to the right of your hand) your writing will be constricted. As you work down the paper, when you reach a point where your hand is no longer comfortable or properly supported, move the paper up on the board so that the position of your elbow, arm, and hand remain as suggested above.

how to begin

In every medieval script, although the angle of the pen point may occasionally change and some strokes may be made with the corner of the point, there is a single angle for most of the strokes. Your first practice must therefore be to move the pen in different directions while keeping the point at the same angle. Common are 0, 30 and 45 degrees. A perfect 45-degree angle is a line from the bottom-left to upper-right corner of any square on the grid. If you form this line correctly while holding the pen properly, the line will be the thinnest your pen point can produce. And the corresponding line, from the upper left to the lower right, will produce the broadest line possible. Practice some perfect *x* shapes, making the thin line uphill or downhill, but the thick line only in a downhill direction. In general the pen point is not pushed forward. Such motion is not easily controlled and involves the danger of the point biting into the paper, coming to a sudden stop, ripping the paper, or perhaps spattering ink in all directions. Medieval scribes did push uphill in order to save an additional stroke, but they had already achieved good control, and they used almost no pressure, in order to avoid having the pen point snag.

Diagonal Strokes

Now practice some straight strokes. If you keep the point or nib at 45 degrees to the writing line, the horizontal and vertical strokes will be of equal thickness.

Straight Strokes

Next, practice lettering some O shapes. The smoothest way to form an O is to imagine it as the face of a clock. Start at 11 and pull the point down and around to 5. Then place the point where you began and pull it up, over, and down to 5. If you have held your pen point at a 45-degree angle, the O will be thinnest at 11, where you began, and at 5. It will have smoothly and beautifully broadened to its widest at 8 and 2. Practice the letter *C*. It, too, begins at 11 and swings down and around to 5, begins again at 11 and swings up, over, and down to 2. The same practice applies in forming a lowercase *b*. After making the vertical stroke, place the pen point against the right edge of the vertical stroke to begin and bow of the *b*. Pull the pen point up and around to 5 and then stop. Do not push the pen point uphill to reach the vertical stroke. Rather, pick up the point and start on the vertical stroke, pulling down and around to 5.

Curved Strokes

Some scripts require vertical strokes in which the pen point starts at one angle but is twisted or rotated to a different angle while descending. This can be done in three different ways: (1) roll the body of the pen between your fingers as you ink the descending stroke; (2) hold the pen and fingers steady, but change the angle of the point by turning your hand, which is resting lightly. If your hand and arm are relaxed, the most noticeable movement will be made by your elbow, which will swing away from your body as you rotate the point counterclockwise; and (3) is a combination of the two. A twisted or rotated stroke is difficult only in appearance. Executing it can quickly become a simple maneuver almost without thought. A little practice will show you which of the above motions is the most comfortable and easily controllable for you.

Twisted or Rotating Strokes

Pen twists were used in many scripts to form serifs as a start, finish, or both, to a stroke. The twists were either clockwise or counter-clockwise; and the angle at which each started and the degree to which each twisted often varied from script to script or hand to hand. I have marked each twist in demonstrating the ductus of the scripts in *Writing Medieval Scripts*. It should quickly become very easy for you to look at any facsimile and see exactly what angle to start a twisting stroke, in which of the two directions it must twist, and at what pen-angle and position to stop.

Some scribes did not use twist-strokes when they would have produced the same result as

GETTING ACCVSTOMED TO THE PEN:

A. With the pen point at 45°, make some diagonal lines... If the lines are angled at 45° they will be the thickest and thinnest the point can produce.

B. Now with the point at the same angle, make some horizontal and vertical strokes... Notice that with the point at this angle, both lines have exactly the same thickness.

C. With the point steadily at 45°, form circles in two steps...

D. Simple letter shapes with the point at 45°...

E. Practice changing from using the entire width of the point to only one corner or the other — and then back to full width, all within the same stroke...

Between X's only the left-hand corner of the point touches the surface.

The stroke ends with only the right-hand corner of the point touching the surface, as the pen "skates" off.

F. Practice twisting strokes. Four variations are shown below, drawn with a pen point half an inch wide, and each is followed by a "Stop-action" version showing the pen point's angle is constantly changing as the stroke proceeds.

The twisting stroke, to be done well, must be accomplished in one continuous movement.

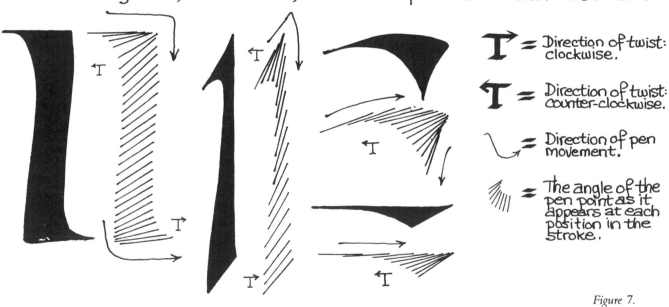

T = Direction of twist: clockwise.

T = Direction of twist: counter-clockwise.

= Direction of pen movement.

= The angle of the pen point as it appears at each position in the stroke.

Figure 7.

82

multiple strokes. It may have depended on the way they were taught, or what came easiest to them in accomplishing precisely the result they wanted. That same freedom of choice is yours.

As you practice letter shapes and become comfortable in holding and maneuvering the pen point, you should find that many thin-line strokes or thin portions of strokes that vary in width can be made thinner by tipping the pen slightly so that the leading corner of the point does not touch the paper's surface. This is a valuable maneuver, useful in many scripts. Practice by making curves and, when the stroke reaches its thinnest portion, gently lift the leading corner, skate on the trailing corner, and then smoothly let the raised corner settle back onto the paper as the stroke reaches the point where it should again begin to broaden.

Skating Strokes

Further practice involves getting comfortable with the pen; maintaining the angle, gaining more control, and becoming quicker in executing the strokes. A pen that rests on the paper or moves very slowly has a tendency to deposit more ink, causing thicker lines. This is a result of your hesitancy and not the fault of the pen. The more quickly and smoothly you can form an arc, the more graceful it will be. The less pressure you use, and the less tension you create, the more comfortable and beautiful your writing will become.

The matter of applying pressure is difficult to describe. Pressure you exert in gripping the pen or in pressing the pen against the paper—when it is the result of nervousness or concentration—is something a little practice will eliminate. You will want to vary the pressure of point against paper, but you cannot vary it unless you are relaxed and in control. For instance, a curve is most gracefully made if you gently increase the pressure as you enter the curve and relax the pressure as you swing out of the curve. A vertical stroke is more controlled and precise if it begins with minimal pressure, increasing as you descend. When you reach the bottom of the stroke, you will then have sufficient tension to lift the point directly away from the surface, leaving a perfectly crisp end to the stroke. If you arrive at the end with no pressure or tension, the act of lifting might add a bit more to the length of the stroke or make the line turn a hair to the right. Ending a vertical stroke under pressure will also enable you to produce perfectly the pressure-easing quick lift of the point when vertical or almost vertical strokes are to end with a minor stroke going off at an angle.

Applying Pressure

Once you are relaxed and your motions are flowing, there is one other touch to learn. If the stroke you are making is one in which the point creates its thinnest line at the end, do not stop dead at the end of the stroke. Keep right on moving. As you near the end of the stroke, raise the leading corner of the point. As you finish, let the remaining corner of the point glide up and off the surface. This will cause the end of the stroke to thin to nothing rather than ending blunt. Practice until you can do this in one single rapid motion.

Finishing Touch

If your pen has a rather heavy flow of ink (not caused by letting it rest or moving it slowly) so that the thin lines seem too heavy, or if you want the thin lines reduced almost to hairlines (a very calligraphically pleasing effect), there is a simple trick. Turn the pen over so that the pen point is upside down. It looks foolish, but what do you care. The difference in result is usually considerable. This is especially useful when you advance to using pen points of narrower width for writing smaller letters. The narrower the point, the less difference between thick and thin strokes, and the greater help this trick will be. It can be done without any concern if your point is cut straight. If you are lefthanded and using a point cut conveniently oblique left, it will be useless to you upside down. Instead, turn upside down a point cut oblique right, which will then become oblique left. Similarly, if you are righthanded and using a point cut oblique right, you must turn an oblique-left point upside down to produce the same convenient angle. (This turning over of pen points provides two other aids. Those who write lefthanded need points cut oblique left, occasionally difficult to obtain. As a substitute, turn an oblique-right point upside down. And those who write righthanded and enjoy penning scripts whose basic pen angle is horizontal will find an oblique right point more convenient than a straight one,

Thinner Lines

because it allows the hand to rest beside rather than directly below each stroke. If an oblique right point is not available, turn a left oblique point upside down.)

Since fountain pens were not designed to be used with their points upside down, you may find that when you pause to admire these thinner strokes and then begin again, the ink will not flow. In that case turn the pen around right-side up and make a few strokes on a scrap. The ink should flow again and you can return to upside down. If that does not work, grasp the point in a cloth and pull the cloth down and off the point. This should allow the ink to flow again. If, on the other hand, too much ink is the problem, wipe the entire point with a cloth. If you have accidentally paused long enough for the ink to dry at the tip of the point, a last desperate measure is to dip the end of the point in a liquid. An open bottle of ink will do. Since I always have one handy, I use a cup of coffee . . . if nobody is watching.

Positioning the Exemplar

Practice completed, you are ready to letter the medieval scripts themselves by learning the ductus of each script in *Writing Medieval Scripts.* A word of advice: Position the book so that the part of the page you are concentrating on is as close to where you are writing as possible. The shorter the distance between what you see and where you copy it, the shorter the time elapsed between seeing and doing, and the greater the chance that your writing will look more like the exemplar.

Word of Good Cheer

Finally, a word of good cheer: Your first attempt may discourage you. Calligraphy implies visual beauty, and your sorry attempt falls short of perfection. Do not be discouraged. Look back at some of the facsimiles with your now-wiser eyes and you will see that many of the examples you originally viewed with awe were, in reality, penned by rather inept scribes. Many facsimiles are included in this book not because they are bravura performances, but because they are representative examples of a working hand within a particular script. Your own hand is going to improve slowly but surely with practice. There is no reason why you will not, in a matter of time, be writing almost as well as any scribe in this book. And better than some.

UNDERSTANDING THE DUCTUS

The *ductus* is the direction and sequence of the strokes of each letter. To the best of my knowledge, gained from talking with paleographers, reading many texts, and examining original examples with a magnifying glass, each ductus in *Writing Medieval Scripts* is either the one used by scribes of that time or the best approximation. There are cases where two scribes worked the same letter or ligature differently, or where they changed the ductus of a letter depending on the letter that preceded or followed it. Variations are indicated where it was possible to discern them. In very few places I suggest a variation I cannot prove is authentic, but which I believe is more productive than the way I know it was done. Occasionally I had to guess what the ductus of a particular letter might have been, and to do so I considered the ductus of similar letters. In this way, too, I added to the medieval alphabet's letters those which we need today but which did not exist then.

The ductus of each script was, in its time, the most productive way to letter it. But that is not to suggest that you will find it easy or even immediately logical at the outset. Once you have

familiarized yourself with it, however, you will probably find it so functional that you will not want to make any changes in it for your own convenience (unless you normally write with too much pressure upon the pen and cannot comfortably use the medieval calligraphers' shortcut of pushing the pen forward to finish the line of a letter).

There are two ways in which the ductus of a letter can be diagrammed. One is to show the letter as a whole and surround it with numbered arrows showing the sequence and direction of the strokes. The other is to show the letter in the process of creation: the first stroke alone, then the first and second strokes, until the final stroke has been made and the letter stands complete. I prefer the latter. When you normally write a letter, you do so in steps; the letter cannot suddenly appear full-blown. I think it is helpful to visualize the evolution of a letter. No one forms each stroke perfectly all the time, and the appearance of the stroke you have just made may suggest an adjustment you should make in the next stroke in order to counteract what you find at fault. Also, overlapping is frequent in the formation of letters. If you cannot see the individual stroke because a later one overlapped its beginning or end, you can have no idea what that full stroke was.

I have lettered each page in *Writing Medieval Scripts* in the ductus of that particular script. The resulting shape of my letter is occasionally a close study, but sometimes a more modern readable hand based on the ancient script. Occasionally I chose a more pleasing letter shape from another scribe's hand in a facsimile elsewhere in the book, or from a source not included here. In other words, I have been influenced by many hands in that script in arriving at what has become my own hand—just as did every scribe whose work appears in this book's facsimiles. *You will be doing yourself a disservice if your study of a ductus page results in your acquiring a hand based on mine.* My hand is there *only* for the purpose of showing you the *ductus*. With this knowledge, you should then examine the facing medieval facsimiles, search out other examples elsewhere in this book (in the front of the book is a listing of *Plates by Script*), and then proceed to other sources. Choose letter forms that appeal to you. Allow yourself to be influenced by one scribe's sweep of the pen, another's decorative touch, and another's eye for proportion and spacing. This is how the medieval calligrapher, through reading and copying other scribes' hands, arrived at his own. If you do this, you can create your own modern adaptation of a medieval hand or mirror the old style completely, unsullied by any interpretation or idiosyncracy of a 20th-century instructor.

VI WRITING MEDIEVAL SCRIPTS

Ne dicas . . . 'Quia bene scribere nescio,
iccirco excusatus sum,' sed scribe ut
potes et nichil a te amplius exigetur.

[. . . you have no right to say "Please, excuse me, I do not write well." Write
as well as you can; no one can ask more.]

—Abbot Johannes Trithemius of Sponheim, in his *De Laude
Scriptorum* ("In Praise of Scribes"), 1492 [3]

Scribere qui cupiunt, sensum Deus augeat illis.

[Let God increase sense for those who desire to write.]

—A medieval monk's comment at the end of a manuscript.

ROMAN RUSTIC · 1ST TO 6TH CENTURY

Brief History

In about 700 B.C. the Romans borrowed the alphabetical concept from the unfinished Greek alphabet and the finished Etruscan alphabet. This conglomeration of capital letters, to which the Romans added their own minuscule and majuscule creativity, evolved over the centuries. In the 1st century B.C. the majuscule form (familiar to us from inscriptions on monuments) attained a calligraphic charm when it acquired sophisticated serifs. But the detailed strokes that this script, called *Roman Square Capital*, involved, and the time and space it demanded, doomed it as a functional, popular script, and it became obsolete by the 6th century.

For more functional work the scribes of the 1st century, impressed by *Roman Square Capital,* enhanced their cursive capital writing by reflecting the majuscule appearance and the serifs of the elegant script. The result, *Roman Rustic*, soon became popular as a functional book script. A majuscule with minimal ascenders and descenders, except for occasional embellishment, it appeared in many variations as more scribes took it to hand and as *Roman Square Capital* became perfected and served as a model. Before the 1st century had ended, *Roman Rustic* had become the standard book script in the Empire, and this was so as the medieval era began.

Plate 73. [Rome, Biblioteca Apostolica Vaticana, Codex Vaticanus Palatinus 1631 (P), folio 112 verso] A 4th or 5th century scribe, a fine calligrapher, carefully rotated the pen while making each vertical stroke, so that the line gently widened as it descended.

VNVMEXVIAPEDEMVINCLISINVESTERECINCTA
TESTATVRMORITVRADEOS·ETCONSCIAFATI
SIDERA·TVMSIQVODNONAEQVOFOEDEREAMANT
CVRAENVMENHABET·IVSTVMQVEMEMORQVEP
NOXERAT·ETPLACIDVMCARPEBANTFESSASOPORE

Plate 74. [Same ms. as above, folio 131 recto] A slightly narrower pen point, and perhaps a different scribe, gives this detail a lighter but equally calligraphic aspect.

ESTDORYCLICONIVNX·DIVINISIGNADECORIS·
ARDENTISQVENOTATEOCVLOSQVISPIRITVSILLI·
QVISVOLTVS·VOCISQVESONVSETGRESSVSEVNTI·

Plate 75. [Florence, Biblioteca Medicea-Laurenziana, Ms. Plut. 39.1, folio 159 recto] A late 5th-century example, sometime before 494, illustrates a less-compacted, less-calligraphic hand.

LYDORVMQ·MANVM·COLLECTOSARMATAGRESTIS·
QVIDDVBITAS·NVNCTEMPVSEQVOSNVNCPOSCERECVRRYS·
RVMPEMORASOMNIS·ETTVRBATAARRIPECASTRA·

Plate 76. [Rome, Biblioteca Apostolica Vaticana, Ms. Vat. Lat. 3867, folio 3 verso] As stately as Plate 73 but without the twisted vertical stroke, c. 450–500.

FORMONSVM·CORYDON·PASTOR·ARDEBAT·ALEXIN
DELICIAS·DOMINI·NEC·QVID·SPERARET·HABEBAT
TANTVM·INTER·DENSAS·VMBROSA·CACVMINA·FAGOS
ADSIDVAE·VENIEBAT·IBI·HAEC·INCONDITA·SOLVS

ROMAN RUSTIC · 1st TO 6th CENTVRY

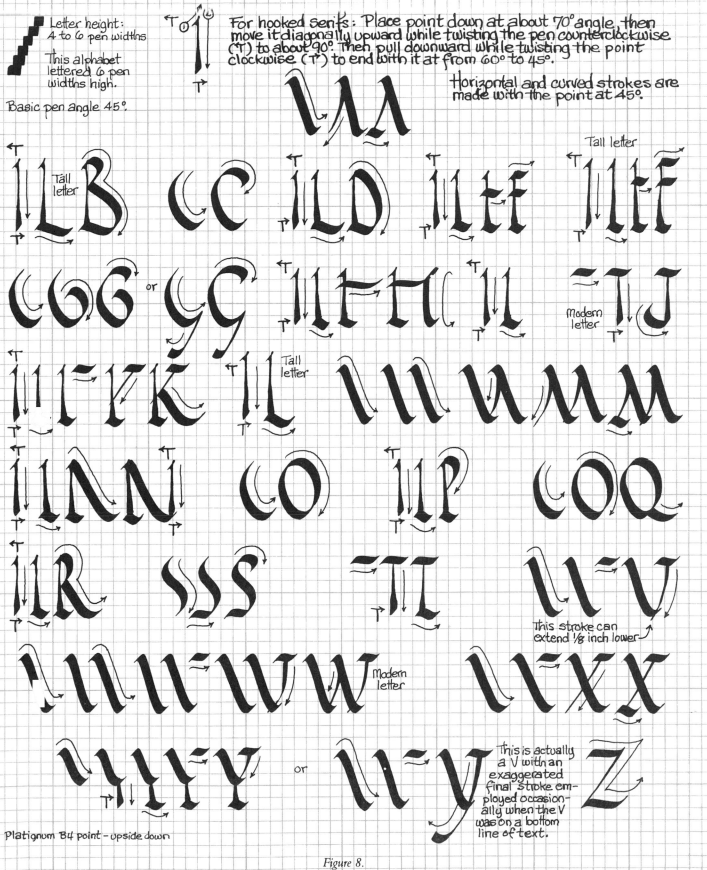

Letter height: 4 to 6 pen widths

This alphabet lettered 6 pen widths high.

Basic pen angle 45°.

For hooked serifs: Place point down at about 70° angle, then move it diagonally upward while twisting the pen counterclockwise (T) to about 90°. Then pull downward while twisting the point clockwise (T) to end with it at from 60° to 45°.

Horizontal and curved strokes are made with the point at 45°.

Tall letter

or

Modern letter

Tall letter

Tall letter

Modern letter

This stroke can extend ⅛ inch lower

This is actually a V with an exaggerated final stroke employed occasionally when the V was on a bottom line of text.

Platignum 84 point – upside down

Figure 8.

Plate 77. [Details of *Plates 73, 74* and *75*] *Letter Embellishment*: Embellishment was extremely limited and precise. The letter *G* would appear in its descender-bearing form on the bottom line of a text, so that the descender could flow gracefully below it. When a *Q* appeared on a bottom line, its tail would also have room to sweep. What appears to be a long-tailed *Y*, however, is a *V* in which the sometimes minutely-extended righthand diagonal stroke has been embellished to extreme. (For another bottom-line example, see the *L* in *Plate 76*.) Letters appearing in the top line of a text or against the righthand margin, also could be exaggerated. In the left-hand margin, serifs might extend. The initial stroke of a *V* or the serif of an *A* could break the pattern. But not every opportunity was acted upon. An average might be no more than two embellishments in any one margin, although half that number would be better. Embellishment was all the more appealing because it was rare, subdued, and did not disturb the majuscule flow of the text.

CHARACTERISTICS: Designed to be written somewhat rapidly, *Roman Rustic* was lettered with the pen point primarily at an angle of from 45 to 70 degrees. Arcs were sloped and diagonal lines either straight or slightly curved. *Roman Rustic A* may also have been penned left-leg first, and the legs of *M* penned consecutively from left to right. Uniform letter height was usually broken only by tall letters *B, F, L* and occasionally *E* and *P*. In the 2nd and 3rd centuries, *F* might extend well below the base line, and *M* stand on widely spread legs. The early *G*'s tail was penned much like the tail of *Q*. In the later refined script, *G* appeared in two forms; the nondescender version within the text, and the version used on bottom lines. Letters were spaced well apart, but no additional space separated words. Dots were sometimes inserted between words at mid-minim height. Words at line-endings, generally not broken, were split between syllables, although in the earliest manuscripts, following the Greek fashion, the break occurred after a vowel.

CAPITAL LETTERS: Since it was a majuscule script, an initial letter to begin a paragraph was penned slightly larger than the rest, using the same pen used for the text. It might also be slightly embellished. A paragraph would begin at the left margin, with no additional space between it and the end of the preceding paragraph.

FURTHER READING: Most books include at least one example of *Roman Rustic* and discuss it briefly. I would suggest, for examples, Thompson's *Greek and Latin Palaeography*, Lowe's *Codices Latini Antiquiores*, and *Handwriting*, Morison's *Politics and Script*, Degering's *Lettering*, Fairbank's *The Story of Handwriting*, Anderson's *The Art of Written Forms*, and Weitzmann's *Late Antique and Early Christian Book Illumination*. For discussion of the script I suggest the above by Thompson, Morison, Fairbank and Anderson, as well as John's *Latin Palaeography* and Ullman's *Ancient Writing and Its Influence*.

Plate 78. [Details of *Plate 75*] Minor designs, occasionally relieving large, bare page areas or setting off titles, were written in an incidental manner, a particular design casually repeated with apparently offhand changes. The examples in *Figure 9* are free-hand variations.

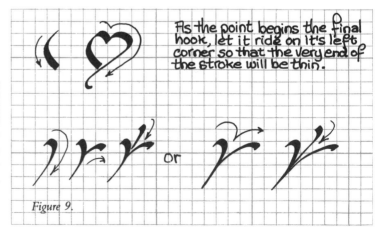

As the point begins the final hook, let it ride on it's left corner so that the very end of the stroke will be thin.

Figure 9.

UNCIAL · 3RD TO 6TH CENTURY

Brief History

In the 1st and 2nd centuries the scribes of Europe wrote most formally in *Roman Square Capital* and less formally and more conveniently in *Roman Rustic*. Their subject matter was almost wholly non-Christian. In Rome, Greek manuscripts predominated, since Latin had yet to become the official Church language. With the demand for church-related manuscripts, it was probable that the primary source was the intellectual community of North Africa, where Latin was the literary language of the Church and the population knew both Latin and Greek. The scribes there sought an appropriately dramatic Latin script suitable to the importance of their new religion, but some changes had to be made so such a script could be produced more rapidly to fill the demand for manuscripts. Since the pen more easily and rapidly produces curves than straight lines and angles, scribes began adopting some of the round strokes which were a hallmark of formal Greek script since the 3rd century B.C.

This adaptation resulted late in the 2nd or early in the 3rd century in a script as majuscule and important as *Roman Rustic*, but now with its letters wide and curved, reminiscent of the finest Greek formation. When the Church in Rome adopted Latin as its official language and sought to represent itself in a script both different from the pagan literature's *Roman Rustic* but familiar to people accustomed to that script or accustomed to Greek—*Uncial*, a formal but quick script, was the obvious choice. By the 4th century it had become an established script for manuscripts of importance, and by the end of the 5th century it had eclipsed the pagan scripts and reigned supreme.

Plate 79. [Oxford, Bodleian Library, Ms. Auct. T.II.26, folio 82 recto] This Italian scribe's *Uncial*, c. 450, is an excellent calligraphic example of the script's early form. His quick touch allowed minor gaps to appear between strokes, so many letters clearly indicate their ductus. The pen point was held at about 30 degrees, and the movement was controlled and flowing.

ETPERSEUERAUITCAPTIUITASANNLXXVUSQUE
ADSECUNDUMANNUMDARIIFILIIHYSTASPIS
QUIPERSISASSYRIISETAEGYPTOREGNAUIT•SUB
QUOAGGAEUSETZACHARIASETUNUSEXDUO
DECIMQUIUOCATURANGELUSPROPHETAUE
RUNT•SACERDOTIOQ•FUNCTUSESTIESUSIO
SEDEC•HAECSUPRADICTUSUIR
QUODAUTEMLXX•ANNUSDESOLATIONISTEM
PLIALTEROANNODARIFUERITEXPLETUSDO
MESTICUSTESTISESTZACHARIASPROPHETA
SECUNDOANNODARIITADICENS•DNEO
MNIPOTENSQUOUSQUENONMISEREBERIS
HIERUSALEMETCIUITATIB•IUDAQUASDES
PEXISTIISTELXX•ANNUS•

Plate 80. [Rome, Biblioteca Apostolica Vaticana, Basilicanus D.182 (Arch. Pietro D.182), folio 298 recto] This Italian scribe wrote a less calligraphic *Uncial* early in the 6th century (shortly after 510). He may have been an early advocate of the Greek fashion then coming to vogue in Latin usage, of holding the pen point horizontally, for his is held not far from that angle.

NESSUNTTUTIORESINHISENIMPROPHETAEAUTMANEN
TESAUTDEMERSIDISPUPROPHETABANT ABSISTITE
ABAUXENTIOSATANAEANGELOHOSTEXPIUASTATORE
PERDITOFIDAEINEGATOREQUAMSICESTREGIPROFES
SUSUTFALLERETSICFEFELLITUTBLASPHEMARETCON
GRAEGETASNUNCILLEQUASUOLETINMESYNODOSETHAERE
TICUMUTSAEPEIAMFECITPUBLICOTITULOPROSCRIBAT
ETQUANTAMUOLETIRAMINMEPOTENTIUMMOLIATUR

UNCIAL · 3RD TO 6TH CENTURY

Letter height: 4 to 5 pen widths.

This alphabet lettered 4 pen widths high.

Basic pen angle: 30°.

Line above penned with Platignum B-3 point, upside down, at 5 pen widths height.

A. Serifs are penned at 30°, as part of the minim stroke. No twisting occurs.

B. Vertical strokes should bow slightly instead of being rigid. To thin the ending of long descenders, the point can be twisted slightly counterclockwise (T).

Curved strokes may end with no serif, or with a slight counterclockwise twist.

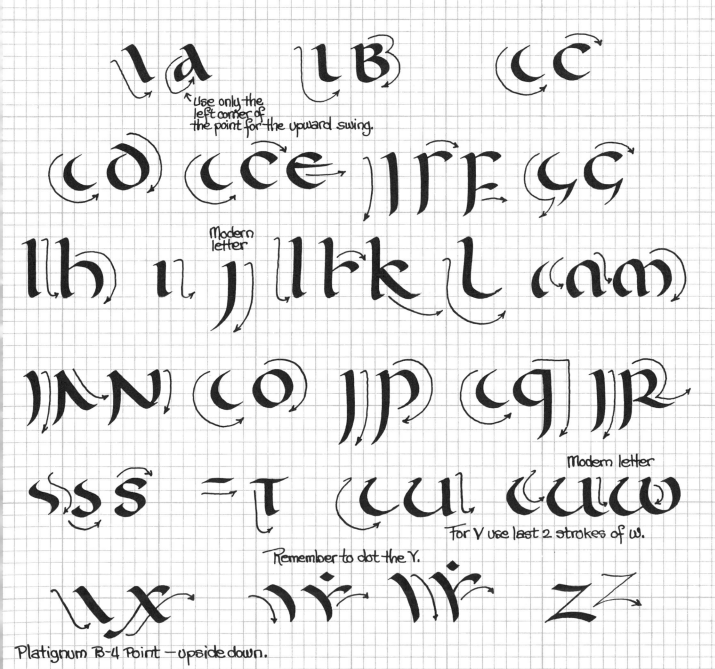

Use only the left corner of the point for the upward swing.

Modern letter

Modern letter

For V use last 2 strokes of w.

Remember to dot the Y.

Platignum B-4 Point — upside down.

Figure 10.

CHARACTERISTICS: A majuscule script whose letters were bold, upright, and well-rounded, *Uncial* also possessed cursive characteristics. Ascenders and descenders varied from short to extreme, depending upon the scribe. Vertical strokes contained a slight curve, a graceful sweep that expressed its flowing appearance. This was made possible by the pen point angled at approximately 30 degrees. The letters *I, F, N, P, Q,* and *R* contained descenders, and *H, L,* and *D* ascenders. In the earliest versions the cross-bar on the *E* was as high as possible, the *B* stood taller than its fellow letters (as was typical in *Roman Rustic*), and the first stroke of *M* was nearly vertical. A variation of this script contains *B* and *D* in the form of *b* and *d*. And in all versions a dot was centered over the *Y* so as to indicate that the letter was not to be confused with one or another of two Runic symbols of the time. (These two symbols were to become part of the Anglo-Saxon alphabet and the dot over the *Y* therefore appeared in every later script.)

Uncial, despite its cursive elements, contained bold minim strokes. Even though there was a slight curve to the long vertical strokes (*F, L, N, P,* for instance) in the more calligraphic hands, the majuscule quality of the script was not lost. This quality was emphasized by space left between words, although dots at mid-minim height were occasionally used as an indicator. There was no attempt to indicate paragraphs either by leaving blank lines between them or indenting first lines. Given a choice, the scribe preferred to end a word on the line. Those who split words did so between syllables.

PUNCTUATION: A brief pause was indicated by a single point at mid-minim height, and a colon or a colon and dash indicated a complete stop. By the 6th century a slanted line was the equivalent of a comma, the semi-colon came into being, drawn as a combination dot and slanted line, the question-mark appeared as a horizontal *S*-shape, and the single-quotation mark (compared to today's mark which begins and ends with double strokes) was becoming known. The end of what would be considered a paragraph was marked either by the colon, a colon and dash, or three points in a triangular formation at mid-minim height.

FURTHER READING: Information on the history of *Uncial* is found in Anderson's *The Art of Written Forms*, Fairbank's *The Story of Handwriting*, John's *Latin Palaeography*, Morison's *Politics and Script*, Thompson's *An Introduction to Greek and Latin Palaeography*, and Ullman's *Ancient Writing and Its Influence*. For further examples of *Uncial* hands, I suggest the above by Anderson and Thompson, as well as Degering's *Lettering*, and Lowe's *Handwriting*, his two-volume *Palaeographical Papers*, and his volumes of the *Codices Latini Antiquiores*.

CAPITAL LETTERS: When capital letters were called for (generally for the beginning of sentences rather than for names) the scribe usually inked an *Uncial* letter in larger size, or occasionally used a *Roman Rustic* letter in its place; in both cases he used the same pen as for the text. These letters were sometimes exaggerated and decorated, but the lasting impression of an *Uncial* page is one of neatness and lack of fussiness. While the script itself was an intentional new design in terms of its comparison with *Roman Rustic*, the delight in simple presentation appears to have been carried over. Creative capital letters, sometimes constructed of human, animal, fish and bird forms, were to be seen more and more often toward the end of this script's life-span.

ARTIFICIAL UNCIAL SIXTH TO TENTH CENTURY

Brief History

Adopted as the chief script of the Church, *Uncial* was the most important script of the 4th, 5th and probably 6th centuries. Its direct descendant, *Artificial Uncial*, was born because of the scribes' unceasing calligraphic enthusiasm and the adoption of a seemingly small Greek lettering technique, no more than the turning of the pen point to the horizontal.

When this occurred in the 6th century, it quickly gained popularity. By holding the pen point horizontally, the scribe gave the letters more impact, since vertical lines now achieved the greatest possible width and horizontal lines the least. Such a pen position also demanded more concentration and time. Either the acceptance of such an angle meant that the scribe was capable of spending more time, or the calligraphic result was so beneficial that time became less important. In either case, once this was established as a technique and the script no longer considered a relatively speedy, functional one, it was a hey-day for those with calligraphic aspirations. With time of less consequence and the point at an angle whose resulting lines were capable of myriad embellishments, *Artificial Uncial* became increasingly more intricate to pen and more strikingly artistic. By the 7th century it had achieved total acceptance and recognition, further embellishments being heaped upon it. An exaggerated and elaborate script by the 9th century, it required so much time and skill that its use was reserved for brief key points of lesser manuscripts or for the text of special works. By the 10th century, *Artificial Uncial*, the victim of the enthusiasm it engendered, died as a script, but became the basis for a display alphabet of capitals. Even further embellished, considered equal in stature to the venerable *Roman Square Capitals* with which they were now occasionally mixed, *Artificial Uncial*'s letters were used only one at a time as Early Gothic and Gothic *versals*, or to form, for instance, the most important word or two of a book's chapter openings. In this manner, *Artificial Uncial* was employed to the end of the Middle Ages, its history having spanned almost 1,000 years.

Plate 81. [New York, J. Pierpont Morgan Library, Ms. 23, folio 65] *Artificial Uncial,* penned in gold on purple vellum late in the 10th century:

MEAS ZACHARIA QUO ELISABETH PARIETTIBIFILIU
EXAUDITAEST DEPRECA ETUOCABIS NOMENEIUS
TIOTUA ETUXORTUA IOHANNEM ETERITGAUDIU

For 8th century hand see *Plate 84.*

For letter *K* see *Plate 85.*

Plate 82. [Durham, Dean and Chapter Library, Trinity College, Ms. B.IV.6, folio 169*] A superbly calligraphic *Artificial Uncial,* penned in Italy in the 6th century: ETPLACUITSERMO / INCONSPECTURE / GISETPRINCIPUM / ETMISITADEOSPA / CEMFACEREET / RECEPERUNTILLA / ETIURAUITILLISREX / ETPRINCIPESET / EXIERUNTDEMU / EXIITDEMETRIUS / SELEUCIIFILIUS / ABURBEROMA / ETASCENDITCUM / PAUCISUIRISINCI / UITATEMMARIMA / ETREGNAUITILLIC / ETFACTUMESTUT

Plate 83. [Oxford, Bodleian Library, Ms. Hatton 48, folio 22 recto] An Anglo-Saxon scribe's fine hand, c. 680–720: QUINTUSHUMI / LITATISGRADUS / EST•SIOMNES / COGITATIONES / MALASCORDISU / OADUENIENTES / UELMALAASEAB / SERICORDIAEIUS / ETITEMPROFE / TA•DELICTUMME / UMCOGNITUM / TIBIFECIETINIUS / TITIASMEASNON / OPERUI•DIXIPRO

ARTIFICIAL UNCIAL
SIXTH TO TENTH CENTURY

Lines above penned with Platignum B-3 point

Letter height to pen width ratio can vary considerably, from less than 3 to over 5.

This alphabet lettered 4 pen widths high.

Basic pen angle: 10°.

A B

Serif A is typical of insular scribes' work. Serif B indicates European origin — notably Italian.

The serif is pulled almost straight across at the top. The bottom one is formed by ending the vertical stroke with a clockwise twist (T) and a pull to the right.

Vertical strokes that "tail off" do so in varying shapes. The righthand one is finished with the lefthand corner of the point.

A. Made with a counterclockwise twist.

B. Made by starting a counterclockwise twist, lifting all but the lefthand corner of the point, and pulling it down.

C. A counterclockwise twist using only the lefthand half of the point.

D. Lefthand half of the point in a clockwise twist.

use corner

or ... or

use corner of point

or ... or

Modern

Use only the left half of the point for the turn at the end of this stroke.

or

This stroke at 45°

or ... or

dot the Y.

For V use last 2 strokes of W

Platignum B4 point — upside down

Figure 11.

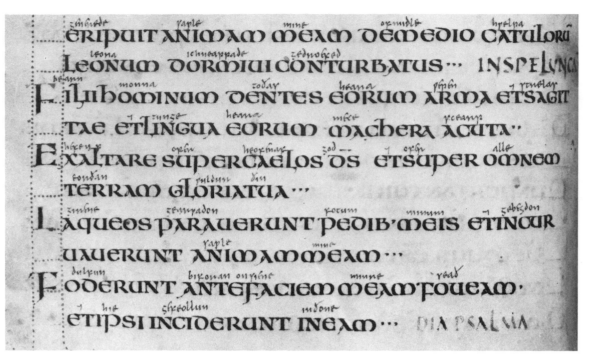

Plate 84. [London, British Museum, Ms. Cotton Vespasian A.I., folio 55 verso] By an English scribe, probably in Canterbury, c. 700–725. The gloss is *Anglo-Saxon Minuscule*, c. 850–900:

ERIPUIT ANIMAM MEAM DEMEDIO CATULORU
LEONUM DORMIUICONTURBATUS•••INSPELUNCA
FILIIHOMINUM DENTES EORUM ARMA ETSAGIT
TAE ETLINGUA EORUM MACHERA ACUTA••
EXALTARE SUPERCAELOS DS ETSUPER OMNEM
TERRAM GLORIATUA•••
LAQUEOS PARAUERUNT PEDIB•MEIS ETINCUR
UAUERUNT ANIMAMMEAM•••
FODERUNT ANTEFACIEM MEAM FOUEAM•
ETIPSI INCIDERUNT INEAM•••

Plate 85. [Oxford, Bodleian Library, Ms. Hatton 48, from misc. folios] Somewhat rare examples of the use of *K* in an English hand, c. 680–720. The lower example is unfortunately not as clear because the lettering from the opposite side of the sheet shows through. Note the stroke above the first line's *KA*, indicating an abbreviation. Even this simple symbol is handled with calligraphic care; beginning with a clockwise pen twist and ending with an opposite turn. This would appear to have been inked with a narrower point than used for the text, but was most likely done with the same point tipped slightly to keep half its width off the writing surface—a delicate maneuver. This is the mark of an exceptional calligrapher; to take great care in the smallest things, particularly where its absence would not have been questioned.

CHARACTERISTICS: Artificial Uncial, a dramatic decorative majuscule script, was written slowly. The scribe held his pen point on or near the horizontal and carefully added embellishment wherever possible to each letter form. Serifs were extended and enlarged into triangular shapes with at least one elongated point. Minim strokes were occasionally broadened slightly at the base. The execution of this script required precision, frequent changes in pen angle, and intricate pen twists. Letters were written large, often with a particularly broad point for greater impact, and considerable space was left between lines and between letters.

Because *Artificial Uncial* first came into being in the 6th century and was in use for more than 400 years as a monumental script, it spanned the eras of several more functional scripts, each of which had its own characteristics; and these characteristics had their effect on the use of *Artificial Uncial*. In the early centuries, in the style of that time, it was written without word separation. When separation became popular in the more functional scripts of the 8th century, *Artificial Uncial* followed suit. You should check the characteristics of the scripts of the period you have chosen, and allow your interpretation to mirror their usage, but without affecting their form.

One general difference between Anglo-Saxon and European ornamentation of *Artificial Uncial* can be suggested: Anglo-Saxon scribes tended to make the triangular serif's right sides at an angle. European scribes usually made that side of the serif vertical and extended the lower point considerably. But this is only a generalization; students followed their teacher's style, and he may have come from distant shores.

PUNCTUATION: The punctuation you use depends on the century which you choose your *Artificial Uncial* to represent, so check the information on punctuation given for scripts of that particular century. In general, in the early centuries, verses were divided by a comma or oblique flourish. A full stop was indicated by two dots, one beside the other at mid-minim height, with a comma at base level centered between them. A comma was represented by a diagonal slash mark with a point at its lower end at base level, or (specifically in the 7th century) by a single point at minim height. In the 7th century the modern semicolon came into use, as did the double quotation mark, which in the 6th century had been a single stroke.

LIGATURES: While words were broken at line endings, considerable effort was made to avoid this, as is apparent by the wide variety of ligatures generally used at the ends of lines but not throughout the text. Several examples are shown in *Plate 86* and others undoubtedly would have been created had the medieval scribes been faced with the peculiar letter combinations of the English language. So feel free to create your own. These ligatures are conjoined letters, with one of the strokes representing a portion of both letters. To be precise, a ligature does not infer conjoining but only implies that two whole letters touch at some point. But the term has included these examples for so long that it has become generalized. One example you may run across, not shown here: French scribes, writing *LL*, used a single serif linking both tops, running the horizontal stroke of the first *L* into that of the second.

CAPITAL LETTERS: Capital letters normally were larger versions of the *Artificial Uncial* letter forms of the text, made with the same pen used for the text. In the late medieval era, when this script was purely decorative, a capital letter might be a versal. This was quite compatible because *Artificial Uncial* was the source for many of the versal letter forms. *Roman Square Capital* letters were used, but less frequently; one example is the *Roman Square Capital E* beginning line 5 of *Plate 84*—a letter comfortably "at home" because the scribe gave its serifs an *Artifical Uncial* turning. See also *Decoration* below and *Plates 87* and *88* and *Figure 13*.

One peculiarity of this script (and it appears elsewhere) is that the abrupt change in size from capital to standard text letter was too extreme for some scribes. Large capital letters were often followed by a second letter smaller than the capital but larger than the text letters (especially if the capital was enormous), and some portion of the decoration added to the capital was extended to the "middle" letter. This practice generally died out in the 8th century. (See *Plates 87* and *88*.)

Capital letters were positioned wholly in the margin or extended into the margin. And the beginnings of the following lines of text followed the outline of the capital's righthand side until it reached a depth where it could once again commence at the margin.

DECORATION: Because *Artificial Uncial* spanned such a long period, its use was altered by the popular trends of each century. You should see what was done at the time you wish your script to mirror, and adopt appropriate touches. In the earlier centuries the capital letters were set in a frame of, or tightly outlined by, red dots. They might be enlarged and penned in a single color, or as in *Plates 87* and *88* made enormous and constructed of frameworks of one color and fillings of another, topped by an edging of red dots. A scribe might occasionally increase the emphasis by inking a second row of such dots, and even fill in areas with them. Large areas the scribe might have felt uncomfortable leaving blank were occasionally crisscrossed with a "trellis" of red dots. Rarely was red exchanged for another color, though. Orange dots have been used, and in a late medieval design with blue background white dots proved most effective. When red dots were used in a single row surrounding

Plate 86. [Oxford, Bodleian Library, MS. Hatton 48, from misc. folios] Line-ending, space-saving ligatures in an English hand c. 680–720, are as follows:

AE	NT
ON	NC
UB	OS
UT	NS
US	AE

Such combining of letters was usually avoided in the body of the text and only used as an expediency when lack of space required it as the scribe reached the right-hand margin.

the capital in the early period, it was often customary to continue the dots to outline the letter following the capital. Decoration of the page itself followed the custom of the period of its use. In general, the script itself was so dramatic that decoration usually was unneeded, and absent, within the area of the text.

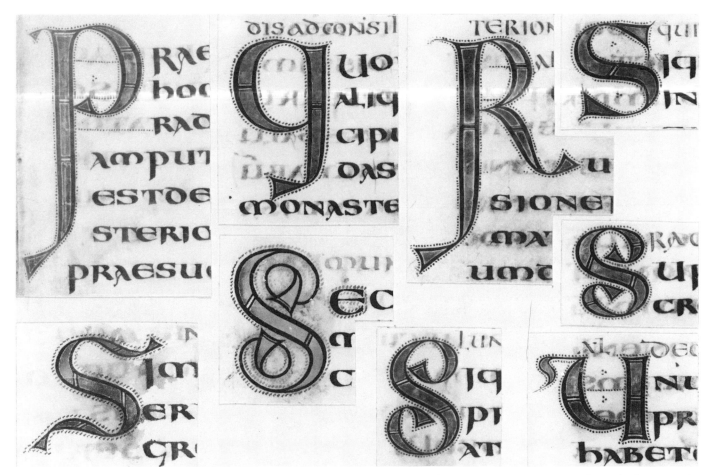

Plates 87 and *88.* [Oxford, Bodleian Library, MS. Hatton 48] Details from numerous folios of this Anglo-Saxon manuscript, c. 680–720 include at least one example of every different letter capitalized in the manuscript. The letters were penned in two colors, the lighter filling color never touching the framework, and the whole surrounded by red dots. The forms are exaggerated copies of text letters, accompanied in many cases by smaller and less-exaggerated second letters penned in black ink.

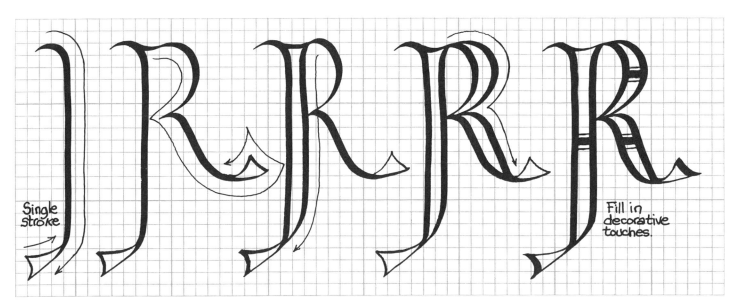

Figure 12. Enormous capitals in the style of the manuscript above, can be made with the same pen used for the text, and they can stand well enough alone in black ink. For most strokes the pen point is held horizontally. While only the letter *R* is shown, you should have little difficulty penning others. Keep in mind that the longer, smoother single stroke is more authentic and more productive than a series of overly-cautious short strokes. And, as you can see from the details of the accompanying Plates, while the decorated capitals extend into the margin, the greater space they occupy is taken from the text, which is indented to fit the needs of the particular letter.

FURTHER READING: For writings on *Artificial Uncial* I would suggest Anderson's *The Art of Written Forms*, John's *Latin Palaeography*, Lowe's *English Uncial*, Morison's *Politics and Script*, Thompson's *Introduction to Greek and Latin Palaeography*, and Ullman's *Ancient Writing and Its Influence*.

For examples of the script I suggest the Anderson, Morison, Lowe and Thompson volumes above, as well as Degering's *Lettering*, and Lowe's *Handwriting, Palaeographical Papers*, and volumes of the *Codices Latini Antiquiores*.

For excellent color photographs of ornate manifestations of *Artificial Uncial*, see Mutherich and Gaehde, *Carolingian Painting*, and Thomas' *Great Books and Book Collectors*. The latter contains a color plate of the *Golden Gospels* page (*Plates 25* and *86* of this book). Lowe's *Palaeographical Papers* contains a series of composite photographs showing comparative letter forms of the *Golden Gospels*.

For decoration—particularly if you are interested in the use of red dots in "trellis" patterns, and in forming capital letters from animal, fish, bird and human forms—see Van Moe's *The Decorated Letter*.

roman half-uncial
third to ninth century

Brief History

The most noticeable and awesome scripts of the early centuries were the large, stately majuscules; *Roman Square Capital*, followed by *Roman Rustic*, and then *Uncial* and its exaggerated offspring *Artificial Uncial*. Each in their time served as the scripts for important works. But the scribes were at the same time under constant pressure to handle the more mundane paperwork of their day—most easily accomplished in a simpler script, easier to write quickly and in less space, and yet equally readable. By the 3rd century it is evident that such a script had already become popular, devised apparently from cursive elements with design imitating the *Uncial* of the time. It is thought that this work-a-day script, known as *Roman Half-Uncial*, may have originated when scribes wished to write additional notations in the margins of their *Uncial* manuscripts; and faced with *Uncial* forms but needing to write far smaller letters and in relative haste, they jotted their additions in a cursive variation of the *Uncial*.

As *Roman Half-Uncial* developed as a distinct script, it became a turning-point in the history of calligraphy, for, because of its cursive element of long ascenders and descenders (the vestigial remains of cursive lettering's exaggerated sweeps) and the new form it gave to many letters—which we know today as lower case shapes—it became the first medieval *minuscule* script. By the 6th century it had achieved so much popularity that it began appearing as a script for books, although not ones of importance. As time passed, it became more calligraphic, although it was always to remain, in terms of visual appeal, humbled by almost every other script of the era. But its minuscule form excellently filled the need, and the script was transmitted throughout Europe in the letters, paperwork and minor manuscripts of Church officials and monasteries.

105

Plate 89. [Rome, Biblioteca Apostolica Vaticana, Basilicanus D. 182 (Arch. S. Pietro D. 182) folio 159 verso] Here the scribe held his pen almost horizontally, writing probably late in the 5th century:

inponis cuiusdiuinitutis plenitudohabitet inxpo
siueropatrisestedocequomodocorporaliter
haecineoinhabitetplenitudo•sienimcorporali
modopatreminfiliocredis•paterinfiliohabitans
nonextabitinsese siueroquodestpotiuscorpo
raliterineomanens divinitatenaturaeineo
diexdo significat ueritatem•dumineodsest
nonautperdignationem•autperuolumtatem
sedpergenerationem uerusettotuscorpora
lisecundumse plenitudinemunens•dumquod

Plate 90. [Oxford, Bodleian Library, Ms. Douce 140, folio 59 verso] This scribe probably worked in England c. 700, but his work is noted for its French mannerism. The pen is held horizontally:

ne capitulat;nuncergo discrib tosexto ado
ruginemredit•eadem brebiter aliterque

dicturus•VII posthaecinquid uidi quatu
orangelos stantes per quattuorangulos
terrae•tenentes quattuoruen tos terrae
nein terris flarent•neueinmari•neueinulla•ar
bore; inquattuorangelis istis regnaquattu
or:designari aeclesiainiohan ne cognascetur
as siriorum•etmedorum etpersorum etroma

roman half-uncial

third to ninth century

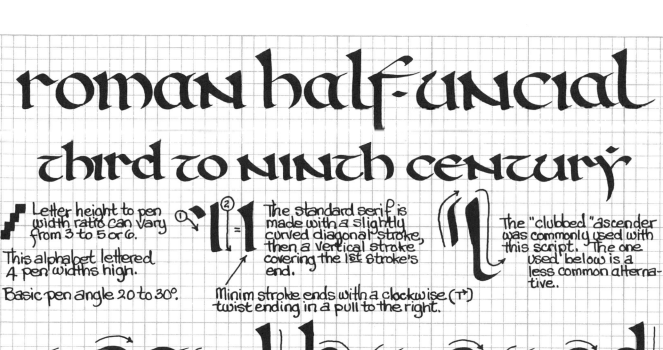

Letter height to pen width ratio can vary from 3 to 5 or 6.

This alphabet lettered 4 pen widths high.

Basic pen angle 20 to 30°.

The standard serif is made with a slightly curved diagonal stroke, then a vertical stroke covering the 1st stroke's end.

Minim stroke ends with a clockwise (↻) twist ending in a pull to the right.

The "clubbed" ascender was commonly used with this script. The one used below is a less common alternative.

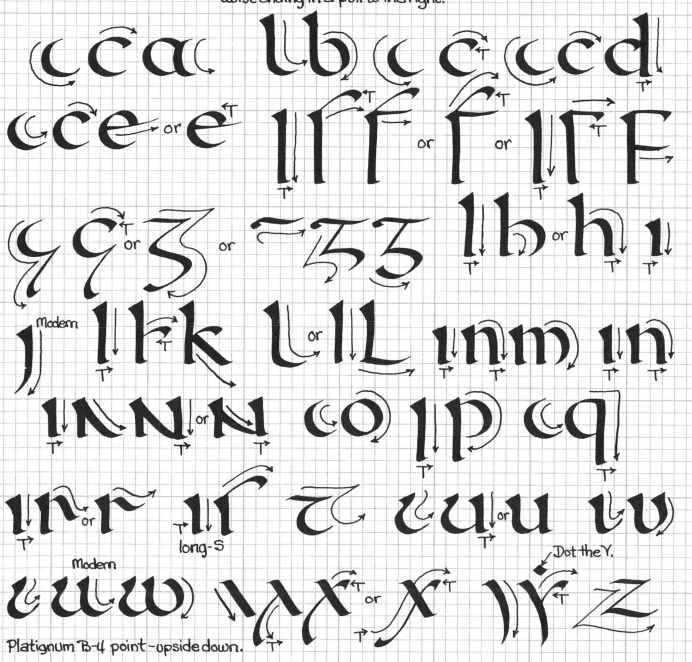

Modern

or 3

or

long-S

Modern

Dot the Y.

Platignum B-4 point - upside down.

Figure 13.

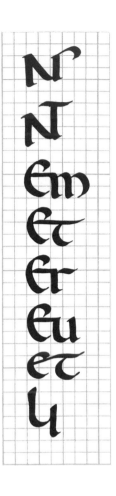

Figure 14. As befits a cursively oriented script, *Roman Half-Uncial* contained numerous ligatures. They appeared primarily at the end of a line where there was insufficient room to end a word, rather than as a standard practice within the text. Some ligatures are shown here; *N* with *long-S*; *N* with *T*; a tall *e* capable of linking its cross-bar with *m, t, r,* and *u*; a standard size *e* linked with *t*; and an *l* linked with *i*, the latter customarily inked with the *i* sitting a half-minim-height lower than the accompanying letters. The most popular linking letter, employed within the text, was the standard size *e*, whose cross-bar might conveniently run to the beginning of the following minim-height letter.

CHARACTERISTICS: A work-a-day script of cursive qualities imitating *Uncial* forms, *Roman Half-Uncial* was originally written with the pen point held either at the horizontal or somewhere up to as much as 30 degrees for convenience and speed. As *Uncial* acquired its *Artificial Uncial* manner in the 6th century, more *Roman Half-Uncial* writers turned their pen points towards the horizontal for a more formal appearance. But *Roman Half-Uncial* evolved its own particular forms by becoming minuscule instead of following other scripts' majuscule dicta. Ascenders and descenders were noticeably marked. The top loop of *B* disappeared and an ascender was born; the compact *S*-shape became a more sweeping *long-s*; the *D* became *d* and another ascender joined the alphabet; the *E*'s upper half closed to become *e*; and *Q* acquired a descender.

When the dramatic majuscule form of *R* became simplified, it approached in appearance what we would consider a lowercase *n*, particularly when written or read rapidly. So in *Roman Half-Uncial* the capital (*Uncial*) *N*-shape remained. But except for *N*, and of course *Z* (although both were written smaller), and overlooking *long-s*, the entire *Roman Half-Uncial* alphabet was lowercase in form. The *long-s* lasted not only throughout the medieval era but still appeared in use in some typefaces of early American books as late as the early 19th century.

A humble script not intended for ornate productions but mirroring the fashions of the day, it was written without word separation up to the 8th century. It was not paragraphed and was broken between syllables at line ends.

CAPITAL LETTERS: Capitals were usually larger versions of text letters, inked with the same pen. *Uncial* or *Roman Rustic* letters might occasionally be substituted. But there was seldom any careful exaggeration made or decoration added because this was not a script one thought of as accompanied by embellishment. In the latter two centuries of its existence, however, the script was employed as an accompaniment to the more popular script of that time, looked upon as an antique hand and penned rather more artfully than in the past. In such cases similar care would have been taken in producing well-turned capitals.

PUNCTUATION: The punctuation employed was the same used for the more important scripts of the different periods in which *Roman Half-Uncial* thrived. Depending on which period you wish to imitate, you should refer to punctuation suggested for *Uncial, Artificial Uncial,* and four scripts on the immediate pages ahead; *Insular Majuscule, Insular Minuscule, Luxeuil Minuscule,* and *Carolingian Minuscule.*

FURTHER READING: Information on the history of *Roman Half-Uncial* can be found in Anderson's *The Art of Written Forms,* John's *Latin Palaeography,* Morison's *Politics and Script,* Thompson's *Introduction to Greek and Latin Palaeography,* and Ullman's *Ancient Writing and Its Influence.* For examples of the script see all the books above, as well as Degering's *Lettering* and Lowe's *Codices Latini Antiquiores.*

Insular majuscule
6th to 9th centuries

Brief History

Roman Half-Uncial was well established as a functional minuscule script for humble manuscripts when St. Patrick began his mission to Ireland in 432. The land was unusual because it lay beyond the Roman Empire, was unfamiliar with Latin, and had no serviceable written language of its own. St. Patrick's followers learned *Roman Half-Uncial* and adapted it. The Celtic artistic traditions undoubtedly influenced the script, and Ireland's virtual isolation from outside influences, and its serenity as compared to the upheavals affecting England and Europe, made possible an excellent environment for purely Irish calligraphy to evolve. The Irish scribes created the exaggerated serif and so formalized the script that the humble minuscule became a majuscule script in the 6th century. The most spectacular version of the script is seen in the *Book of Kells*, c. 790-830. It was a formal monumental script executed with a special flamboyance; letters stretched and ligatured to suit either space or whim.

Irish monks in about 565 took their *Irish Majuscule* abroad to Scotland and northern England, teaching it to Anglo-Saxon scribes. Their students were so imitative at first that *Irish Majuscule* and *Anglo-Saxon Majuscule* are generally referred to together as *Insular Majuscule*, although the differentiation becomes easier to see by the mid-8th century as Anglo-Saxon scribes developed their own more regular, less-flamboyant versions. As the Irish missionaries had been moving southward, the students of Augustine (who had in 597 arrived in southern England bearing *Artificial Uncial* manuscripts) were teaching their way northward. In the early 7th century scribes favoring *Artificial Uncial* and *Insular Majuscule* mingled in Northumbria, and by mid-century the script of Irish origin, along with a minuscule that had developed with it, succeeded *Artificial Uncial*. By the 9th century *Insular Majuscule*, both in Ireland and England, was suffering the familiar impracticality of being too formal. Within the next 100 years it became obsolete.

Plate 91. [Dublin, Trinity College, Ms. Book of Kells, Ms. 58(A.1.6), folio 146 recto] This manuscript by Irish scribes c. 790–830 is considered the finest *Irish Majuscule* ever produced. The enlarged and decorated figure is actually an ampersand; the Latin word for *and* (*et*) with the *e*'s horizontal stroke serving as the cross-bar for the *t*, and the *e*'s tail sweeping up to become the *t*'s trunk.

multos aegros &sanabant.
& audiuit herodis rexmanifes
tum enim factumest nomen
eius & dicebat quiaiohannis baptiza
surrexit amortuis. &propterea o

Plate 92. [London, The British Museum, Ms. Cotton Nero D.IV, folio 143 verso] This example from the *Lindisfarne Gospels*, penned by Eadfrith, Bishop of Lindisfarne c. 700, is considered the finest *Anglo-Saxon Majuscule* ever produced. It is accompanied by a 10th century Anglo-Saxon gloss.

&dixit illis angelus
nolite timere
ecce enim euangelizo
uobis gaudium
magnum quod erit
omni populo
quia natus est nobis
hodie saluator qui

Plate 93. [Oxford, Bodleian Libary, Ms. Auct. D.II.19, folio 117 verso] Somewhat less calligraphic is the *Irish Majuscule* of the early 9th-century *Mac Regol Gospels*. It, too, is marked with an Anglo-Saxon gloss.

aparentih; & fratribus & cognatis & amicis &
ad ficiant exuobis & eritis odie omnibus p
nomenmeum & capillus decapite uestro n
bit inpaticentia uestra possedebetis anim

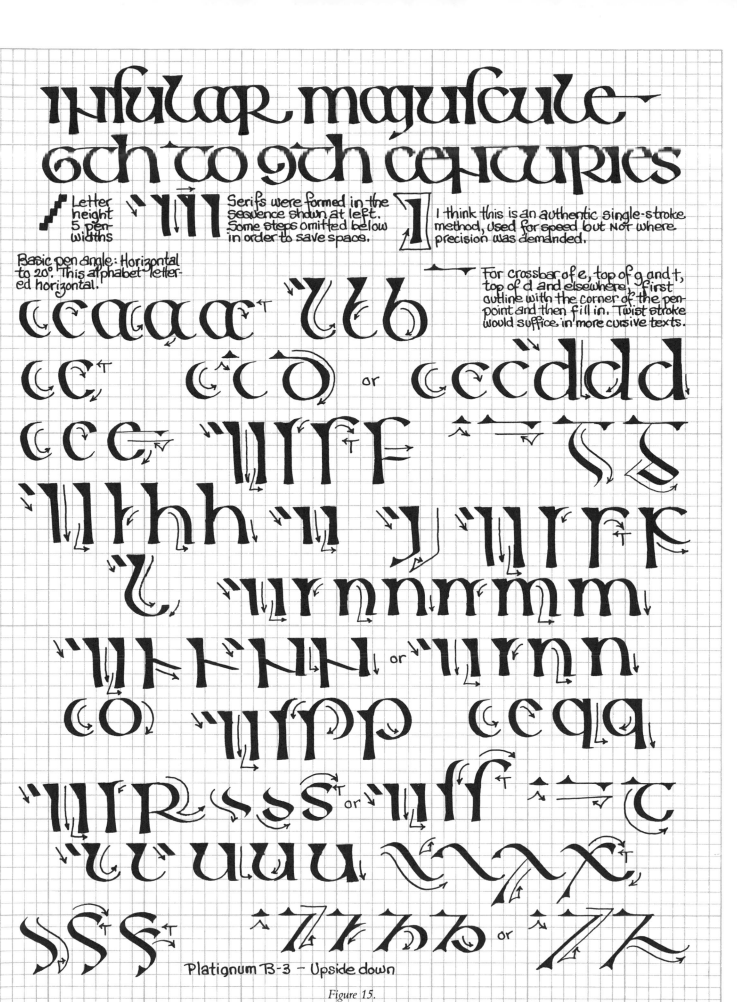

INSULAR MAJUSCULE
6TH TO 9TH CENTURIES

Letter height 5 pen-widths

Serifs were formed in the sequence shown at left. Some steps omitted below in order to save space.

I think this is an authentic single-stroke method, used for speed but not where precision was demanded.

Basic pen angle: Horizontal to 20°. This alphabet lettered horizontal.

For crossbar of e, top of g and t, top of d and elsewhere, first outline with the corner of the pen-point and then fill in. Twist stroke would suffice in more cursive texts.

or

or

or

or

or

or

Platignum B-3 – Upside down

Figure 15.

Plate 94. [*Top line:* Dublin, Trinity College, Ms. Book of Kells, Ms. 58 (A.I.6), folio 145 verso; *second line;* folio 309 recto; *remaining lines;* Oxford, Bodleian Library, Ms. Arch. Selden B.26, folio 34 recto] These examples from the late 8th and early 9th century show *Insular Majuscule*'s penchant both for stretching letter shapes to fill space, and creating ligatures so as not to waste space. In the top line (*Irish Majuscule*) an *M*, *N* and *S* are stretched. A simpler wide *M* was made by omitting the knot-work and sending out the *M*'s final arc, bringing it back to end in a curl, the two horizontal lines bowed to create a slightly pinched effect. (See line 2, *Plate 98*, for a variation of this.) For examples of stretched *M*, *S* and *T*, see *Plate 98*. *H* was similarly stretched, and *E* extended by lengthening its cross-stroke. The remaining examples (*Anglo-Saxon Majuscule*) indicate a *tall-E*'s versatility in ligatures with *G, R, N, M* and *T*.

CHARACTERISTICS: This was a bold script with strong lines and fully rounded curves, lettered with the point generally horizontal or at no more than 20 degrees. At its calligraphic best, as in the *Book of Kells*, no effort was too great to achieve perfection. Serifs were formed in the least functional but best controlled manner; minim strokes were broadened at the base with overlapping strokes; arrows marking horizontal strokes were first outlined with the corner of the point and then filled in; single-stroke curves were instead penned in two strokes; and a final reverse stroke overlapped thinning tails to broaden them gracefully as they reached out to touch adjacent letters. All these maneuvers are detailed on the ductus page. In lesser works some of the above were abandoned for convenience and others imitated less calligraphically with quickly-penned twists.

Insular Majuscule was an unusual creation in that it contained some letters we recognize as capitals (*N, P, R, Z*), others we recognize as lowercase (*a, b, d, e,* etc.), and among them many that could fit either category. Although obviously a majuscule script, nonetheless, blunted ascenders and descenders were everywhere evident, occurring in unlikely places (*N* and *R*). And several letters (*D, N, R, S, Z* for instance) had more than one form.

Unlike previous scripts, almost every opportunity was taken to link letters by a touch, and occasionally through ligatures (see *EG* ligature in *Plates 93* and *94*). Considerable space was left between lines, and when words required breaking at line ends, it was done between syllables; although, since the scribes' creativity was always at play, it was preferable to stretch the lettering (*Plate 94*) so as to avoid breaks.

CAPITAL LETTERS: Capital letters were usually text letters written larger and with the same pen. If a particularly large capital was used, the following and, occasionally, even the letter beyond that, were inked consecutively smaller in size, so that the range from capital to text size was stepped. When a standard-size capital was used, it might be exaggerated slightly, or if it normally involved a lefthand bow (*A, C, D, E, O, Q, T*) the bow might be pulled out to a point (*Plate 28*, line 2).

PUNCTUATION: Plate 91, line 5, contains a mid-minim-height dot serving as an ordinary stop. The same Plate, line 1, contains a formation of triple dots at the ending mark of a paragraph or chapter. This might also appear as a colon or a colon and dash. The semicolon existed in its modern form, but the comma was still represented by a diagonal slash.

FURTHER READING: The greatest number of color photographs of the finest example of *Insular Majuscule* of the Irish school are to be found in Henry's *The Book of Kells*, which also includes a number of examples of the script from other works. See also volumes of Lowe's *Codices Latini Antiquiores*, Morison's *Politics and Script*, and Thompson's *Introduction to Greek and Latin Palaeography*. For information on the history of the script, I suggest the Henry, Morison and Thompson books above, Anderson's *The Art of Written Forms*, John's *Latin Palaeography*, Lindsay's *Early Irish Minuscule Script*, and Ullman's *Ancient Writing and Its Influence*.

insular minuscule 6ᵗʰ c. on

Brief History

No sooner had the Irish scribes' *Insular Majuscule* evolved in the 6th century, than the Irish found a need for a less formal, more functional script for mundane paperwork of the day. Using the cursive elements of *Roman Half-Uncial*, they applied to them the same inventiveness that had resulted in their new majuscule script. The unique serifs created for the majuscule—although to some degree an encumbrance to speed to the scribe working in a minuscule script—were then applied to the minuscule which suggests that pride in their unique calligraphy influenced the scribes' direction. By the mid-6th century *Irish Minuscule* had achieved great popularity and was taught by the Irish monks who were establishing outposts in Scotland and Northern England from about 565 onward. The Anglo-Saxons copied their teachers, hence the gathering of *Irish Minuscule* and *Anglo-Saxon Minuscule* under the general title *Insular Minuscule*. And by the mid-7th century it had been adopted throughout England. It had already, by then, been carried abroad by both Irish and Anglo-Saxon missions to Europe, ironically bringing a version of *Roman Half-Uncial* back into its original environment.

Insular Minuscule in Ireland and England continued to thrive. After a calligraphic reformation spread across Europe in the 9th century and, by the next century, crossed the Channel to England, Anglo-Saxon scribes abandoned *Insular Minuscule* for texts in Anglo-Saxon. With the Norman conquest in 1066 and the subsequent enforcement of Northern European tastes, calligraphic and otherwise, *Insular Minuscule*, by the end of the 11th century, became obsolete in England. Less influenced by Europe's innovation, the Irish nurtured their *Insular Minuscule* through the Middle Ages, and they retain it to this day as the script for Gaelic.

Plate 95. [Oxford, Bodleian Library, Ms. Bodley 426, folio 76 recto] This is in an Anglo-Saxon hand (probably Wessex), c. 800:

k•suscipe exoreilliuslegem siue edictum utalii dix erunt. & poneser quaepraecipit etconserua,,restituraberisiste factorutuoru k,sireuersus fueris ad omni potentem aedificaberis aliidix erunt peniteat; aedificaberis id est cotidie reparaberis, siue aedifica beris intem plum scm indno. siueincogitatione atq,scientiadipro fici endo aedificaberis necessariahaec adpaenitentia cohorta tioest. quopossint peccatores gloriamperditam reparare,,

Plate 96. [Oxford, Bodleian Library, Ms. Lat. Bibl. c.8(P), folio 105] A more striking Anglo-Saxon hand in southern England, c. 800:

que impium condemn abunt im
pietatis sin at eum quipec
cauit dignu uiderint plagis
prpernent et coram se faci
ent•uerberari promensura
peccatierit et plagarum mo
dum ita dum taxat ut quadra
gmariu numerum nonexcedant

Plate 97. [Oxford, Bodleian Library, Ms. Laud Misc. 442, folio 10 recto] Less than a half-century after the above examples, this Anglo-Saxon hand in Germany displayed considerable calligraphic care.

sereno, Credo finees samuel,helias. et petrus tardi fuerunt adiram,et tamen peccantes uel gladio ueluerbo pemert, Sed et moyses cu esset uir mi tissimus. exiuit apharaone. que incor rigibile, uidit iratus nimis cominatuseipaena

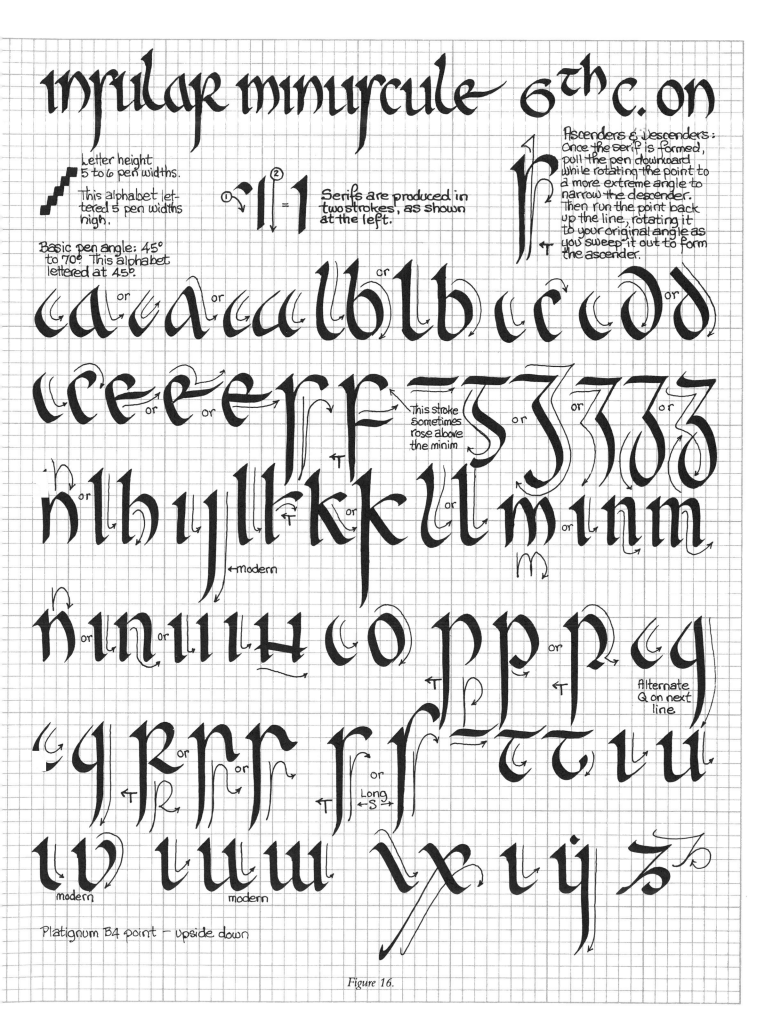

insular minuscule — 6th c. on

Letter height 5 to 6 pen widths.

This alphabet lettered 5 pen widths high.

Basic pen angle: 45° to 70° This alphabet lettered at 45°.

Serifs are produced in two strokes, as shown at the left.

Ascenders & descenders: Once the serif is formed, pull the pen downward while rotating the point to a more extreme angle to narrow the descender. Then run the point back up the line, rotating it to your original angle as you sweep it out to form the ascender.

or or or or or or

or or This stroke sometimes rose above the minim or or

←modern ←modern or or M m ininm

or or Alternate Q on next line

←T ←T or or Long ←S→ or

modern modern

Figure 16.

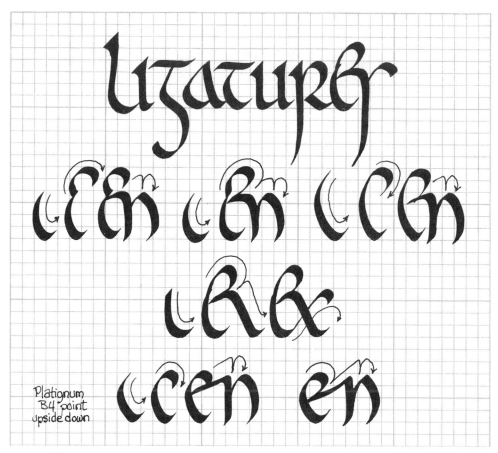

Platignum
B4 point
upside down

Figure 17. The most common ligature was the *tall-e* which links with *f, g, i, m, n, p, r, s, t, u, x, y*, and *z*. Had they existed in the script at that time, additional ligatured letters with *tall-e* would have been *j, v*, and *w*. Another possibility would be an *ed* ligature (*Plate 96*, bottom line), but this comes close to being no more than a touching of the two letters. Since this was a functional script intended for rapid writing, many letters in *Plates 95, 96, 97* and *98* touch their neighbors, but these do not qualify as ligatures. The ductus for the *tall-e* and *n* ligature is shown in three variations along with the ductus for *tall-e* and *x*, and two variations of *e* and *n*. The choice depends only on how many maneuvers you can make with your pen without stopping.

FORMAL MINUSCULE: In general terms, *Formal Minuscule* is an *Insular Minuscule* hand by a scribe familiar with the sophisticated calligraphic techniques of *Insular Majuscule*, and who cannot resist adding decorative touches to a functional script. This happened in varying degrees wholly dependent upon the whim of the scribe, his ability and available time. Letters with lefthand bows might have their bows distorted to points; descenders might be carefully delineated so that the descending and ascending overlapping strokes were separated; and any potential sweeping line was swept along with a passion. For examples of this application of *textura* qualities to *cursive* or *formata* lettering, see *Plate 98* and *Figure 19*.

Figure 18 (opposite). An experiment in exaggerating *Insular Minuscule* while giving it *Insular Majuscule* decoration.

Plate 98 (opposite). [Dublin, Trinity College, Ms. Book of Kells, Ms. 58 (A.1.6); *top*, folio 24 recto; *middle*, folio 25 verso; *bottom*, folio 23 verso] Adding majuscule embellishments to the minuscule script, an Irish scribe created his personal formal minuscule hand in the *Book of Kells*, c. 790–830:

Honore est inpatria est suaubi filium pegulisana

uit

paruit ei increbat eum● terpasce oues
& cumtertio manifertar& se ihs chscipulis &tat petro chcens
meas &sequere me
euntib;aduillam &apostolis &benedicens
eos ascendit in caelis

116

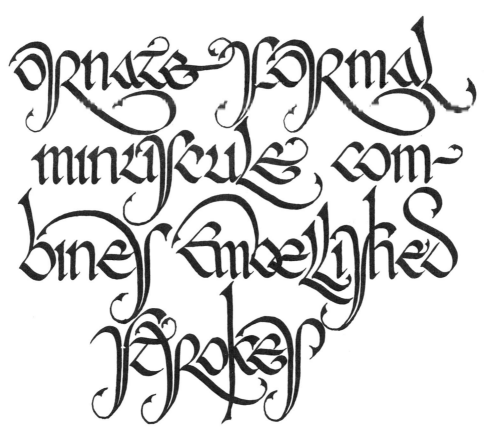

Figure 18.

CHARACTERISTICS: The cursive element is obvious in the extreme angle at which the pen was held (well beyond 45 degrees), and the length of the descenders. Unlike the extreme care taken in penning *Insular Majuscule*, particularly in the script of the *Book of Kells*, (where additional, reverse, and overlapping strokes accompanied point-corner work), *Insular Minuscule* was far hastier penned and less exacting. While it mirrored much of the majuscule style, at an angle, the great care of the majuscule was replaced by rapid pen twists. Indeed, in this script it is difficult to specify a basic pen angle because the pen seems to be turning constantly.

Descenders were probably executed in a single stroke, first descending and then returning over the same path, conveniently allowing the scribe to keep the point on the writing surface. A more calligraphic hand can be produced by lifting the point at the end of the down-stroke and setting it down again where the second stroke springs from the first. Another cursive aspect is the abundance of ligatures. *Plates 95* through *98* show the scope of the script; first a hasty, compact example; a perhaps equally calligraphically limited version but appealingly bold and dramatic; a fuller, more careful, graceful hand; and finally an ornate, ironically slowly produced and hardly cursive version. In all cases considerable space was left between lines, and words were broken between syllables at line endings.

CAPITAL LETTERS: Capital letters were usually produced with the same pen used for the text. For the shape of the capital the scribe merely enlarged a text letter and, in so doing, may have exaggerated it to a degree. One popular way, if the letter contained a lefthand bow, was to pull this out at its center to a point. Another was to give the letter as much sweep as possible to its curves, ascenders, or descenders. In short, add Formal Minuscule characteristics to the minuscule shape to give the letter importance.

PUNCTUATION: Because of the broad span of the script's life, the system of punctuation changed from time to time. For appropriate information on *Insular Minuscule* of the Irish and Anglo-Saxon versions up to the early 8th century, see punctuation under *Insular Majuscule*. For later centuries, see *Luxeuil Minuscule, Carolingian Minuscule,* and *Early Gothic.*

FURTHER READING: More examples of the script may be found in Temple's *Anglo-Saxon Manuscripts 900–1066,* Henry's *The Book of Kells,* Degering's *Lettering,* Morison's *Politics and Script,* Thompson's *Introduction to Greek and Latin Palaeography,* and volumes of Lowe's *Codices Latini Antiquiores.* Both Irish and Anglo-Saxon versions of *Insular Minuscule* are well represented in the above-mentioned books. For the history of the script, see the Henry, Morison and Thompson books above, as well as Anderson's *The Art of Written Forms,* John's *Latin Palaeography,* and Ullman's *Ancient Writing and Its Influence.*

Formal (Insular) Minuscule (Irish) is discussed very briefly and illustrated in several Plates in the Henry volume.

Luxeuil minuscule 7th and 8th centuries

Brief History

In the 6th and 7th centuries *Roman Half-Uncial*, used throughout Europe, was altered by the scribes in different areas of the Continent. To the *Roman Half-Uncial* base they added their own calligraphic inflections, which were influenced by the scripts being introduced by missions from Ireland and England. In some cases these elements were united and exaggerated to the point of unreadability and became sophisticated charter or court hands—complicated in their execution to suggest their great importance and to be safely indecipherable to unwelcome eyes. From these variations, sometimes predominantly from the sweeping complexity of the charter hands, scribes of each region evolved their own scripts known as *national hands.*

Shortly after 590 an Irish mission established a monastery at Luxeuil in eastern France, and introduced *Insular Majuscule* and the accompanying but as yet uncalligraphic *Insular Minuscule.* But due to an uncomfortable relationship between the Irish leadership of the monastery and the Burgundian sovereigns, the Irish influence was weakened. By 625 the Burgundian king's former secretary, who had earlier joined the monastery, reached a position of considerable influence—his effect upon Luxeuil's scriptorium being of most interest to us. The monk Agrestius probably was the one who introduced to the scriptorium the king's court hand, *Merovingian Charter Hand,* and the scribes soon simplified its complexity while retaining much of its cursive elements, and created *Luxeuil Minuscule,* probably Europe's first truly calligraphic minuscule script.

The earliest surviving example of *Luxeuil Minuscule* was written in 669. It reached its peak by 700 and was so much admired throughout France and beyond that its techniques were borrowed and employed in other regional scripts. As the monastery of Luxeuil grew, it sent out missions and established other monasteries. At one in Corbie, the script evolved into distinct *Corbie* variations. The unique style that was *Luxeuil Minuscule* disappeared well before 800.

Plate 99. [Verona, Biblioteca Capitolare, Ms. XL (38), folio 65 verso] An early 8th-century hand:

complissethieremias loquens;adpraehen derunteumsacerdotes•et prophetae etomnis populus dicens;mortemoriatur quarepropheta uitinnominedni; EcceInnebuladns uocemleuat•quiaobscuras mentessuperbientium directoprophetacorripuit;ecceaquarum Impetus eumprotenus operuit•quiaabinsurgentibus populis•et causasuaecorreptionis Instigatis•IpseInhieremiamcunctapertu lit quicorreptionisuerbamandauit;persemetipsum quoquedns Innebulauocemleuauit•quandopraesentem seetiamadsumptocor poreexhibens•multa suispersecutoribus•selfiguris enigmatum•

Plate 100. [Paris, Bibliothèque Nationale, Ms. Nouv. Acq. Lat. 2243, folio 1 verso] Another early 8th-century hand:

propinquamus Nequeenim tunc cuiusli bet animaInmerito terretur quandopostpu sillumhocInuenit quodlinaeternum muta renonpossit Consideramus quipp equoid uiamuitaepraesentis nequaquamsinecul patransirepotuimus Consideramus u etiam quinehocquidem sinealiquoreatu nostro est quodlaudabiliter gessimus siremo

Plate 101. [London, British Museum, Ms. Addit. 29972, folio 35 verso] A hand in the latter half of the 8th century: cem etartesuau sus dil genterfabricet Vasutileinco / uersatio nemuitae Reliquiasau temeiusoperisadprae / parationemescaeabutatur etreliquum horum quoid / adnullosusosfacit lignumcuruum tuer ticibusplenum / Sculpatdiligenter peruacui tatemsuam etperscienti / amartissuaefigure tillud etadsimiletilludimagini

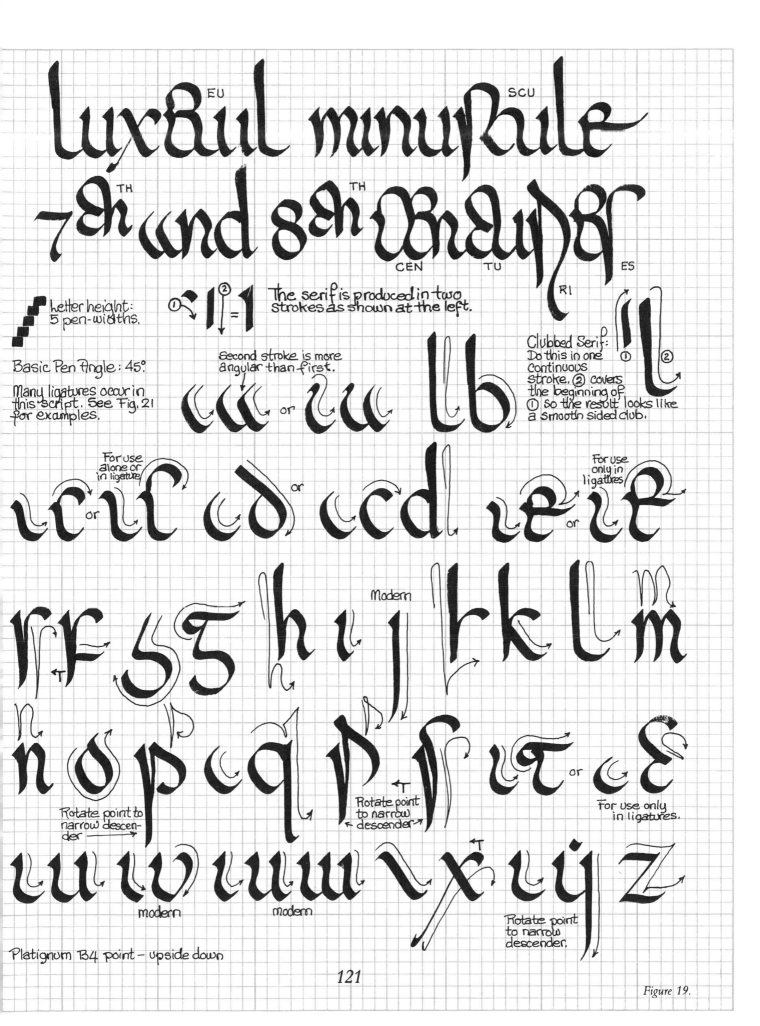

Figure 19.

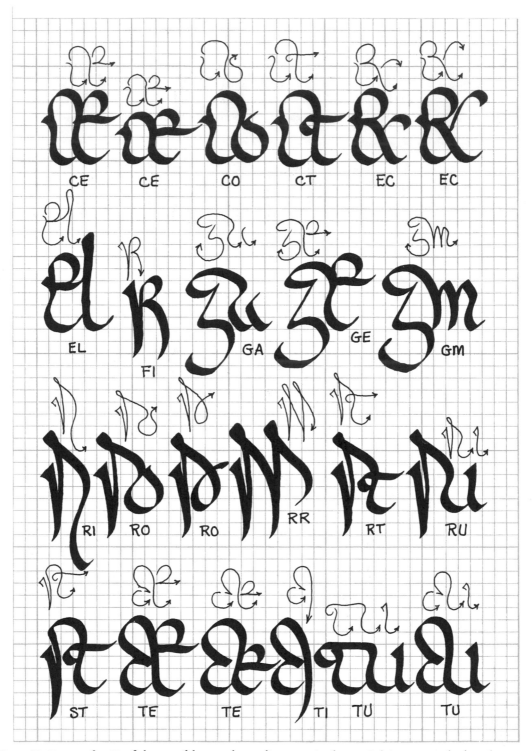

Figure 20. Ductus for 23 of the possible two-letter ligatures is above. Others are marked at the top of *Figure 19.*

LIGATURES: The cursive heritage of *Luxeuil Minuscule* is evident in its many ligatures. Increasing this number is the continuation from earlier scripts (*Insular Majuscule* for example) of linking *tall-e* to its next letter; the addition, new to this script, of *tall-c* for the same purpose; and a somewhat redesigned *t* capable of more flourishing ties.

Some double and triple ligatures are employed and marked in the two-line heading of *Figure 19*, and 23 others are shown in *Figure 20*. But they are by no means all the possibilities. Triple ligatures were not uncommon, but even though the possibility

offers itself, I would suggest resisting them and any number beyond that, for the script is strange enough to modern eyes even without ligatures. While the standard-size *e* could be as effective as *tall-e* in many ligatures, the taller would be the better choice, being more representative of the script's peculiar characteristics. In general, link any two letters when the first ends conveniently positioned to where the second begins. But use *o* as the first letter of a ligature sparingly and consider omitting the unusual *ri* and *ti* ligatures, since they would be incomprehensible to most readers.

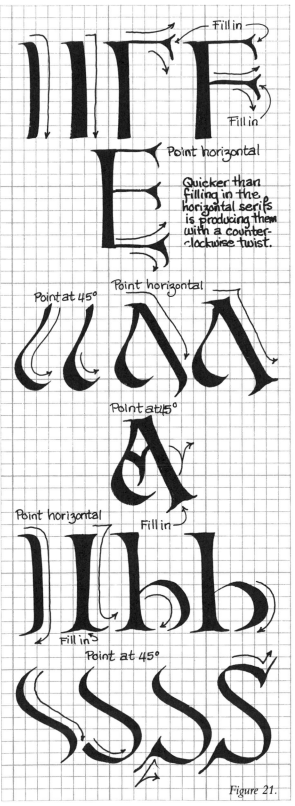

Figure 21.

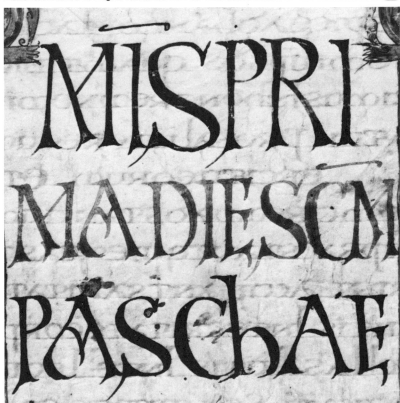

Plate 102. [From the top: Verona, Biblioteca Capitolare, Ms. XL (38), folio 65; Rome, Biblioteca Apostolica Vaticana, XL (38) Reg. Lat. 317, folio 169 verso; London, British Museum, Ms. Addit. 29972, folio 35 verso and folio 36 recto] The elaborate capitals of *Luxeuil Minuscule* were exaggerations of *Roman Square Capital* with an occasional minuscule form (as in the *h* in *PASCHAE*). Creativity was an important element: note the three cross-bar variations in *A* (line 2, top example). The first two examples above are early 8th century, and lower two are late 8th century.

123

CHARACTERISTICS: This script is an excellent example of strong cursive tendencies (long ascenders and descenders, multiplicity of curves, abundance of ligatures) with the inherited characteristics of a fine charter hand (compactness of letter forms, exaggeration of lines in order to be both dramatic and not universally legible). *Luxeuil Minuscule* was designed to be written rapidly, with the pen point held at about 45 degrees and the ratio of pen point width to letter height about 1 to 5, making the strokes slender and therefore allowing for the compactness without diminishing readability.

Because of the righthand minim strokes of *h, i, m, n,* and *u,* and similar turns in *a, small c, small e, t* and *y,* the pattern in a carefully written hand gave an appealing "wavy" character to a line of lettering. And the rotating of the pen while forming the descenders of *p, r, s* and *y,* and occasionally *f,* gave it more grace and prevented the script from appearing heavy-tailed. *Luxeuil Minuscule* contained numerous characteristics of earlier scripts: the clubbed ascenders and *g* of *Roman Half-Uncial;* the *d* and *q* of *Uncial;* the *q* and, to a degree, the *l* of *Insular Majuscule;* and a somewhat subdued and less calligraphic version of the wedged serifs of *Insular Minuscule.*

Words were sometimes separated; and at line endings were broken between syllables. What appeared to be a preponderance of the capital *I* or baseless *l* was actually the scribes' preference for a *long-i,* called *i-longa* by paleographers, in order to make *i* more easily recognizable.

CAPITAL LETTERS: Overlapping strokes, pen angle changes and the forming of drawn-out serifs are the characteristics in producing *Luxeuil Minuscule* capitals. Some examples are shown in *Figure 21,* and can be produced with the same point used for the text. Some of the exaggerated shaping of strokes and serifs can be accomplished with twist-pen strokes. Note in the example at the top of *Figure 21* that reduced-size capitals set inside or between other larger ones added to the design of the line and at the same time conserved space.

PUNCTUATION: A dot at mid-minim height indicated an ordinary stop. The end of a paragraph or chapter, however, would be marked more emphatically, with a series of dots (one variation being ∴), or by a colon or a colon followed by a dash. The comma, in the early days of the script, appeared as a dot level with the top of the minim stroke; but the comma was becoming known in its modern form and location in the latter days of the script (it was standard in the Carolingian era, the era which immediately follows *Luxeuil Minuscule*). Quotation marks had long since been established, as had the question mark.

FURTHER READING: Examples of this script can be found in Lowe's *Palaeographical Papers* and volumes of the *Codices Latini Antiquiores,* Morison's *Politics and Script,* and Thompson's *Introduction to Greek and Latin Palaeography.* For historical material on the script I suggest the above-mentioned volumes, as well as Anderson's *The Art of Written Forms,* John's *Latin Palaeography,* and Ullman's *Ancient Writing and Its Influence.*

carolingian minuscule
eighth to mid-twelfth centy

Brief History

In 800 Charlemagne, ruling France, Germany, half of Italy and areas of the Baltic, became Emperor of the West. While he was late to be educated and never did master spelling and writing, he was greatly concerned about the educational and religious advancement of his subjects. And he was supported in this by one of his numerous scholarly teachers, the Anglo-Saxon Benedictine monk Alcuin. An important early step was the establishment of a single script that would be recognizable through the empire, and that would be simple to write and easy to read. Neither Charlemagne nor Alcuin "invented" such a script. But they were familiar with the variations that surrounded them, particularly with the highly readable and easily written versions produced at the Corbie monastery, whose scriptorium was the most famous of its time. Corbie's scripts, and those similar to it, were generally termed *Littera Gallica*. One such variation was adopted by Charlemagne's court scriptorium, and thereafter became the official script to be used empire-wide; a script we call *Carolingian Minuscule*.

Employed in the production of classical texts, religious books and educational material, *Carolingian Minuscule* could as easily have gained eminence on its own. In the normal execution of *Carolingian Minuscule*, earlier scripts were used for capitals, headings, etc. Thus was saved not only much of the classical literature itself, but an indication of its appearance. *Carolingian Minuscule* created a true renaissance in calligraphy. It was adopted as a basic script far beyond the Empire's borders, being used for Latin work in England in the 10th century and for Anglo-Saxon material there after 1066. It became increasingly calligraphic, and its eminence declined in Europe during the 11th century and in England during the 12th century, as the Gothic era dawned.

125

Plate 103. [London, The British Museum, Ms. Harley 208, folio 87 verso] A 9th-century hand, perhaps Anglo-Saxon:

ualui urae excellentie pandere n erubesco ne
mini parcens qui minus ueritati testimoniu (pro)
fera. Vid&ur eni mihi nullu plus peccasse In
huius impi&atis facto qua custode illius scelera

ti ex cuius neglegentia tanta mala postea exhor
ta sut cu pace eoru dica qui has litteras legere
audiant. Iustius aestimo ee. illu cuius neglegen
tia ille reus lapsus e de uinculis eade pati uincu

Plate 104. [Oxford, Bodleian Library, Ms. Bodley 717, folio VI verso] A more calligraphic 12th-century Anglo-Saxon hand:

Virgo xpi Eustochiu transire ad ysaiam; Et qd sce ma
tri tue Paule du uiueret pollicitais su tibi reddere. Quod
quidem & eruditissimo uiro fri tuo Pammachio pmisis
se me memini; Cumq; in affectu par sis presentia. Itaq & tibi &
illip te reddo qd moneo. obediens xpi pceptis(qui) ait. scrutami

Plate 105. [Oxford, Bodleian Library, Ms. Bodley 717, folio 5 recto] Another skilled 12th-century Anglo-Saxon hand:

cipibus usq; adextrema plebem.a doctoribus usq; ad impitum uulgus / in nullo sit sanitas. sed oms impietati pari ordine consentiant. / A planta pedis usq; ad uertice. non est in eo sanitas. Win & liuor & plata tums. / Seruat coeptam transla-

tione. A pedib(us) usq; ad uertice id est ab imo / usq; ad summu. ab extremis usq; ad pmos toto confossi sunt corpore. / Vulnus inquit & liuor & plaga tumens. Aut em uerberib(us) liuent / corpora. aut plagis tument. aut hiant uulneribus. Querimus / cui hec tempori coaptanda sint. Post babylonia captiuitatem / sub zorobabel & esdra ac neemia isrl reuersus est in iudeam. & an

126

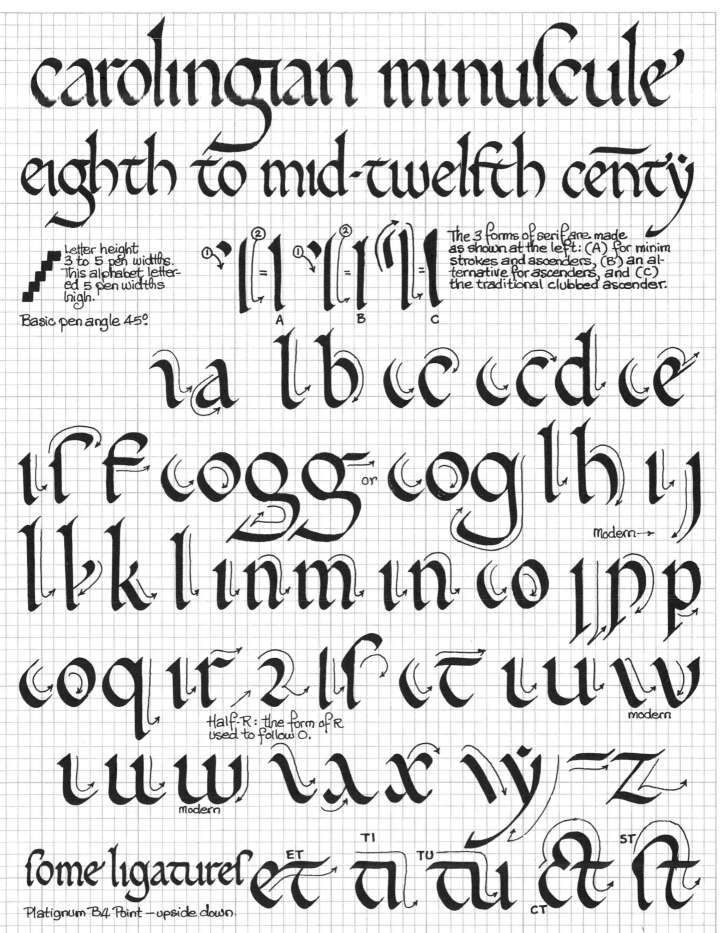

carolingian minuscule
eighth to mid-twelfth centy

Letter height 3 to 5 pen widths. This alphabet lettered 5 pen widths high.

Basic pen angle 45°.

The 3 forms of serif are made as shown at the left: (A) for minim strokes and ascenders, (B) an alternative for ascenders, and (C) the traditional clubbed ascender.

Modern→

Half-R: the form of R used to follow O.

modern

modern

some ligatures

Platignum B4 Point – upside down.

Figure 22.

CHARACTERISTICS: A cursive script intended to be readable but not time- or space-consuming, *Carolingian Minuscule* was a clear and relatively simple script with nicely rounded curves. Its clarity is due to a lack of ligatures but for *st, ct,* and *rt,* all of which are clearly decipherable; an attempt to keep letters separate; and a clear separation of individual words. The letters *t* and *e* were sometimes linked with others as a cursive convenience. The pen point was held at about 45 degrees. Although a cursive script, ascenders and descenders were curtailed, their length equal to that of the minim stroke. New to the alphabet was the lowercase *n,* except in cases where the old

NT ligature was used; and the appearance of a *half-r,* an *r* that followed *o* and whose minim stroke was omitted because the righthand side of *o* appeared to represent it.

Later use of this script, particularly in 12th-century England, showed the inevitable addition of calligraphic technique; compare *Plate 103* (9th century) with *Plates 104* and *105* (early 12th century). (NOTE: An odd technique I was shown in a manuscript at Cornell University illustrated that in penning *d* the scribe first penned an *o* and then overlapped it with the vertical stroke.)

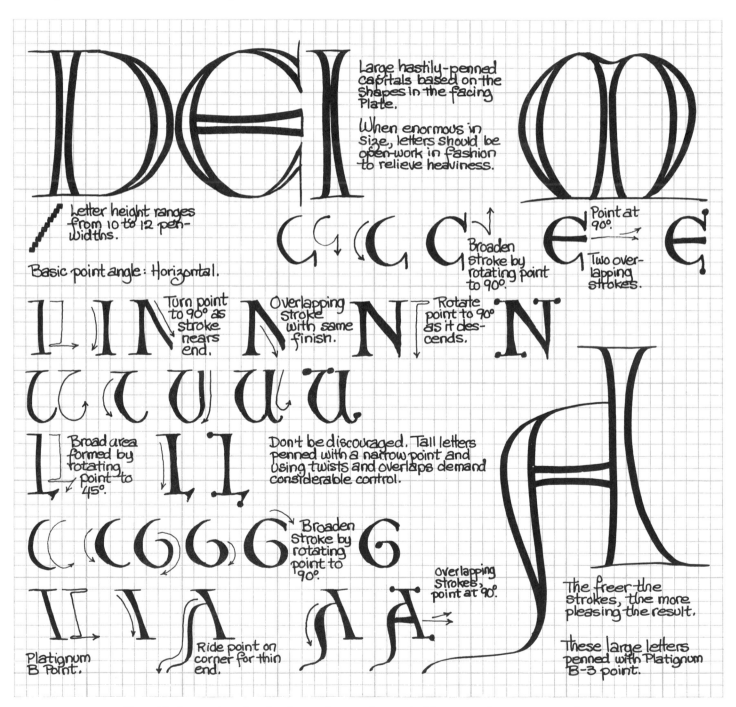

Figure 23. Suggestions for the ductus for penning capital letters as they appear in *Plate 106.*

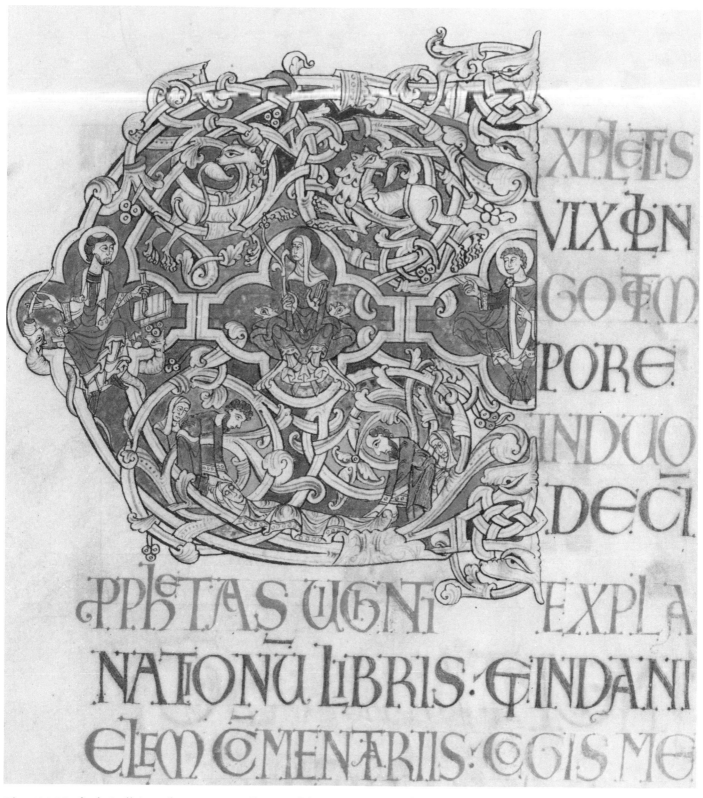

Plate 106. [Oxford, Bodleian Library, Ms. Bodley 717, folio VI verso] This is a detail of the page immediately above the text in *Plate 104.* The capital shapes are based both on *Roman Square Capital* and *Uncial.* The curl ending the bowl line of *P* (first letter, third line from the bottom) is not a *P* variation; the follow-through loop indicates that the *P* stood for *PRO,* the word being *PROPHETAS.* Still in evidence is the technique seen in the presentation of *Luxeuil Minuscule* capitals; some letters reduced in size and fitted either within other letter shapes or in the remaining space between two letters. Note the clear and calligraphically pleasing 12th-century Anglo-Saxon ampersand on the next-to-the-last line. The Latin *ET* for *and* is transformed into a single figure, with but one cross-bar serving both the *E* and *T.*

129

CAPITAL LETTERS: This script systematized the use of earlier script letters for its capitals, penned with the same point used for the text. In most cases a relatively simple capital was *Roman Rustic*, although *Roman Half-Uncial* and *Roman Square Capital* were also employed (the rule for which was appropriate would be unknown to modern viewers).

The capitals in *Plate 106*, however, are an extremely calligraphic version produced by building up the shapes with overlapping strokes. When capitals are so carefully "overworked" and over-sized, they are referred to as *display lettering,* sometimes considered a completely separate category. *Plate 106* shows the precursor of *versals* which accompanied later medieval scripts.

New to the family of capitals in this script was the *W* (line 3, *Plate 105*), an overlapping of two *V*'s (line 1, *Plate 104*).

LIGATURES: The most common ligatures were *st* and *ct*. Less frequent was the tying of *rt* and the old *NT*. The letters *e* and *t* occasionally tied to those following, but it was less a ligature than a convenient touching. Unlike some previous scripts, the letters of the ligatures of *Carolingian Minuscule* were clearly decipherable.

PUNCTUATION: The mid-minim-height dot served as an ordinary stop. But the colon or a colon followed by a dash was used to indicate a period at the end of a paragraph or chapter. The comma appeared as a comma, and punctuation included the modern form of question mark and quotation marks. Occasionally the periods and commas were seen at the minim base line; but raising them does give the line of lettering more flavor.

FURTHER READING: For the history of the script I suggest reading in Anderson's *The Art of Written Forms,* John's *Latin Palaeography,* Ker's *English Manuscripts in the Century After the Norman Conquest,* Morison's *Politics and Script,* and Ullman's *Ancient Writing and Its Influence.*

More examples of the script as it appeared both in Europe and England can be found in the above-mentioned Anderson, Ker and Morison volumes, as well as Alexander's *Norman Illumination at Mont St.*

Michel 966–1100, Bishop's *English Caroline Minuscule,* Huber's *Europe of the Invasions,* volumes of Lowe's *Codices Latini Antiquiores,* Temple's *Anglo-Saxon Manuscripts 900–1066,* Thompson's *Introduction to Greek and Latin Palaeography,* and Van Moe's *The Decorated Letter.*

Temple's volume contains a less common example; an *RT* ligature in *Plate 264.* And I understand a paper is being prepared on the peculiarities in the Cornell University manuscript.

early gothic
eleventh & twelfth centuries

Brief History

It is difficult to be specific about the time at which *Early Gothic* was born and later died, because it was an interim script spanning *Carolingian Minuscule* and the Gothic *textura* scripts. The Carolingian script, an appealing, neat, rounded calligraphic form, went out of fashion in Europe while it was having an artistic heyday in England. Scribes were altering its features to give it the qualities we now label as *Early Gothic* while others were still penning it in its most sophisticated form.

In or after the 10th century, due to an increasing demand for manuscripts (universities would soon rise like spring clover across Europe) and by a better-educated public, *Carolingian Minuscule* was necessarily changing. The need for speed caused the brisk cutting of rounded shapes, and the demand for more text in less space required the compression of letters. This coincidentally produced an effect considered visually pleasing. The angularity of the individual letters and the density of letters to space, became appreciated for its artistic appeal. The calligraphic aspirations of scribes everywhere were activated, and experimentation resulted in further angularity and greater compression and density. During the 11th and 12th centuries throughout the Western world—each region's scribes progressing at their own pace—*Early Gothic* appeared first as a slight change and then a considerable departure from the original *Carolingian Minuscule*.

By the end of the 12th century *Early Gothic* had become so calligraphically embellished that angularity and compression could proceed no further. The resulting new style we now term *Gothic Textura Quadrata*, and its variation *Gothic Textura Prescisus vel sine Pedibus*. As the 13th century brought the blossoming of the Gothic textura scripts, all that was *Early Gothic* merely faded away.

Plate 107. [Baltimore, Walters Art Gallery, Ms. 10.18, folio 175]
A bold calligraphic Anglo-Saxon hand of the 12th century:

xpi IHV per uolunta omnib; qui inuocant
tem dei• & sostenes fr• nomen dni nri IHV xpi•
eccte dei que est chorin in omni loco ipsorum
thi• sanctificatis in xpo & nro• Cra uobis & pax
IHV uocatis scis• cum a deo patre nro & dno

Plate 108. [London, The British Museum, Ms. Harley 3038, folio
13 verso] A magnificently bold *Early Gothic* was penned by a
scribe in the English abbey of St. Mary at Buildwas in
Shropshire in 1176.

bet. & postea intellexerit
peccm suu. offeret hostia
dno. hyrcu de capris in
maculatu ponetq; manu
sua sup cap ei. Cuq; imola
uerit eu ilocu ubi solet
mactari holocaustu coram

Plate 109. [Oxford, Bodleian Library, Ms. Auct. E. Inf. 2, pg. 262]
Written at Winchester c. 1150–1200
(from Matthew 1:12–15). Points of
interest in this hand: the graceful *st*
ligature (line 1); ascenders' top-
heavy but visually pleasing trunks;
the heavy use of *versals* (the subject
of following pages); and the capital-
ization for the beginning of sen-
tences but not the beginning of
proper names: tione babylonis. Et
post transmigtio / ne babylonis.
iechonias gen salathiel. / Salathiel au
gen zorobabel.zorobabel au gen /
abiud. Abiud au gen eliachim:
eliachim au gen / azor. Azor au
genuit sadoch: sadoch au genuit /
achim. Achim aute genuit eliud. eli
ud aute genuit eleazar. Eleazar aut

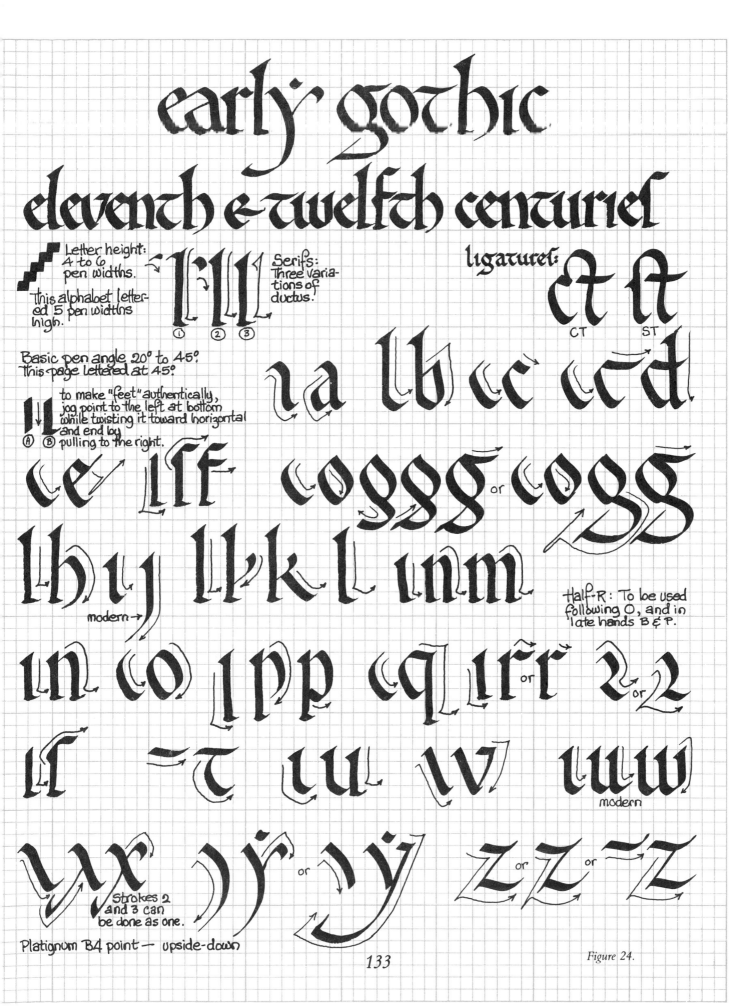

early gothic

eleventh & twelfth centuries

Letter height: 4 to 6 pen widths.

This alphabet lettered 5 pen widths high.

Serifs: Three variations of ductus.

ligatures: CT ST

Basic pen angle 20° to 45°. This page lettered at 45°.

to make "feet" authentically, jog point to the left at bottom while twisting it toward horizontal and end by pulling to the right.

Ⓐ Ⓑ

modern →

Half-R: To be used following O, and in late hands B & P.

modern

Strokes 2 and 3 can be done as one.

Platignum B4 point — upside-down

133

Figure 24.

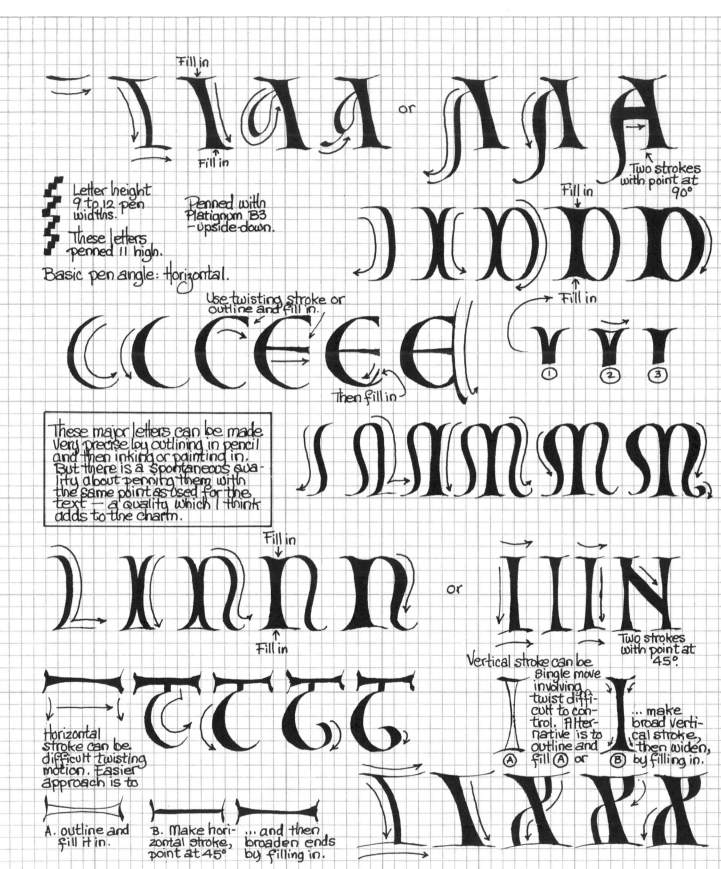

Letter height 9 to 12 pen widths.

These letters penned 11 high.

Basic pen angle: Horizontal.

Penned with Platignum B3 — upside-down.

Fill in

Fill in

or

Two strokes with point at 90°

Fill in

Use twisting stroke or outline and fill in.

Then fill in

①　②　③

These major letters can be made very precise by outlining in pencil and then inking or painting in. But there is a spontaneous quality about penning them with the same point as used for the text — a quality which I think adds to the charm.

Fill in

Fill in

or

Two strokes with point at 45°

Vertical stroke can be single move involving twist difficult to control. Alternative is to outline and fill Ⓐ or
Ⓐ
Ⓑ ...make broad vertical stroke, then widen, by filling in.

Horizontal stroke can be difficult twisting motion. Easier approach is to

A. outline and fill it in.

B. Make horizontal stroke, point at 45°

...and then broaden ends by filling in.

Figure 25. Suggestions for the ductus of several capitals employed with *Early Gothic* hands. See *Plates 110* and *111*. See also *VERSALS* and *CAPITAL LETTERS* on page 136.

134

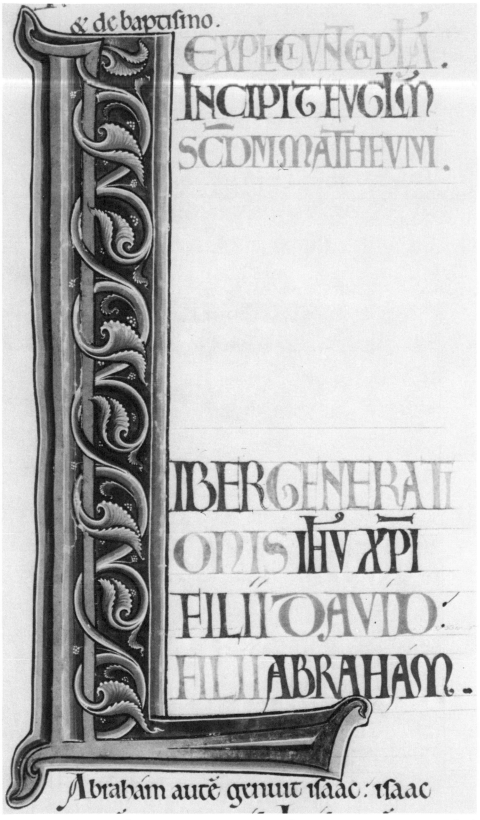

Plate 110. [Oxford, Bodleian Library, MS. Auct. E. Inf. 2, page 262] English capital-letter shapes of the second half of the 12th century include both *Roman Square Capital* and *Uncial* forms. Note the dual forms of *A, D, M, N,* and *T*. Some letters are fairly simple exaggerations created with overlapping strokes, while others (notably the *E*'s and *F*'s) have serifs that extend to create pockets of space. (See next page.)

Plate 111. [Oxford, Bodleian Library, MS. Douce 368, folio 54 recto] *Roman Square Capital* and *Uncial* forms intermingle in this set of versals from one of the finest Western English manuscripts, c. 1100–1150. Note the unusual versal *A* at the top and even less frequently seen *AE* ligature at the bottom. (See next page.)

CHARACTERISTICS: *Early Gothic* was basically an adaptation of *Carolingian Minuscule* in which letters became compacted in width by restricting their curves. This applied angles to and reduced the extent of the curves, giving the script a sharper, more jagged appearance while at the same time giving the entire page a more contrasting appearance because the lettering was compressed.

The script was still cursive—the pen held at 20 to 45 degrees. The end of many minim strokes ended in a sharp upward flick of the pen as it sped to its next working position. (Some English scribes went to considerable care with clockwise twists to make some minim strokes end flat; hallmark of what may have been the elder of the two classic Gothic scripts to appear shortly.) *Early Gothic* quickly acquired *formata* techniques as the angles of the strokes and the impact of the page gained appeal among the more talented scribes.

The Carolingian *half-r*, employed only following *o*, began following other letters with righthand bows. The more modern appearance of *s* (as opposed to *long-s*) came back into fashion, although only at the end of words; and the *Uncial* form of *d* returned to use. The letter *g* approached an 8-shaped figure; the left leg of *x* swung below the minim and beneath the preceding letter; when *t* ended a word, it acquired a downward flick of the pen at the end of the cross-stroke; and *ii*, to avoid confusion, was penned *ij*. All of these changes in the script's evolution cannot be found in a single example, since the script matured at different times and at a different pace in the scriptoria of Europe and England.

PUNCTUATION: In general you would not be amiss to use all forms of modern punctuation in writing in *Early Gothic*, but an antique flavor would be added to your hand by penning periods and commas at mid-minim height. And the question mark's curve should be angled to conform to the script's style.

LIGATURES: *Early Gothic* spelled the end in general to *ct* and *et* ligatures, although one is found, for instance, in line 7, *Plate 108*. The *st* ligature remained in fashion (line 2, *Plate 107*, and line 1, *Plate 109*. Yet to become a ligature called *conjoining*, a specific characteristic of this script was the butting of letters with adjacent bows, such as *be, bo, od, og, oo, pe* (line 2, *Plate 108*), *po*, etc. If not butted, only the slightest space would be allowed between such combinations.

CAPITAL LETTERS: In most cases capital letters were produced with the same pen as used for the text. Simple capitals might be nothing more than large *Roman Rustic* or *Roman Square Capital* forms. For more dramatic effect either these two styles or *Uncial* would be called upon for the highly exaggerated capital letter versions then becoming established as versals.

VERSALS: With the advent of this script, capital letters became rounded, their curves swelling, their straight strokes slimming at the middle, and their serifs extending to enclose the surrounding spaces (making them part of the letter design). This technique produced capitals thereafter called versals, which were used interchangeably during this period with somewhat simpler capitals. See *CAPITAL LETTERS* above, and additional versals with the scripts of following pages. When used a few letters at a time or in writing a lengthy statement (in *Plate 110*) the letters are termed *Display Lettering*.

FURTHER READING: Information on the history of the script will be found in Anderson's *The Art of Written Forms,* John's *Latin Palaeography,* Ker's *English Manuscripts in the Century After the Norman Conquest,* Morison's *Politics and Script,* and Ullman's *Ancient Writing and Its Influence.* Additional examples of the script appear in the above-mentioned Ker and Morison books, as well as in Berkowitz's *In Remembrance of Creation,* Branner's *Manuscript Painting in Paris During the Reign of St. Louis—A Study of Styles,* Miner's *Two Thousand Years of Calligraphy,* Thomson's *Latin Bookhands of the Later Middle Ages 1100–1500,* and Thompson's *Introduction to Greek and Latin Palaeography.*

gothic textura quadrata
thirteenth, fourteenth, & fifteenth centuries

Brief History

In the Carolingian script the shape of the individual letter was distinct from its neighbors and the readability of the letter was the scribe's goal. The script's transition in the 11th and 12th century as *Early Gothic* altered that considerably. Angularity of line and compression of letters reduced their "independent" status, and the scribes began considering the word, not the letter, as the goal of fine design. The result of *Early Gothic's* evolution was a set of letters so severely angled and compressed that some at times became almost indistinguishable from others. Rather than avoid this, the scribes accentuated it: by making identical those strokes of the letters not absolutely necessary to their individual recognition, they could form letters into words of sophisticated repetitive patterns. So letters lost their individual importance to the visual impact of the word as a whole, produced so calligraphically that the words appeared as a woven pattern (or in Latin, *textura*). The angularity of strokes, particularly the turned base of the vertical strokes, resulted in "feet" or diamond shapes.

Gothic Textura Quadrata became extremely popular in the 13th century and remained so for the duration of the medieval era. Difficult to decipher with modern eyes, its great popularity suggests that it was certainly approved of and highly readable to the people of its time. With the advent of printing in the mid-15th century, the script became a model for the first typefaces—resulting in the public's continued familiarity with it in printed books well into the Renaissance, while the scribes themselves had, for the most part, abandoned the script and its monumental calligraphic restrictions in favor of simpler Renaissance scripts—ironically based on the same *Carolingian Minuscule* that had led to *Early Gothic* and then *Gothic Textura Quadrata.*

remitte peccata:
ut nullis a te ini
quitatibus sepa
rati tibi domino
semper ualeant
adherere. Per.

um gemitibus.
et cunctorum
medere uulnerib(us);
alienus auenia.
Per xpm.

Plate 112. [The Hague, Koninklijke Bibliotheek, Ms. 78.D.40, folio 124 recto] From a missal written in Amiens, 1323.

Plate 113. [Author's collection] A well-controlled French hand from a prayer book, c. 1450:

ihesu propter nomen tuum
salua me ne peream. et qui
plasmasti me redemisti me
ne permittas me dampnari
quem tu ex nichilo creasti
o bone ihesu ne perdat me ini
quitas mea. ergo te pijssie

Plate 114. [Cambridge, Magdalene College, Ms. 2981] This well-formed set of lowercase letters, unfortunately trimmed hundreds of years ago, contains a well-lettered alphabet of English origin c. 1400. Note the fine hairline work; the *half-r* and *long-s;* an indication that the *y* was still dotted; an example of ligatured *est;* a mark predating the use of dots over *i*'s (end of line 5); the height of capitals in relation to lowercase letters (*C* on line 5). The last three lines read: amen. Confitemini / domino quoniam bon(us) / qm in selm mia eius.

gothic textura quadrata
thirteenth, fourteenth & fifteenth centuries

Letter height can vary from 3 to 5 pen widths. This alphabet lettered 5 pen widths high.

Space between vertical strokes is one stroke, and between words is two strokes.

Each vertical stroke is actually 3 separate strokes.

Diamonds should line up perfectly

If diamonds touch at the top, this letter is an n; if at the bottom, a U. The difference can be almost undetectable.

Split ascender: After making the vertical stroke, place the point again at the start and slide it a fraction to the upper right to make a tiny projecting spur. With the ink that has just been deposited, take the corner of the point and pull the ink out to make the left spur.

Basic pen angle from 30° to 45°. This alphabet lettered at 45°.

A. Diamond clean if it is to be followed by another.
B. It can have a trailing flick if no stroke follows.
C. Ornamental version of B.

If you have good control, you can create the right spur by beginning the vertical stroke with the spur. That would probably be more authentic.

A B
A. Vertical stroke drops straight from the diagonal stroke.
B. Variation where pen slips to the left before descending.

The bottom diagonal stroke needs to be pulled further to the right for B, C, D, E, F, O, R, long-S, T, the right-hand base of the 2nd W, and X. In these letters, to maintain the overall pattern, the diamond has to be almost imperceptibly wider.

Half-r follows right-hand bows.

Conjoined letters

t can tie to following vertical.

ST ligature

Platignum B-4 Point – Upside down

139

Figure 26.

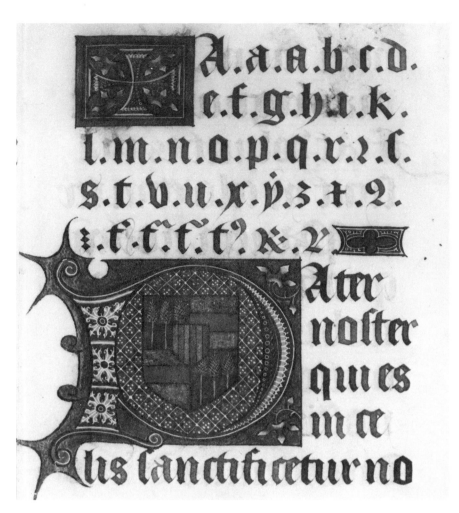

Plate 115. [Oxford, Bodleian Library, Ms. Rawl. Liturg. e.40, folio 40 recto] Written shortly after 1386, this sheet contains an alphabet (notice in particular the arrival of *v*), followed by an abbreviation for *et*, and abbreviation signs ending with the symbol for *rum*, and then a pater noster: Pater / noster / qui es / in ce- / lis sanctificetur no

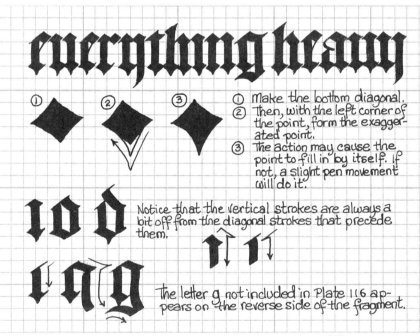

Figure 27. The most prominent characteristic of the hand in *Plate 116* is the drawn-out exaggeration of the points at the bottom of the diagonal strokes. Tiny flaws in the inking of diagonal strokes indicate that this was done with a filling-in motion (see, for instance, the *S* ending line 8, where the scribe forgot to fill in the point after outlining it, and the third letter of line 6, where another error occured). The drawn-out effect can also be produced with twist-pen maneuvering; penning the left half of the foot and the point with a counterclockwise stroke, and then completing the foot with an overlapping clockwise stroke. The power of this hand is emphasized by the compressing of lines and by the upper diamonds which always extend to the right of the vertical strokes. In other words, the maximum amount of text space was filled with ink.

CHARACTERISTICS: A textura script formed with the design of the entire word in mind rather than the shape of the individual letter, *Gothic Textura Quadrata* required considerable dexterity. While the pen point was held at approximately 30 to 45 degrees, speed was not a consideration. To create the uniformity of line desired, vertical strokes were separated by a space equal to the width of a stroke, and the space between words was the width of two vertical strokes. Care was taken, in emphasizing the uniformity, to have all the diagonal beginnings and endings of each vertical stroke appear to be at the same angle and in the same length. In this way the repetition of diagonal and vertical strokes gave the appearance of a picket fence. It aided the design as well if no sudden blank area appeared in a word, and for this reason a trailing line extended down into the blank area from the final stroke of *r* (one occasionally extended out from the center of *e* in some hands for the same purpose). To keep lines identical and to avoid gaps, it was therefore necessary to adjust the bottom diagonal in some letters. You should flatten the angle slightly when penning the bottom diagonal of *b, d, f, o, r, t, v* and *w*, in order to have the diagonal stroke extend a bit farther to the right. This is important because in *b, d, o, v* and *w* the letter does not conclude with a diagonal foot, and this leaves a noticeable gap if the diagonal is not stretched. In *f, r* and *t* the stretching is advisable so that the base of the letter extends as far to the right as does the upper stroke(s). For *c* and *e* this may not be necessary if you keep the upper stroke short.

The diagonal beginning of the vertical stroke usually was penned alone, the scribe lifting the point before making the vertical stroke. This is the best procedure. Some scribes merely halted and then proceeded with the vertical, never lifting the point. But the diagonal base stroke was always a wholly separate stroke.

The *half-r* followed every vowel (even though its appearance after *a, e,* and *i* seemed illogical), and any other convenient bows (*b, d, p*). The butting or near touching of adjacent bows first seen in *Early Gothic* became an overlapping of the bows in such combinations as *be, bo, po, og,* and *oc.* Done most accurately, both angular bows are inked, the second one fitting exactly over the first, so that the overlapped area is only one stroke in width.

The *g* finally closed its bottom loop, *w, y,* and *z* became standard letters early on; and *j* was added after 1400, bringing the alphabet to twenty-six letters. The letter *t* acquired a pointed top, *i* was distinguished by a curved flick of the pen which, in the 14th century, became a dot; and *Uncial d* (angularized, however) was customary.

Plate 116. [Opposite]. [Author's collection] This boldly exaggerated late 15th-century German hand is unfortunately a fragment. Note the scribe's unique space-saving ligature of *l* and *e* (bottom line):

n exicium	bera nos.
cat ad cor	fac ppter no
ns auxiliu	tuu: quom
emis proph	e sunt aduer
niquitates	snre. Tibi e
os?r conten	peccauimus
t contra nos;	tacio isrl: sal

CAPITAL LETTERS: While versals served as the grandest capitals, they were invariably done in color. A simpler but no less calligraphic capital, penned with the same point and ink used for the text, is shown in *Plate 117,* and its ductus given in *Figures 28* and *29.* Using the same approach as that for versals, these capitals were produced with overlapping strokes exaggerating curves, and applied "bulges" which added appropriate weight to vertical strokes; the whole filled with hairlines perhaps representing in simplified form the decorative filling of versals. (For versals see *Plates 118-125*).

What appears to be a double-*F* and other doubles in *Plate 117* was the Gothic form of capital. Gothic *textura* capitals varied from scribe to scribe, the selection on the following two pages representing the creativity of only one English calligrapher, c. 1400. The freedom in creation of capitals may be due to the fact that until now no script had had its own set of capitals but had either enlarged its own script or called upon the traditions of earlier scripts. So this was a new "field" and many variations were created.

HAIR-LINES: Depending upon the whim of the scribe, this script was additionally decorated with the corner of the pen point running the thinnest possible lines in sweeps extending the ends of some strokes. Examples are the *half-r* (line 2, *Plate 112*), *c, n,* and *p* (lines 1 and 2, *Plate 114*), and the *h*'s and *x* (*Plate 113*). Occasionally punctuation marks were also ornamented. Close examination of manuscripts shows that frequently the hair-lines were not executed as a final turn of a stroke, but were added later as a separate stroke. Use your own discretion regarding how many hairlines to cultivate in your hand, as there apparently was no rule to follow.

LIGATURES: The only familiar ligature remaining in this period was *st.* Less frequent was *tr.* While not ligatures by definition, conjoining appeared in many combinations (see *CHARACTERISTICS* above).

PUNCTUATION: In general, all modern punctuation would be appropriate. The question mark should have its curve angularized. And flavor would be added if periods and commas were set at mid-minim height.

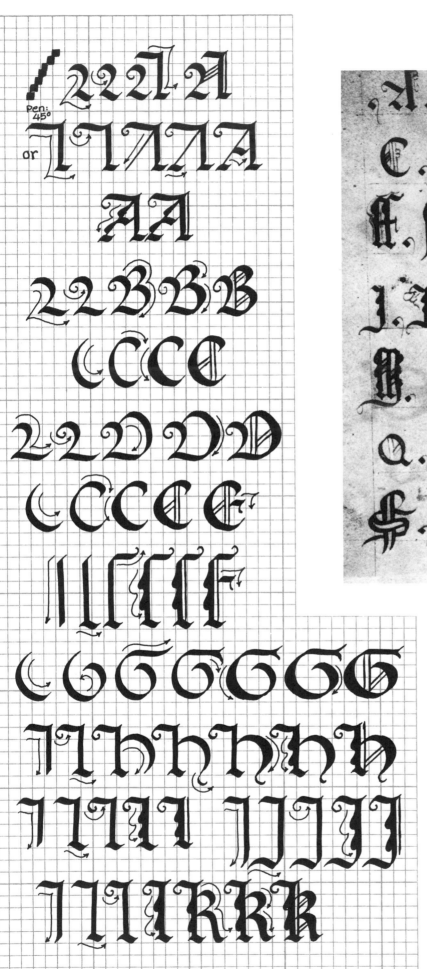

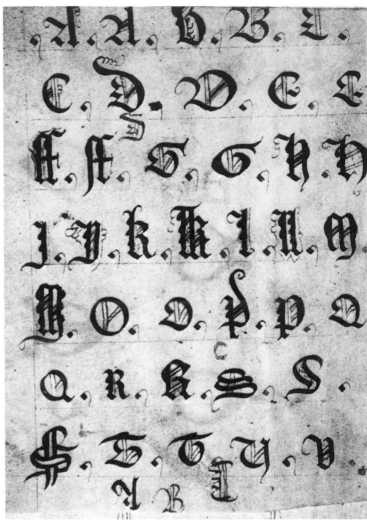

Plate 117. [Cambridge, Magdalene College, Ms. 2981] This unfortunately severly trimmed sheet, probably English c. 1400, displays an almost complete set of capitals intended for use with Gothic *textura* scripts. Variations created the need for repetition of letters.

Figures 28 & 29. The anonymous calligrapher of *Plate 117* suffered from an urge to quill, which his lack of precision could not stifle. He enthusiastically lettered out an incomplete alphabet of capitals in which three styles were scrambled. The two ductus sheets can be used to reconstruct his letters of one of the styles, but I have made some minor changes in the letter forms to try and make his embellishments uniform and, in a few cases, to make the letter more easily recognizable. The second *A* shown in *Figure 28* is based on an A from *Plate 129* (end of the third line from the bottom) since the *A* in *Plate 117* would be unrecognizable today. For the two additional styles see *Figure 30*.

Figure 28.

Figure 29.

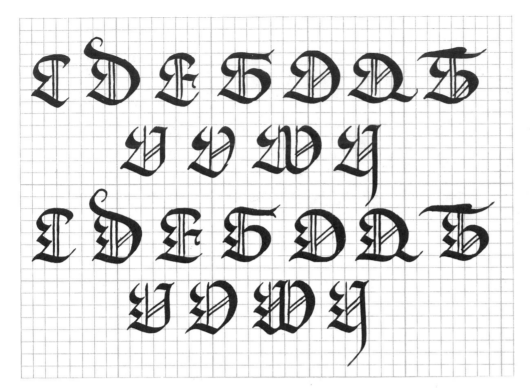

Figure 30. The calligrapher of *Plate 117* indicated two additional variations possible for the letters *C, D, E, G, O, Q, T, U, V, W,* and *Y.* The ductus would be similar to that shown in *Figures 28* and *29.* In *Plate 117* note that the scribe sometimes added overlapping strokes to strengthen letters with bows to the right and left, but he was not consistent. In one case, the second *O,* he did so with the bow at the base of the letter. Despite his example, a good general rule to follow is to add overlapping strokes to all large bows to the right or left, but never above or below (except for the top of *T*). Small bows, like those on the left sides of the letters here, should not be augmented.

Plates 118-121. [Cambridge, Magdalene College, Ms. 2981] Versals, probably by the same English scribe, c. 1400, who penned *Plates 114* and *117.*

Plate 120.

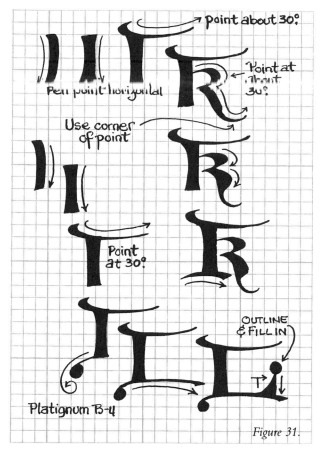

point about 30°.

Pen point horizontal

Point at about 30°.

Use corner of point

Point at 30°.

OUTLINE & FILL IN

Platignum B-4

Figure 31.

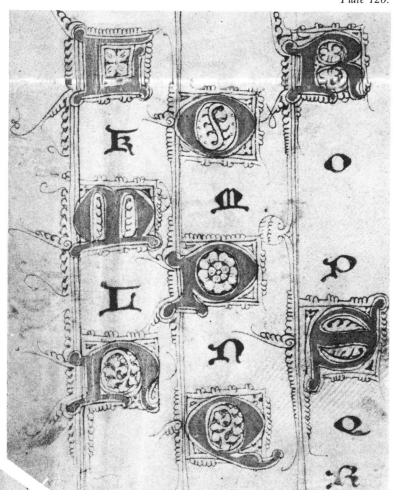

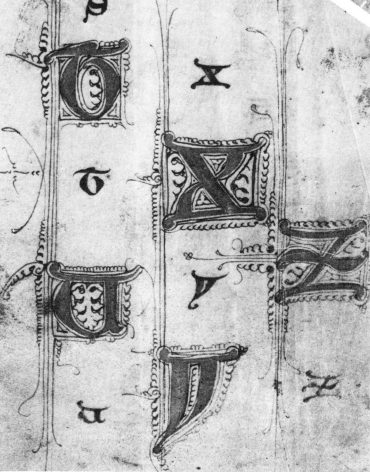

Plate 121.

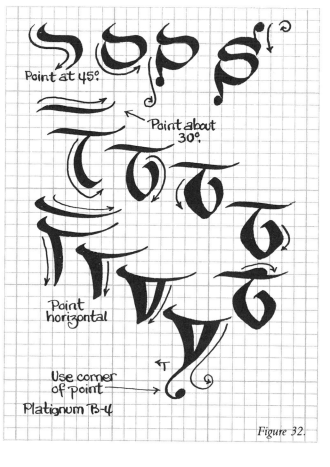

Point at 45°.

Point about 30°.

Point horizontal

Use corner of point

Platignum B-4

Figure 32.

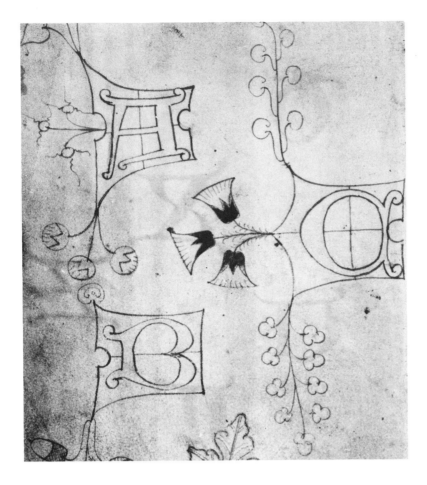

Plate 122. [Cambridge, Magdalene College, Ms. 2981] Here the scribe of the four previous Plates showed the preliminary outlining work involved in decorated versals. In this case his intention was to paint in the outlined letter. The alternative would have been to pen or paint the letter freely with overlapping strokes, and then add the surrounding decoration.

Plate 123. [Author's collection] This is an interesting example produced in Holland (perhaps Utrecht) c. 1480–90. On one page can be seen a standard capital (*P*, fourth line from the bottom), standard versals, and an elaborately decorated versal, its delicate lavender tracery flowing into and spreading in the margin. Among the versals is a somewhat rare sight—a *W* most calligraphically formed and at the same time displaying its obvious origin as double-*u* (see two pages further for demonstration of the ductus). The capital *P* and the versals *O, W,* and *A* are red; versals *B, D, G* and *I* are blue.

Plate 124. [Author's collection] A variety of red and blue versals by a scribe probably in France, c. 1490. Even in their necessarily small size, each is nonetheless distinct and graceful.

146

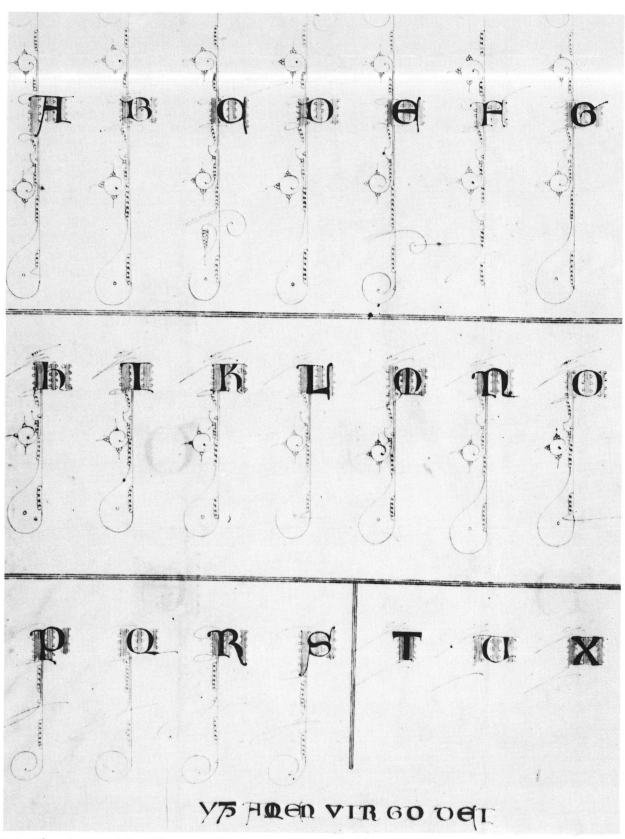

Plate 125. [Bloomington, Lilly Library, Ricketts MS. 240] Versals and their decorations in a display sheet dated August, 1450, by Guinifortus de Vicomerchato of Milan. While many versal forms are especially pleasing (*B, D, S* and *U* in particular), *T, X* and *G* are unfortunate, and the fine-line patterns inside and to the right of the versals appear to have been produced without any consideration for the individual letter shapes. Yet this is an interesting guide to versals and extended vertical designs of carefully produced decoration with graceful sweeping curves.

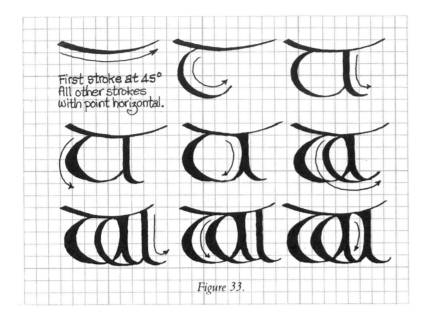

First stroke at 45°
All other strokes
with point horizontal.

Figure 33.

Figure 33. Ductus for the versal *W* in *Plate 123.* The medieval scribe's ductus is really not decipherable. I have here demonstrated the sequence I find most convenient, which involves setting down each *u* form one at a time. You may prefer to augment each stroke immediately after penning it. The scribe may have penned the single sweep across the top as the next-to-the-last or last stroke. With less scriptorium experience than he, I pen it first because it is the freest stroke and establishes the height and width of the letter. Once set down, the rest falls into place proportionately with relative ease.

FURTHER READING: For information on the history of the script I suggest Anderson's *The Art of Written Forms,* John's *Latin Palaeography* Morison's *Black-Letter Text* and *Politics and Script,* and Ullman's *Ancient Writing and Its Influence.*

For additional examples of the script see the above-mentioned Anderson and Morison volumes, as well as Branner's *Manuscript Painting in Paris During the Reign of St. Louis—A Study of Styles,* Degering's *Lettering,* Longnon's *The Tres Riches Heures of Jean, Duke of Berry,* Miner's *Two Thousand Years of Calligraphy,* Randall's *Images in the Margins of Gothic Manuscripts,* Thomas's *The Grandes Heures of Jean, Duke of Berry,* Thomson's *Latin Book Hands of the Later Middle Ages 1100–1500,* and Thompson's *Introduction to Greek and Latin Palaeography.*

gothic textura prescisus vel sine pedibus
thirteenth century and onward

Brief History

The result of continued exaggeration of *Early Gothic*'s basic design in the 11th and 12th centuries resulted in its evolving as a Gothic *textura* script; a script in which the design of the word took precedence over the individuality of the separate letters. Wherever practical, similar strokes of varied letters were made as nearly identical as possible to a point just short of making each letter itself unrecognizable.

The Gothic *textura* scripts became popular in the early 13th century in northern Europe and England. The English scribes were apparently responsible for creating and promoting a version in which many vertical strokes ended nearly or precisely flat. That is the one and only obvious factor distinguishing *Gothic Textura Prescisus vel sine Pedibus* from *Gothic Textura Quadrata*. Both versions were popular in England and northern Europe. The question of which came first does not seem to have concerned scholars to any great degree, but one theory is that *Gothic Textura Prescisus* originated in England, was copied in northern France and there inspired the creation of *Gothic Textura Quadrata.*

Gothic Textura Prescisus vel sine Pedibus, a calligraphic tour-de-force from its inception, diminished in popularity through the later Gothic period. With the arrival of the Renaissance and its new artistic concepts, the monumental script was doomed. While both variations were retained as typefaces, *Gothic Textura Quadrata* with its more severe *textura* quality (due to the repetitive close pattern of diagonal-stroke feet) held greater nostalgia as the most extreme example of that "archaic" period. *Gothic Textura Prescisus vel sine Pedibus,* both literally and figuratively without a foot to stand on, fell.

Plate 126. [Oxford, Bodleian Library, Ms. Douce 366, folio 64 recto] An East Anglian hand, c. 1300, from the *Ormesby Psalter* (from Psalms 44—45:14—18): fimbriis aureis: circumamicta uarietatib(us) / Adducentur regi uirgines post eam: proxi / me eius afferentur tibi / Afferentur in leticia (et) exultatione: adducen / tur in templum regis. / Pro patrib(us) tuis nati sunt tibi filii: consti / tues eos principes super omnem terram. / Memores erunt nominis tui domine: in om / ni generatione (et) generationem.

Plate 127. [Berlin, Staatsbibliothek Preussischer Kulturbesitz, Lat. 2°, folio 384 verso] A German writing-master's hand, c. 1400 (from Psalms 5:2—3): UErba mea auribus / percipe domine intel / lige clamorem meum / intende voci oracionis / mee:.

gothic textura prescisus
vel sine pedibus
thirteenth century and onward

This alphabet lettered at 45°.

First two lines penned 5 pen widths high, B4 pt.

Third line penned 5 pen widths high, B 3 point

Alphabet is 4 pen widths, with B4 pt.

1 2 3 A B C

1 2 3 A B

For the flat ascender, ① set the point down horizontally, then pivot it on the right corner to 45 degrees, ③ and make the vertical stroke at 45°. An alternative is to Ⓐ make the vertical stroke at 45°; Ⓑ place the point at the starting position to deposit ink and outline with the right corner of the point. Both are authentic, as are the two below.

For flat bases, ① finish the normal stroke, ② outline with the left corner of the point, and ③ fill in. Or, at the end of the stroke, Ⓐ pivot 45° on the left corner and, if you like, Ⓑ pull slightly to the right.

1 aa Lbb cc cd ce ff

ggg lh i j lk l mm m

co pp cq r 2 or 2 ss or ff
 Half-r Long s

t ui w uw x ij zz

gothic textura prescisus
vel sine pedibus
thirteenth century and onward

This alphabet lettered at 45°.

This alphabet lettered 4 pen-widths high.

Letters are set closer together:

Proper form for E in conjoining:

Ligatures cl and ti:

abcdefghijklmnopqrsstuvwxyz

Platignum B-3 point - upside down.

151

Figure 34.

CHARACTERISTICS: Because this script is much like *Gothic Textura Quadrata*, I suggest you refer to that script's *CHARACTERISTICS*. The only significant difference is the appearance of the bottom of many of the minim strokes—in this case finished without the addition of a diagonal stroke producing a diamond shape or "foot." *Plate 126* is a good example of the style. *Plate 127* is included because it is considerably more extreme in its passion for strong vertical strokes. Letters *a, c, d, e,* and *y,* which involve strokes that would normally not be considered vertical lines capable of having their "feet" omitted, are nonetheless produced that way, with the result that those letters seem to be almost abstract renderings.

To complement the flat-bottomed strokes, ascenders were penned with flat ends at the top. The technique for this and the flat bottom stroke are explained above the alphabet on the ductus sheet. Scribes often differed in their approach, choosing either a "fill-in" or two-stroke method. Looking closely at the ascender in the *b* of the first word in *Plate 127* you can see that the scribe chose the former method, because in his haste forgot to fill in the left-hand corner after outlining it.

Despite the heavy emphasis on horizontal-stroke beginnings and endings, the script was nonetheless penned with the point primarily held at 45 degrees.

[Many people admire *Gothic Textura Quadrata* as the most familiar example of medieval scripts and the one they feel represents the Middle Ages, century notwithstanding. At the same time they often find it difficult to read and are therefore hesitant to request its use. In such cases I would suggest offering them *Gothic Textura Prescisus vel sine Pedibus*. Although it is less familiar, it carries the same flavor and has the advantage of more easily recognizable letter shapes, thanks to the flat-footed strokes.]

NOTE: For *CAPITAL LETTERS, LIGA-TURES,* and *PUNCTUATION,* see those sections under *Gothic Textura Quadrata.*

FURTHER READING: Writings on the script are found in Anderson's *The Art of Written Forms,* John's *Latin Palaeography,* Morison's *Politics and Script* and *Black-Letter Text,* Thompson's *Introduction to Greek and Latin Palaeography,* and Ullman's *Ancient Writing and Its Influence.* Examples of the script will be found in the Morison and Thompson volumes mentioned above, as well as in Miner's *Two Thousand Years of Calligraphy,* and Randall's *Images in the Margins of Gothic Manuscripts.*

gothic littera bastarda
thirteenth century and onward

Brief History

When the evolution of *Early Gothic* reached the *textura* stage at the beginning of the 13th century, two variations resulted: *Gothic Textura Quadrata* and *Gothic Textura Prescisus vel sine Pedibus*. Both were extremely calligraphic and, while they did not necessarily require considerable space, they did take time to execute well, an unfortunate factor occurring in a period when the demand for textbooks and manuscripts was greater than at any other period in the Middle Ages. The need for a more functional script was therefore considerable. Cursive elements were taken in hand to simplify and more rapidly produce the intricate *textura* characteristics. Evidently in this case the functional script was intended as a copy of the *textura*. It was a new script, to be sure, but it never strayed far from its model. In fact, no sooner did it come into being than aspiring calligraphers produced versions so increasingly artistic that they approached *textura* in their own right.

Gothic Littera Bastarda (lowborn Gothic letters, i.e., not aspiring to nobility), in its lifetime of at least three centuries existed in more variations than can probably be catalogued and counted. So many scribes were at work in so many different tasks, free in this more liberated age to adjust the working scripts to suit their specific needs, that distinct variations can be found not only nationally and regionally but within individual cities and even in differing occupations within a given city. Their profusion, confusion, and their jagged-line imitation of the *textura* scripts, however, precluded their downfall. *Gothic Littera Bastarda, textura* or otherwise, took a secondary position as the simpler and more readable Renaissance script styles became popular.

153

Plate 128. [Oxford, Bodleian Library, Ms. Bodley 596, folio 2 recto] An English scribe's Bastard Secretary, c. 1415, with considerable skill:

Thanne seid Eue to Adam este, my lord I dye for / hungre. wolde god I myght dye or elles [that] I were / slayn of the forwhy for me is god wroth [with] the. / And thanne seide Adam; grete is in heuen and in / erthe his wrethe. Wher' it be for me or for the I note / And [then] seide Eue to Adam, my lord sle me [that] I may / be done away fro the face of god and fro the sight / of his aungeles. so that he may forgete to be wro- / the with the oure lord god [that] so that happely he / lede the in paradys. for why' for the cause of me [th]ou / art putte oute thereof. Thanne seide Adam [to] Eue / speke no more so. lest oure lord god sende his malisoun / vppon vs How myght it be that I myght myne / hoonde in my fleshe. [th]at is to sayne; how myght / it be [that] I shuld slee myne owen flesshe. But arise / go we and seche wher [with] for to lyue and ne stynt / we noght to seche They went and soght. but [they] / fonde noght. als thei hadde in paradys. Neuertheles

Plate 129. [Oxford, Bodleian Library, Ms. Rawl. G. 398, folio 49 recto] A beautiful English hand, c. 1450–75, in Bastard Anglicana. (Note: ff = capital F; line 10): ix Edmundus Holand Comes Kancie factus est admirallus Anglie qui cum / multitudine nauium in partib(us) Britannie videlicet in Insula de Briak appli / cuit et Castellum obsedit vbi in capite percussus cum quarello occubuit Hoc / anno fuit magnu gelu in Anglia et durauit per quindecim septianas. An / no terciodecimo moritur Iohnes Beaufort Comes Somersetie et Capitane(us) / Calesie Hoc eciam anno Dux Burgundie misit ambassiatores in Angliam / ad Regem supplicans (et) postulans auxilium contra Duce Aurelianensem. / Rex vero misit Comite de Arundell Gilbertum vinfravile Counte de Kyme / dum de Cobham et Iohnem Oldcastell (et) alios cum magna potestate ad / dictu Ducem Burgundie in Francian et apud Senclowe iuxta parisuis. / contra dictu Ducem Aurelianensem victoriam obtinuerunt. Anno / quartodecimo Rex iste infirmitate insanabili arreptus vicesimo die Maij / apud Westmonasteriu spiu exalauit et in ecclia xpi Cantuarie honorifice

154

gothic littera bastarda

thirteenth century and onward

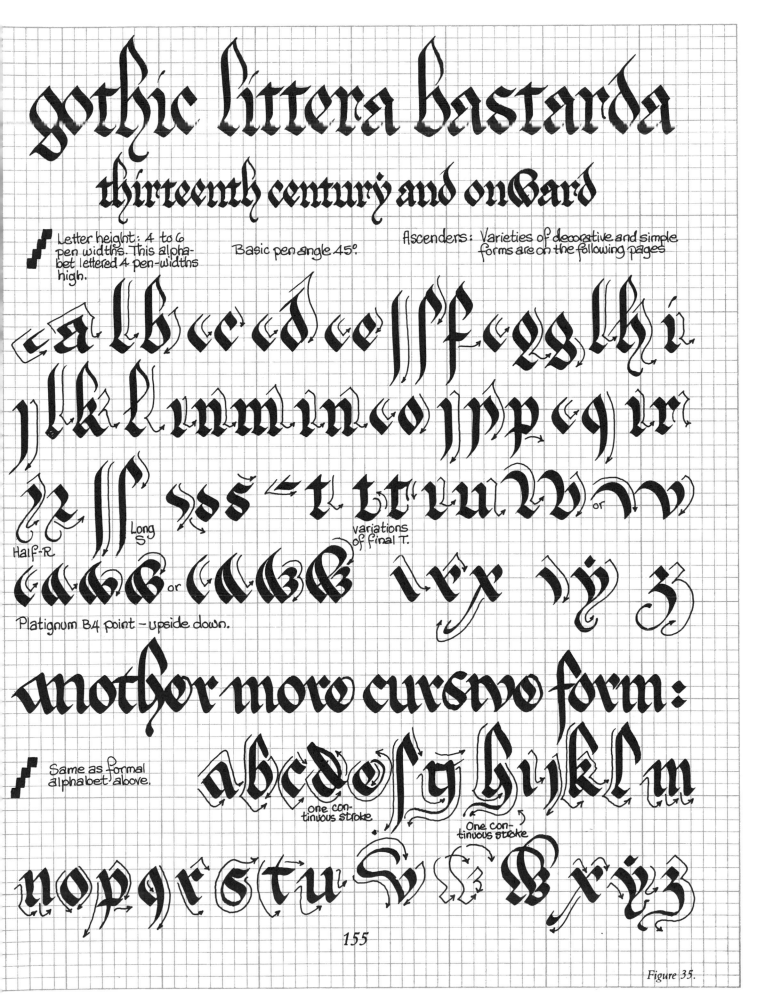

Letter height: 4 to 6 pen widths. This alphabet lettered 4 pen-widths high.

Basic pen angle 45°.

Ascenders: Varieties of decorative and simple forms are on the following pages

Half-R

Long S

variations of final T.

Platignum B4 point – upside down.

another more cursive form:

Same as formal alphabet above.

One continuous stroke

One continuous stroke

155

Figure 35.

Plates 130 & 131. [Munich, Bayerische Staatsbibliothek, Ms. Cod. Germ. 32, folio 22] Neatly written samples by German writing-master Benedictus Schwerczer of Passau, in 1466 [size approx.]: Dem allerdurich leuchttigtsten fuerstn vnd herrn hrn fridztchen / Romischen Kaysr Zu allen czeyten merer des Reichs Hertzogen / zu Osterreich ze Steir (etc.) Meinem allergnedigtsten lieben herrn

Plate 132. [Author's collection] A graceful hand from a French book of hours, c. 1520:

> rum Amen Pater noster.a.m. oro.lx.
> O suauis et fortis in potentia
> iesu christe qui omnem for
> titudinem tuam secundum huma
> ni corporis susceptionem pro sa
> lute nra in cruce misisti cogo te
> bone iesu vt concedas mihi gra
> tiam q(uod) fortitudinem meam vase
> am inte extendere et qs diu vixero
> inhoc mundo. corpore et corde tibi va
> seam seruice et sicut studiu placere
> mundo. ita nocte et die intendam
> et cogitem placere et seruice tibi do
> mino meo iesu christo Amen.pater
> noster Ave maria Oro.x.
> O Largitor omnium bonor
> iesu christe qui totum pre
> ciosum sanguinem tuum in cru
> ce effudi pro nostra saluatione

NOTE: Scribes writing in French *Bâtarde* had passion for a broad vertical stroke in forming *f* and *s*, occasionally so bold as to almost spoil the hand's visual appeal (although this facsimile does not suffer from such overindulgence). The bold *f* and *s* are formed with overlapping strokes.

Plate 133. [Oxford, Bodleian Library, Ms. Ashmole 789, folio 4 verso] More informal and cursive than the examples of the above plates is this English hand, c. 1450–1500. The scribe, possibly Ricardus Franciscus, penned a lowercase alphabet with some ligatures. For the capital letters that accompany it, see *Plate 137*.

Plate 134. [San Marino, The Huntington Library, Ms. El 26.c.9, folio 153 verso] Informal ascenders in the *Ellesmere Chaucer.* c. 1410.

Plate 135. [Berlin, Staatsbibliothek Preussischer Kulturbesitz, Lat. 2°, folio 384 verso] Decorative ascenders by vom Hagen, c. 1400.

See Plate 135

See Plate 134

Based on several Gothic variations.

Platignum B-3 point upside down

Based on the lettering of a Papal Bull of 1228.

Based on the lettering of an Antiphonary in France, 1290.

Based on late 15th Century styles.

Based on the lettering of a diploma in Germany, 1376.

Figure 36. See paragraph entitled *ASCENDERS/DESCENDERS* at the end of this section.

157

CAPITALS: The scripts within the general term *Gothic Littera Bastarda* varied from extremely *cursive* to markedly *formata*. In the three adjacent plates, the basic shape of the capitals was similar to the *textura* scripts' versals, translated into the angular form popular in the Gothic era. The major difference is in the degree of care (and consequently time) taken by the scribe. A *cursive Gothic Littera Bastarda* was served with equally *cursive* capitals. A more elegant version would employ more carefully and creatively produced capitals. And the most *formata* examples would be mirrored by the most impressive capitals (*Plates 141, 142 and 143*). Of particular interest are the capitals in *Plate 129* (and from this same manuscript, in *Plate 63*), where they are clearly much like the *textura* capitals of *Plate 117* (either the precursor or the later and simpler copy). Where *Gothic Littera Bastarda* virtually replaced the *textura* scripts as an elegant presentation hand, it might even be accompanied by the grand versals (*Plate 132*). The simple rule is: use a capital as fine as your script or better; never meaner.

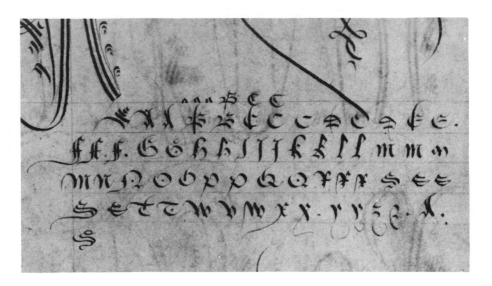

Plate 136. [Munich, Bayerische Staatsbibliothek, Ms. Cod. Germ. 32, folio 22] Informal capital letters penned by Benedictus Schwerczer of Passau in 1466 [size approximate].

Plate 137. (Above) [Oxford, Bodleian Library, Ms. Ashmole 789, folio 4 verso] A more calligraphic set of capitals, English, c. 1450–1500, was penned by the scribe of *Plate 133*.

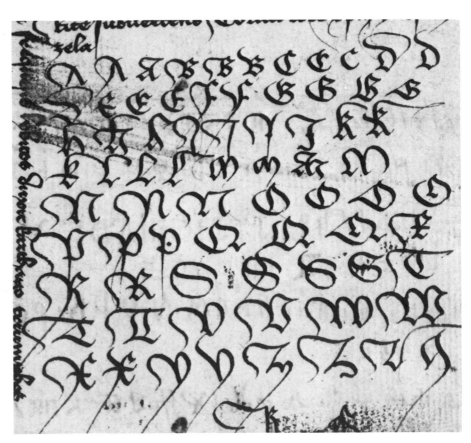

Plate 138. [Munich, Universitatsbibliothek München, Ms. 4°, 810, folio 41 recto] Extremely cursive capital letters by an unknown scribe of Munich in 1428.

The suggested ductus is purely arbitrary. In creating the one most productive for you, try to reduce it to the least number of strokes, penned quickly and easily, as this style tends towards the cursive.

These capitals penned 10 pen-widths high.

Basic pen angle: 45°.

Platignum B-3 point - upside down.

Figure 37.

159

Plate 139. [Oxford, Bodleian Library, Ms. Ashmole 764, folio 114 recto] An English hand, c. 1475–1500, penned this Cadel capital and balanced it with a similarly decorative ascender.

Plate 140. [Oxford, Bodleian Library, Ms. Ashmole 764, folio 100 verso] A Combination Cadel capital balanced by decorative ascender, by the scribe of *Plate 139.*

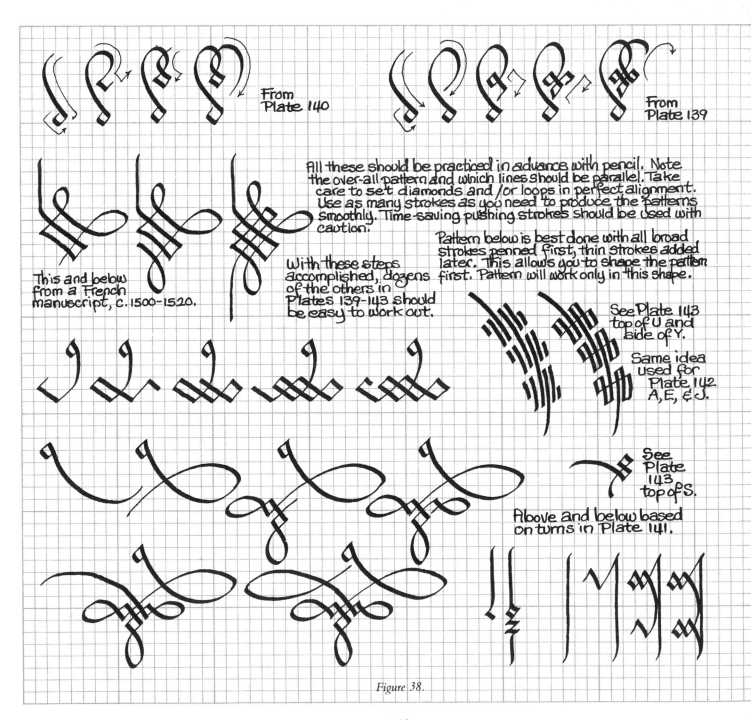

From Plate 140

From Plate 139

All these should be practiced in advance with pencil. Note the over-all pattern and which lines should be parallel. Take care to set diamonds and/or loops in perfect alignment. Use as many strokes as you need to produce the patterns smoothly. Time-saving pushing strokes should be used with caution.

This and below from a French manuscript, c. 1500–1520.

With these steps accomplished, dozens of the others in Plates 139–143 should be easy to work out.

Pattern below is best done with all broad strokes penned first, thin strokes added later. This allows you to shape the pattern first. Pattern will work only in this shape.

See Plate 143 top of U and side of Y.

Same idea used for Plate 142 A, E, & J.

See Plate 143 top of S.

Above and below based on turns in Plate 141.

Figure 38.

160

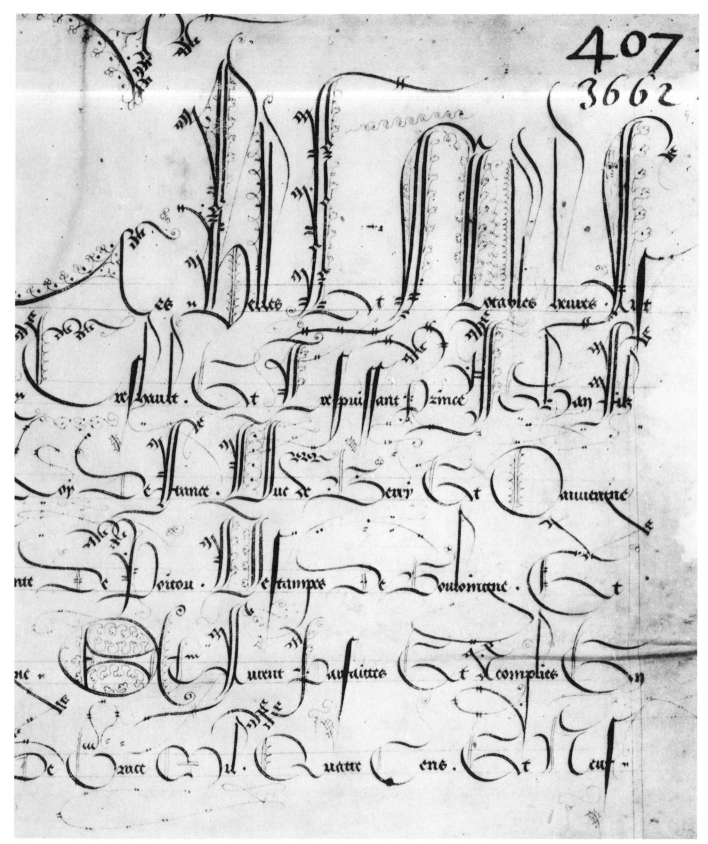

Plate 141. [Paris, Bibliothèque Nationale, Ms. Lat. 919 Frontispiece—ex-libris of Jean de Berry] This is the hand of the noted calligrapher Jean Flamel, secretary to the Duke de Berry, c. 1409.

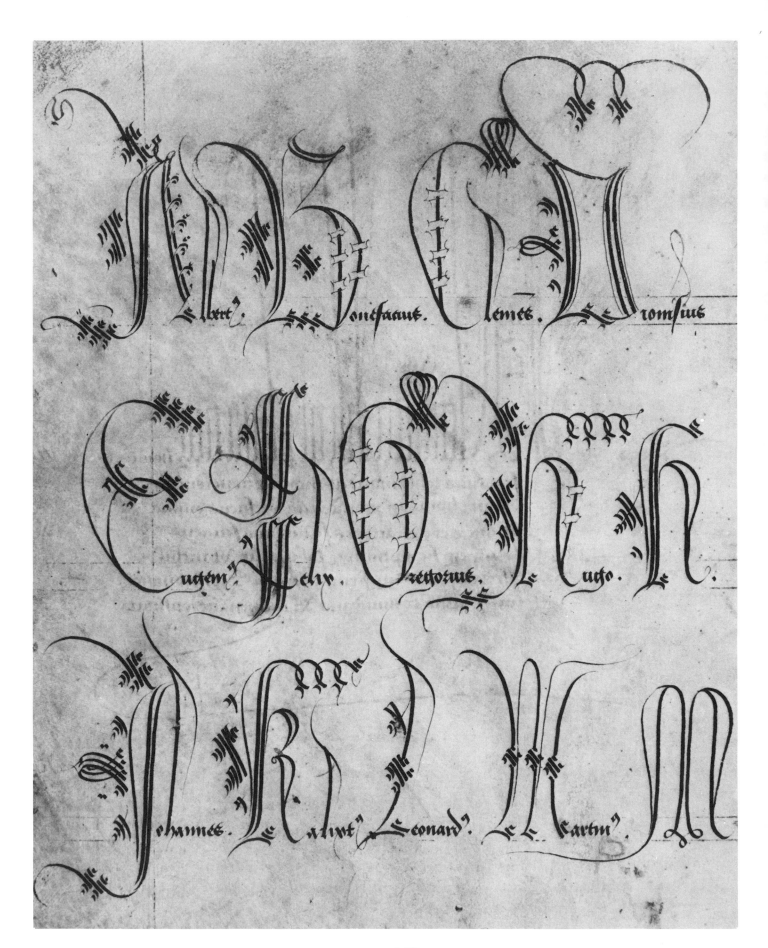

162

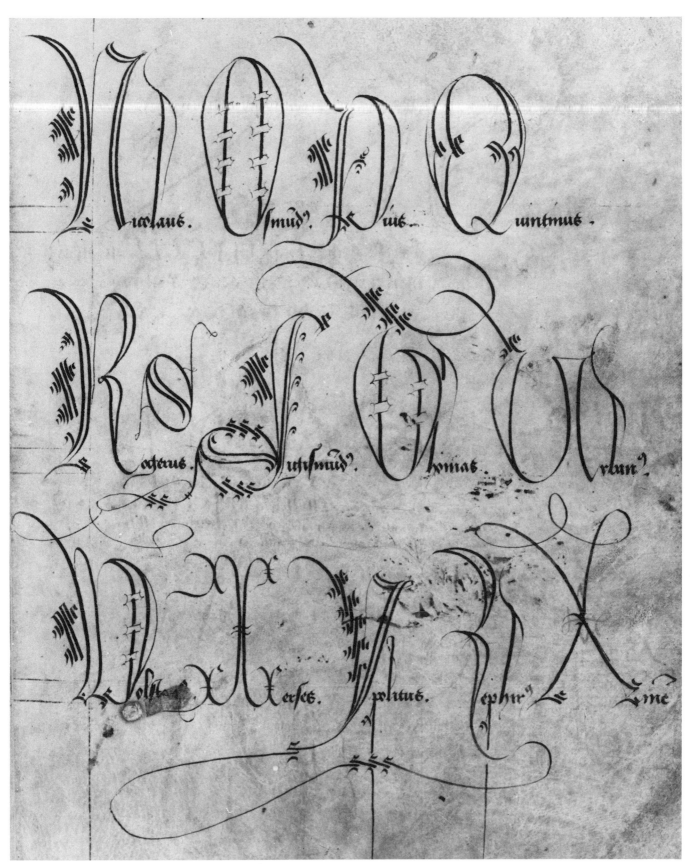

Plates 142 & 143. [Oxford, Bodleian Library, Ms. Ashmole 789, folios 3 verso and 4 recto] The English scribe, possibly Ricardus Franciscus, was expert in producing Cadel capitals; in this example, c. 1450–1500, he decorated an alphabetical list of first names.

CHARACTERISTICS: This is a difficult script to speak of concisely because within its general title lie many variations ranging from the almost *cursive* to those only slightly less ornate than the *textura* duo they were intended to functionally imitate. *Plates 128* and *129* are especially attractive examples. But in *Plate 128* you will discover both a *cursive* and *formata* version of *a*, and vertical strokes sometimes ending in carefully exaggerated feet, at other times with just a hasty flick at an angle. In *Plate 129* many letters are formal in construction, yet the *t* is not, and again there is a choice of vertical stroke endings. To imitate either hand is to mirror it; but to imitate either the more *cursive* or the more *formata* forms within either example results in a hand that mirrors neither. Limiting the discussion of characteristics to only these two hands creates a task.

In general, it can be said that bowed letters, for speed, regained their curves. Horizontal strokes' angled beginnings and concluding feet imitated the *textura* but were simplified by being executed in a single stroke, thereby becoming somewhat softened. Serifs and hair-lines, again for speed, were less exacting and more flamboyant. The more *cursive* form can be produced most easily simply by penning at a greater speed (once you have learned the few letter shapes that are distinctly different from those in the *formata* version). *Half-r* is used instead of *r* after every vowel and every righthand-bowed consonant. Conjoining is optional.

In this script a minimum of space is left between lines, words are clearly separated, and words at line endings break between syllables.

CONJOINS: The conjoins familiar to Gothic *textura* scripts were known and always used by scribes penning *Gothic Littera Bastarda*. An additional conjoin, only occasionally seen in the *textura* scripts (*Plate 112,* for instance), was that of a letter bowed to the right and followed by *a*. But this conjoin is preferable done with the form of *a* as in *Plate 141*, not the form used in *Plate 112*.

ASCENDERS/DESCENDERS: Decorative ascender and descender creativity varied from hand to hand and from *cursive* to highly calligraphic throughout the Gothic period. Ascenders were penned extremely tall when used in the uppermost line of text, to lend decoration to the upper page when given sufficient room. (This was often available because the text would begin with a giant capital or illuminated letter, and the text would never begin level with its top.)

The same general style would be followed with the bottom line of text by elongating the descenders to decorate space left at the bottom of the page.

Within the text-block itself, the scribe maintained the same general style of ascenders and descenders but simplified and/or bent them to fit the far smaller available vertical space. Several variations are shown in *Figure 36*. When penning ornate ascenders and descenders, mix the styles cautiously (see *Explicit, Figure 43* at book's end).

PUNCTUATION: In general, all modern punctuation would be appropriate. However, try to turn the punctuation to blend with the style of lettering, and raise commas and periods to mid-minim height for a more antique flavor.

LIGATURES: The only universally employed ligature during this period was *st*.

CADELS: The Cadel embellishment of woven patterns rests on the calligraphic trick of creating an appealing geometric pattern by drawing a single, constantly-direction-changing-line. The result used for capitals, aside from displaying the calligrapher's creative talent, adds weight and drama to what otherwise would be large, thin-lined, skeletal letters, Flamel himself (*Plate 141*) executed these legitimately. But other scribes often achieved the result without perfecting the technique. A Cadel pattern by another scribe may not prove true in origin because some lines were omitted or because, while it may appear perfect at first glance, testing shows a single line could not have created it.

The notations in *Figure 38* are based on embellishments in *Plates 139, 140, 142* and *143*, all appealing, some perfect, some not. These, and the examples in *Plate 141* and other Plates should help to give you a sizeable start in both the true and the illusionary directions. Don't feel obliged, by the way, to proceed through a Cadel pattern in a single path from beginning to end. Examination under a magnifying glass. of the work of scribes other than Flamel, shows that often the heavy strokes were penned first, placing the most noticeable elements in balanced position. The fine strokes were then added (often, sadly, amiss, occasionally extras added or some omitted). And an additional heavy stroke might be then added to correct the balance.

FURTHER READING: For historical information please see Anderson's *The Art of Written Forms,* John's *Latin Palaeography* [77], Morison's *Politics and Script,* Thompson's *Introduction to Greek and Latin Palaeography,* and Ullman's *Ancient Writing and Its Influence.*

For a full, extraordinary collection of examples from Europe and England, see Thomson's *Latin Book Hands of the Later Middle Ages 1100-1500.* For English history and examples there is no finer volume than Parkes's *English Cursive Book Hands 1250-1500.* An excellent display of 15th-century *Lettre Batarde* appears in Unterkircher's *King René's Book of Love.* And for additional examples of several variations, see the Morison and Thompson books mentioned above.

VII PAGE LAYOUT

The Plates in this book should be an adequate guide to the size in which the letters of various scripts were normally written, the width of the lines on which they were written, and the spacing allowed between lines. In order to include the scripts in their original sizes, it was necessary in most cases to show only a portion of a manuscript page instead of the page in full. And those shown full page may have been trimmed by binders. Therefore some additional information may be helpful when planning the layout of a page.

Medieval scribes had considerable calligraphic freedom within the confines of basic script designs. The same freedom is obvious in the measurements they chose for the *text-blocks* (area of the text itself) and the pages on which they were to be lettered. The variety was almost limitless, although some sizes were more popular than others. Considerable research [29, 35, 81] has been done into the proportions favored by specific scribes, and the scribes of a particular monastery, geographic region, or era. Within some general boundaries, it is safe to conclude that any measurements that appeal to your artistic eye would have been considered appropriate by your medieval predecessor. Consider these general boundaries:

Letter Spacing: Use the facsimiles as a guide. A single concept of spacing was generally universal within a given script.

Height of Letters: Again use the facsimiles as a guide. In the early Middle Ages the tendency ran to larger and taller letters. This was exaggerated in the display books of the late Middle Ages, but that period also brought into fashion small lettering. In general, feel free to write larger or smaller in size than the examples you have seen, but no more than one-and-a-half times the size of the examples and no less than half.

Widths of Lines: In general, the shorter the line and the fewer words upon it, the more appropriate. It is difficult to follow handwritten text that extends the full width of the page, particularly if the letters

are small. A considerable amount of text should be broken into two columns if that would help in being able to follow it more easily and clearly.

Spacing Between Lines:

Use the facsimiles as a guide. Consider whether the particular script entails numerous ascenders and descenders, which would need space so as not to collide, and how much space is needed so that the text will comfortably fill your text-block area.

Page Size:

Any page size would be appropriate, but a proper and pleasing proportion is a page depth one-and-a-half times that of the page width (proportion 3 : 2) or, as a variation, a proportion of 7 : 4½. The pages in *Figure 39* are measured in 3:2. In other words, a page 6 inches wide would be 9 inches deep; 8 inches wide, 12 inches deep, etc.

Text-Block Size:

This, too, can vary, but an appropriate starting point is to have the text-block depth identical to the page width. The text-block width will then depend on your figuring appropriate margins.

Upper and Lower Margins:

The most balanced arrangement of these margins is one in which the lower margin is twice the depth of the upper margin.

Left and Right Margins:

These may vary considerably depending on the specific width you need for the text-block. A good rule for these margins is that they should be larger than the upper margin and smaller than the lower margin. And they should be equal. This rule changes only in a double-page spread (see *Figure 39*), where the most balanced layout demands that the space between the two text-blocks be identical to the margins at the extreme right and left.

Double-columned Pages:

Here, without widening the text-block, simply divide it in two. The amount of dividing space you allow should be noticeably narrower than the margins to the right and left, and consideration should be given to whether you plan to have decorative tracery flowing down the narrow corridor or capital letters extending into it (see *Figure 39*). If you have a text that

can be divided, and it is something in which one portion can be lettered large in size and the other small in size, set the shorter, larger-lettered text within a framework formed by the longer, smaller-lettered portion (see *Figure 39*).

A variation of the above should be considered if you plan to write in *Roman Rustic, Uncial, Roman Half-Uncial, Insular Majuscule,* or *Insular Minuscule.* A study of 150 manuscripts produced through the beginning of the 6th century [52] indicated that a noticeable preference among scribes was that the text-block be square and divided into two columns of 13 or more lines each, the average number of lines being 25. Some sample measurements are given below in inches (width followed by depth) and centimeters (depth followed by width):

Text-block	Page
in inches:	
5 × 5	6¾ × 7½
6¼ × 6¼	6¾ × 9¼
7 × 7	10 × 11¾
8⅛ × 8⅛	10 × 11½
in centimeters:	
12.5 × 12.5	19.2 × 17.2
15.8 × 15.8	23.5 × 17.2
18 × 17.5	30 × 25
20.5 × 20.5	29 × 25.5

If you are aware of these general principles for proper page layouts, you can begin planning a page by knowing only the width or depth of the text planned or, conversely, by knowing what finished page size is most desirable. With either of these in mind, the rest, with a little figuring, can easily be worked out. In many cases you will find that something needs to be adjusted—the text needs an extra half-inch or the page cannot be precisely 3 : 2 or 7 : 4½. It's of no great concern. If it pleases your eye, it will no doubt please others'.

Figure 39. Some page layouts following the general principles stated in the text. (a) a single-column text-block, the same area divided (b) into a two-column block. (c) the same area redesigned to hold a short text (or title) in large letters, surrounded by commentary or text in smaller lettering. (d) in a double-page spread, side margins are adjusted so that the span between text-blocks is identical to the margin to the left and right.

A FEW WORKING HINTS

Letter out the text in pencil first in order to see what alterations you need to make so that it will fall comfortably into a proper text-block proportion.

For a finished page take a sheet larger than the size you plan and pencil in the borders of the full page and text-block. If when you are inking the text-block it runs deeper than you had planned, the larger sheet will allow you to move back the final page margins to suit the longer text-block.

It is a good idea to test the size of the text-block and to "warm up" both your hand and your memory of the script by first lettering the text in ink on a grid sheet. If you plan to do your finished work by placing the grid sheet beneath the finished sheet and tracing the text through it, pencil the horizontal lines on the finished sheet even though you can see the grid sheet lines through it. The thickness of the finished sheet blurs the image, which is often sufficient to make the *exact* position of the guidelines uncertain. You may not even realize this while you are doing the finished inking, but this tiny uncertainty will result in an obvious wobbling of the baseline of the letters when you stand back to admire your work.

And finally, the biggest problem of all: Since this is calligraphy, your eye and mind are on beautiful pen strokes. It is extremely easy to unwittingly see the strokes and not the letters. Even the best calligrapher will discover, while admiring his finished masterpiece, that a letter, a word, or even an entire line was omitted. It's an occupational hazard, and it *will* happen. Be prepared to laugh at yourself, even if through clenched teeth.

At this point . . .

By learning the ductus used by medieval scribes, by getting a practical feeling for *why* one ductus was used instead of another, you have begun to think like a medieval scribe. Now you should be able to examine any manuscript leaf, or even a good facsimile of it, and by knowledge and intuition discern how the scribe lettered it. When doubt arises, when a letter seems reluctant to reveal its ductus, look for an example of it done hurriedly or poorly, when the strokes involved do not mesh precisely and therefore reveal their independent forms. Look for places where converging lines create a heavier deposit of ink, so that you know whether strokes crossed or merely touched; and whether the pen slowed to turn (leaving more ink than normally).

Your horizons should not be limited to this book. You can, if hesitantly at first, approach any medieval script, any appealing medieval hand, and you will discover the scribe himself whispering the instructions to you from the sheet.

VIII WRITING MEDIEVAL NVMBERS

Tolle numerum omnibus rebus et omnia pereunt.

Take from all things their number, and all shall perish.

—Isidore of Seville, c. 600 [55]

Writing numbers appropriate to medieval scripts is not nearly as simple as 1, 2, 3. That is because 1, 2, 3, etc., are *arabic numerals* and were not familiar to Western scribes until the latter part of the Middle Ages. Even then they were a long way in evolution from being the figures we recognize as arabic today. We might think of them as being ancient—and they were—but not in Western culture. Surprisingly, it was not until the beginning of the 17th century that this form of numbering was in general use in England [17].

Arabic numerals were not Arabic in origin. What makes the system unique and convenient is the concept of zero, a multipurpose figure that Indian mathematicians invented in the 6th century [60]. The Arabs, in their dealings in India in the 8th century, brought home the zero [60]. Fascinated by mathematics, they soon became the finest mathematicians in the known world. Many Westerners tend to forget, or are unaware, that Middle Eastern cultures during the medieval era were often equal to, and not infrequently more advanced than, European cultures in terms of refinements in law, art, medicine, architecture, sophisticated corruption, and vice—all things we think of as suggesting civilized society.

Western scribes were introduced to arabic numerals in the 10th century, when the Arabs defeated and occupied what was to become Moorish Spain [60]. But their use by avant-garde

mathematicians in Christian Europe was highly individualistic [*Figure 40*]. While arabic numerals enjoyed a minimal popularity, the concept of zero was considered outrageous. Imagine a number that in itself meant nothing, but at the same time changed the value of any number it sat beside! In 999, for instance, Pope Sylvester II was acquainted with arabic numerals one through nine, but he rated zero on zero [82].

Westerners had their next major confrontation with Middle Eastern culture in the 12th and 13th centuries during the Crusades, and Western scribes became familiar with the more convenient numerical system and carried it back to Europe. Early in the 13th century Leonardo Fibonacci of Pisa wrote the first work on the advantages of using arabic numerals and the zero [82], but it was not until the beginning of the 15th century that they were generally in use in Europe [17] and 200 years later in England.

What Westerners had relied upon—and what should be used in calligraphy for authenticity and clarity—are *roman numerals,* some of which predate the Roman alphabet itself and, in some cases, originate with letter forms of the pre-Roman Greek alphabet.

The roman numeral system used the symbols *I, V, X, L, C, D,* and *M.* The first three symbols, earlier than the Roman alphabet itself and having no relationship to what were to become letters in those shapes, simply represented counting on one's fingers. The numbers are called *digits* for the Latin *digitus,* or finger [82]. The digit I represented one finger, and therefore II was two, III three, and IIII four. The V was an open hand, a thumb protruding in one direction, four fingers in the other—together representing five. And X was two open hands,

Figure 40. General appearance of arabic numerals in the West.[36] The numerals were occasionally reversed or turned 90 or 180 degrees. The zero occasionally appeared in modern form, or it was filled with a plus/minus sign, x, or diagonal stroke.

ROMAN NVMERALS IN MEDIEVAL TIMES

l	1	lx	60
ll	2	lxx	70
lll	3	lxxx	80
llll	4	xc	90
v	5	c	100
vl	6	cc	200
vll or lllx	7	ccc	300
vlll or llx	8	cccc	400
vllll	9	d	500
x	10	dc	600
xl	11	dcc	700
xll	12	dccc	800
xlll	13	dcccc	900
xllll	14	m or ī	1,000
xv	15	īī	2,000
xvl	16	īīī	3,000
xvll	17	īīīī	4,000
xvlll	18	v̄	5,000
xlx	19	x̄	10,000
xx	20	l̄	50,000
xxx	30	c̄ or ɯ̄	100,000
xl	40	d̄ or ʃʋ̄l	500,000
l	50	m̄ or ʃx̄l	1,000,000

Figure 41.

171

or ten. To tell an early Roman "I recognize your skill in reckoning," you would have said "*Novi digitos tuos,*" or "I know your fingers" [55]. Only later was a subtraction system employed, which, for instance, reduced the lengthy four digits representing IIII as four to a simpler IV, or one-less-than-five. The Romans were comfortable with both numbering systems simultaneously, even taking the later system to such lengths as representing eight as IIX, or two-less-than-ten [82].

The symbols *L, C, D,* and *M* came about with the establishment of the Roman alphabet about 700 B.C. Having acquired the Greek alphabet, the Romans used the Greek symbols that were of no alphabetical value to them as numerical symbols. The Greek *Chi* was used for 50 and, by the 2nd century, had become a symbol quite like the Roman *L.* It became confused with *L* and finally became *L.* The Greek *Theta* represented 100 but was lettered much like a *C,* and the Romans, beginning *centum* or 100 with a *C,* used it as a *C* for 100. The Greek *Phi,* used by the Romans for 1,000, was written as an O with a vertical line bisecting it. Taking half of it, the

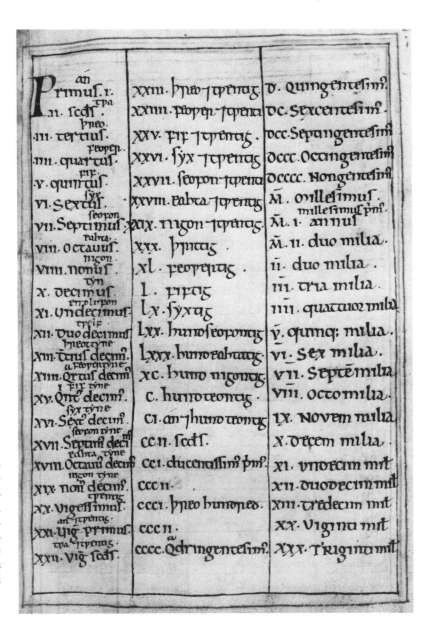

Plate 144. [Oxford, Bodleian Library, MS. Ashmole 328, p. 205] From the handbook, in 1011, of the monk Bryhtferth of Ramsey (Bridfertius Ramesiensis). A list of Roman numerals with the names in Latin and Anglo-Saxon (i.e., *fif, syx, seovon, . . . fiftyne, syxtyne, seofontyne, eahta tyne,* etc.). Also employed is the over-bar indicating 1,000 times the figure's value (i.e., $\overline{\text{I}}$ =1,000, $\overline{\text{V}}$ =5,000). Bryhtferth's notes contain occasional inexplicable omissions and additions.

shape D, they created a symbol for half 1,000, or 500. Since the bisected 1,000 figure bore a close resemblance to the Uncial letter M, and since M was the abbreviation for the Latin mille, or one thousand, that symbol early came into being. [82]

In the early Roman numbering the O-shaped symbol was relied upon to indicate numbers above 1,000. A second circle was placed within it for 10,000, a third for 100,000, and removing the lefthand side of the symbol indicated that it held half the value of the whole. But at that point the upward mobility ground to a creative halt. As Pliny observed, in the 1st Century A.D., "The ancient Romans had no number higher than a hundred thousand; hence even today these numbers are multiplied by saying ten times a hundred thousand, or the like." [76] Before the Middle Ages arrived, that symbol had either fallen into disuse or was considered only as an alternate choice. To reach 1,000,000 and beyond, and perhaps more important to simplify the unwieldy length of many far lower numbers, the Romans did not invent a new symbol but created two adapters with which to make the standard symbols more versatile.

They placed a horizontal bar (known as vinculum in early Rome and titulus in the Middle Ages) over a digit to symbolize that it represented 1,000 times its original figure [Figure 41 and Plates 144 and 145]. And they placed a gate and roof around a figure to symbolize that it was multiplied by 100,000. [55] Hence

$$X = 10 \qquad \overline{X} = 10,000 \qquad \lceil\overline{X}\rceil = 1,000,000$$

The superscript bar (meaning to multiply by 1,000) was primarily a medieval symbol. If you see it in early Roman numbers it more likely indicates that one should recognize the symbol as a number rather than as a letter of the alphabet [55].

Not surprisingly, arabic numerals were considered seriously as a replacement, although there was initial objection to such odd-shaped figures. Before their full acceptance, they could be found mixed with roman numerals. But once they attained general use—and this took well over a century—they caused the virtual demise of roman numerals.

For representing numbers in your work, use roman numerals for relatively low or short numbers. Keep in mind that in the Middle Ages, once lowercase letters had come into use,

1	x	c	$\bar{\imath}$	\bar{x}	\bar{c}
11	xx	cc	$\bar{\imath}\imath$	$\bar{x}x$	$\bar{c}c$
111	xxx	ccc	$\bar{\imath}\imath\imath$	$\bar{x}\imath x$	$\bar{c}cc$
1111	xl	cccc	$\bar{\imath}\imath\imath\imath$	$\bar{x}l$	$\bar{c}ccc$
v	l	ꝺ	\bar{v}	\bar{l}	$\bar{ꝺ}$
vi	lx	ꝺc	$\bar{v}\imath$	$\bar{l}x$	$\bar{ꝺ}c$
vii	lxx	ꝺcc	$\bar{v}\imath\imath$	$\bar{l}xx$	$\bar{ꝺ}cc$
viii	lxxx	ꝺccc	$\bar{v}\imath\imath\imath$	$\bar{l}xxx$	$\bar{ꝺ}ccc$
viiii	xc	ꝺcccc	$\bar{v}\imath\imath\imath\imath$	$\bar{x}c$	ꝺcccc ꞁ·ꝏ

Plate 145. [Oxford, Bodleian Library, MS. Ashmole 328, p. 240] Here Bryhtferth drew a multiplication table using the over-bar system (see Plate 144). To find the multiple of any number in the lefthand column and any number in the top row, find where that column and row intersect. The $\overline{\text{IM}}$ (bottom right) may be his "key" to the table, stating $\bar{1} = M$. The over-bar above the M apparently refers to the alternate use of that symbol, indicating that the M (which has not appeared before) was a number rather than a letter.

roman numerals were written in lowercase form. Since all of them were identical to letters of the alphabet, their form changed to lowercase alphabetical form. If your roman numeral is from the Gothic period, change the number *i* when it appears as the last digit, to *j*. This was done to confirm that it was the final digit, and to prevent falsification [55]. When a number in roman numerals is used within the text, begin and end it with a dot at mid–minim height to set it off from the text.

For higher numbers, if clarity is important, substitute modern arabic numerals but pen them in the style of the letter forms with which you are using them [*Figure 42*]. For dates, however, hold to the fine tradition still employed in some title pages, cornerstones, tombstones, and other things meant to leave a lasting impression: Letter them out fully in roman numerals.

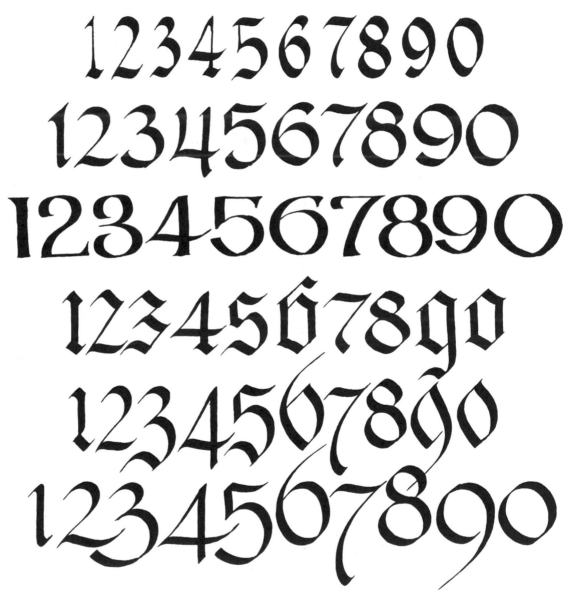

Figure 42. Modern arabic numerals adapted for use with medieval scripts. Top, for *Roman Rustic*. Second line, for *Uncial, Roman Half-Uncial, Insular Minuscule, Luxeuil Minuscule,* and *Carolingian Minuscule*. Third line, for *Insular Majuscule* and *Artificial Uncial*. Fourth line, for Gothic *textura* scripts and (with angles softened) for *Early Gothic*. Fifth line, for *Gothic Littera Bastarda*. Bottom, for today's scripts or any rounded flowing hand.

IX MATERIALS AND RESOURCES

Thin ink, bad vellum, difficult text. [31]

This vellum is hairy.

—Translations of complaints by medieval Irish monks in the
margins of manuscripts.

supplies

A fountain pen spares you pauses for refilling and concern about regularity of ink flow. The *Platignum* is easy to fill and clean and seldom clogs. A wide variety of pen points fit it, all of which produce fine, crisp lines.

Fountain Pens

Platignum points should be *Chisel Edge* or *Straight* or *Oblique Right* for righthanded calligraphers, or *Oblique Left* for lefthanded calligraphers. The manufacturer cautions that India or other waterproof ink should not be used because it clogs the point. But no "India Ink pen" or dip pen I have seen can match the *Platignum* for fine lines. So I use the *Platignum* pen as a dip pen for work in India ink. Remember to rinse and wipe the point when your work is finished.

Points

Dip pens require constant refilling, and some initial strokes must be made on a scrap to be certain that overloading has not increased the speed of flow. But they are handy when you are working briefly with different kinds or colors of ink.

Dip Pens

The best points are well built for maximum strength, designed with a reservoir, and cut to

Points

175

produce the cleanest lines. For ½ to 2½ mm. width I prefer *Heintze & Blanckertz To m. II* points; for 3 to 5 mm., *Brause Chisel Edge Lettering Points.*

Quills

Quills cut from the wing feathers of geese or turkeys are authentically medieval, but they require care to prepare, maintain, and use. They are *not* beginners' instruments, and many professional calligraphers pass them up for their modern equivalents. Do experiment with them, but gain some calligraphic proficiency first. Information on their preparation and use is included in many calligraphy books, and I recommend Edward Johnston's *Writing & Illuminating & Lettering.* (It will take some experimenting, but if you cut the slit far enough off-center to the left, the quill will ink endlessly from the corner of the point, so you can use it for hairlines and extensive decoration.)

Other Pens and Points

For embellishments and fine-line decoration, I use either an off-center cut quill, any *Crow-Quill* (available as a holder with points or as a single unit) or any one of several pointed pen points.

India Ink

For work that may be exposed to sunlight for long periods of time, I prefer India ink. *Higgins Black Magic* is extremely black and just the right consistency.

Special Ink

Chinese or Japanese inks are very useful and satisfying, not waterproof but longlasting. They are available in stick form (so that you can mix them to desired consistency), highly praised by professional calligraphers; and some are also sold in liquid form. I prefer the *Sumi* black liquid (very black, just the right thickness), black stick, red stick, and red liquid (actually a bold orange). *Sumi* ink sticks also are available in silver and gold—which I find preferable to any other gold ink or paint, and which can be burnished, once dry, to gleam very much like finest gold. For use with dip pens or quills.

Paper

I use the *Dietzgen Quickdraft Rag Tracing Vellum No. PG-197-M88,* on which is printed a pale blue grid, which will not photograph. Having the grid on the paper greatly simplifies paste-up work.

Vellum

Real vellum (produced from animal skins) is a joy to work on, both for the authentic feeling and for the delight in seeing the work "float" on the working surface. Sheets can be purchased in many sizes including inexpensive "off-cuts" useful for practice and small pieces. The simplest preparation is to merely wipe the sheet with an absorbant tissue, which will remove any latent grease or foreign particles. But the traditional method (using first pounce [pumice] and then gum sandarac) is best, and this is simply described in Johnston and other books. Do not purchase parchment. It is a "split" skin difficult to ink on neatly and worse to attempt corrections on.

Pencil

My favorite pencil is the *Pentel 3* filled with .3 mm *HB* lead. It is an automatic pencil capable of making the finest possible line. In its lid is an eraser that I whittle to a fine point for more versatility.

Eraser

A "kneaded" eraser is best because it can be conveniently shaped, will not damage the writing surface, and leaves no particles to foul the next stroke of the pen. Any common brand will do.

Color

For producing versals in color, use watercolors or acrylic paint, or Chinese or Japanese inks. Colored fountain or India inks are not opaque and therefore are unsatisfactory.

Where to Purchase Supplies

While a few items may be so unusual that they are available from only one firm, almost all the tools and materials discussed are available from many different firms in the United States and England. Here are a few to begin your source list:

Arthur Brown & Brothers, Inc., 2 West 46th Street, New York, N.Y. 10036. *General supplies, pens and points, inks, gold leaf and powdered gold, Opaline parchment paper.*

Charrette Corporation, 2000 Massachusetts Avenue, Cambridge, Massachusetts 02140. *General supplies, Pentel pencils, Higgins and Artone inks.*

Falkiner Fine Papers, 76 Southampton Row, London. *General supplies, fine papers, pens, quills, stick ink, pounce, and gum sandarac.*

Carl Heinrich Company, 711 Concord Avenue, Cambridge, Mass. 02138. *General supplies, pen holders, Dietzgen pads.*

Calligraphic Society

To be kept abreast of new materials, books, discoveries, suggestions on technique by master calligraphers, and special courses and workshops, it would be worthwhile to join a calligraphic society.

I suggest you apply for membership in the *Society of Scribes and Illuminators* (U.K.). It is primarily interested in the preservation and promotion of Renaissance scripts and *Italic*, and Edward Johnston's version of medieval scripts. The modern scripts are those most popular today, but the best contemporary calligraphers, particularly today's masters, were first schooled in the traditional scripts, and this is often reflected in the society's range of interests.

The society publishes a members' newsletter filled with valuable information on materials, pens, and books (often offered at a discount through the society). The newsletter contains reviews of past workshops, complete with details on history and technique, and announcements of upcoming courses, workshops, and international tours of special interest to calligraphers. The society stands ready to help when you have a technical question, cannot find where to purchase supplies or a special book, are curious about exhibits, etc. Should you be planning a trip to another city or going abroad and wish to locate instruction in a specific script, they will try to put you in touch with the right instructor. Since calligraphy itself knows no boundary, it is helpful to know what has been taught, what will be taught, and what has become known or available. Annual dues were, as of 1980, $20.00.

The address is Society of Scribes and Illuminators, c/o FBCS, 43 Earlham St., London WC2H 9LD, England. Also seek out the nearest regional society.

BOOKS

This list of favorite shops includes those in both the United States and England, and I suggest you not pass up a particular shop just because it is inconsiderately established on the other side of the world. Most shops periodically issue catalogues, some general and some specifically on art, artists, paleography and medieval history. You can write asking to be placed on the mailing list for such catalogues.

Used and Rare Books

Barry McKay Rare Books, Nethercote Road, Tackley, Oxon. OX5 3AW, England.

Bennett & Kerr Books, 99 The Causeway, Steventon, Abingdon, Oxon. OX13 6SJ, England.

Keith Hogg Books, 82 High Street, Tenterden, Kent TN30 6JJ, England.

H. P. Kraus, 16 East 46th Street, New York, N.Y. 10017.

Maggs Bros. Ltd., 50 Berkeley Square, London W1X 6EL, England.

Strand Book Store, 828 Broadway, New York, N.Y. 10003.

Publishers and Distributors

George Braziller Inc., One Park Avenue, New York, N.Y. 10016.

Cambridge University Press, Cambridge, England.

Dover Publications, Inc., 180 Varick Street, New York, N.Y. 10014.

31 East 2nd Street, Mineola, N.Y. 11501.

Oxford University Press, Oxford, England; and 200 Madison Avenue, New York, N.Y. 10016.

Pentalic Corporation, 132 West 22nd Street, New York, N.Y. 10011.

Thames & Hudson, 30–34 Bloomsbury St., London WC1B 30P.

Other Sources

Many fine museums, among them The Cloisters (Fort Tryon Park, New York, N.Y.) of the Metropolitan Museum of Art, and The Huntington Library (San Marino, California), publish their own booklets and books and distribute others published elsewhere. These are available at the museums or by mail.

OBTAINING FACSIMILES

If you would like to have your own facsimile of a manuscript page, libraries and museums will oblige. You should follow this procedure:

1. In a letter, state that you wish to purchase a photograph for personal study or research. The institution will want to know that your intention is not to publish or reproduce it, because this requires considerably more information from you, paperwork on the institution's part, etc.

2. Request a photograph printed the same size as the original manuscript (the better to study it).

3. Ask that the photograph be black-and-white; a *glossy* print (in the U.S.); or a *Bromide* print (in Great Britain or Europe).

4. State the exact manuscript number, the folio number, and whether or not you want the recto or verso.

5. In a few words describe the content of the page.

6. If the institution is abroad, ask that the photograph be sent air mail.

Keep a copy of the letter. You will receive either no response for weeks or no response at all (in which case, after a month, try again). When the photograph arrives, it may or may not be exactly what you requested and in original size. Many institutions catalogue their manuscripts by numbers other than those referred to in some textbooks, and a manuscript may have been recatalogued since the book was published. That is why it is valuable to explain what you expect to be on the photograph. A missing superscript asterisk makes all the difference between a 15th-century *Gothic Littera Bastarda* recipe for parchment and a 6th-century *Artificial Uncial* Benedictine Rule, because a single manuscript can be a collection of widely diverse single sheets.

Some institutions will send the photograph in original size. Many include a tiny scale marking on the margin to indicate whether the print is original size or smaller. But many will send a print with no clue at all. If you suspect that the print's proportion is off, write again and ask for the size of the original page. But be careful: The answer may be the size of the page edge-to-edge, all of which is not necessarily shown in your print, or it might be the *text-block* size. Ask specifically for the text-block width, or, if there is something significantly large and measurable on the page (an enormous capital *N*, for instance) ask specifically for the width or the height of the *N* and then figure from that what the size of the print would be in comparison with the original.

One last caution: Americans normally state width-by-depth sizes. The British and Europeans state depth followed by width.

In terms of expense, you can save considerable time by *not* asking in advance. The cost is usually from $2 to $6 (roughly £1 to £3), including air mail postage. For a particularly large photograph, or in the case where there is no negative on file, and it was necessary to photograph the original in order to fill the order, the cost may approach $14 or so (roughly £7).

FACSIMILE SOURCES

Baltimore

The Walters Art Gallery
Baltimore, Md. 21201 U.S.A.

Bamberg

Staatsbibliothek Bamberg
Neue Residenz
Domplatz 8
86 Bamberg, West Germany

Berlin

Deutsche Staatsbibliothek
Postfach 1312
Unter den Linden 8
108 Berlin, East Germany

Staatsbibliothek Preussischer Kulturbesitz
Postfach 1407
1000 Berlin 30, West Germany

Bloomington

The Lilly Library
Indiana University
Bloomington, Indiana 47401 U.S.A.

Cambridge

Magdalene College
Cambridge CB3 OAG, England

Trinity College Library
Cambridge CB2 1TQ, England

Chicago

Graphic Conservation Department
R. R. Donnelley & Sons, Inc. (The Lakeside Press)
2223 S. Martin Luther King Drive
Chicago, Ill. 60616 U.S.A.

Copenhagen

Det Kongelige Bibliotek
Christians Brygge 8
DK-1219 Kobenhavn K, Denmark

Dublin

Trinity College Library
University of Dublin
College Street
Dublin 2, Ireland

Durham

The Dean and Chapter Library
The College
Durham DH1 3EH, England

Epernay

Bibliothèque municipale
13, Avenue de Champagne
51200 Epernay, France

Florence

Biblioteca Medicea-Laurenziana
Piazza S. Lorenzo, 9
Firenze, Italy

London

The British Library
[formerly The British Museum]
Department of Manuscripts
Great Russell Street
London WC1B 3DG, England

Munich

Bayerische Staatsbibliothek München
Postfach 1500
D—8000 München 34, West Germany

Universitätsbibliothek München
Geschwister—Scholl, Platz 1
8000 München 22, West Germany

New York

The Pierpont Morgan Library
29 East 36th Street
New York, N.Y. 10016 U.S.A.

Oxford

The Bodleian Library
Department of Western Manuscripts
Oxford OX1 3BG, England

Paris

Archives Nationales
60, rue des Francs-Bourgeois
75141 Paris CEDEX 03, France

Bibliothèque Nationale
58, rue de Richelieu
75084 Paris CEDEX 02, France

Rome

Biblioteca Apostolica Vaticana
Vatican City, Italy

St. Gall

Stiftsbibliothek St. Gallen
CH-9000 St. Gallen, Switzerland

San Marino

The Huntington Library
Manuscripts Department
San Marino, California 91108 U.S.A.

Upsala

Universitetsbiblioteket Uppsala
Bibliothèque de l-Université
Box 510
S—751 20 Uppsala I, Sweden

Verona

Biblioteca Capitolare
Piazza Duomo 13
37100 Verona, Italy

Vienna

Kunsthistorisches Museum
Burgring 5
A—1010 Wien 1, Austria

OBTAINING PERMISSION TO STUDY MANUSCRIPTS

Wherever manuscripts are preserved, a certain number are usually on display for the public. The majority, however, are filed away and are available for private study by students. (Some rare works are available only to recognized scholars.) If you wish to examine specific manuscripts or those of a particular time or style, I suggest the following procedure:

In a letter to the director of the library or museum, briefly explain your interest in the field and list by shelf-mark a few manuscripts of special interest, or detail the kinds of manuscripts you wish to see, and your purpose in seeing them. If you are affiliated with a school, it is helpful, but not essential, to enclose a letter of introduction on school stationery from someone in an official position who knows of your interest. You will probably be asked to bring such a letter when you visit. If the museum or library is some distance away, mention when you wish to visit, or ask when you may. Some special manuscripts may be unavailable at various times. If possible, write some months in advance. After a month of no response, write again.

If you are writing to a foreign institution and do not speak the language, write in your own language—and expect the reply to be in theirs.

REFERENCES

As in olde feldes, cornes freshe and
grene grewe, So of olde bookes cometh
our cunnyng newe.

Old bokes maketh young wittes wise.

John Hardyng [87], 1464

Numbers refer to authors and those of their works used in research for this book. Much of my research was done at the Bodleian Library, Oxford. I tried to remember to jot down the shelf-marks or catalogue numbers of texts studied there. If you have the opportunity to research material at the Bodleian, these shelf-marks may save you innumerable tiring trips down the stairs, dodging scholars and tourists, to the General Catalogue Room. Where available, the shelf-marks appear following the books' listing.

1. Alexander, J. J. G., and A. C. De La Mare. *The Italian Manuscripts in the Library of Major J. R. Abbey.* London, 1969.
2. Anderson, Donald M. *The Art of Written Forms—The Theory and Practice of Calligraphy.* New York and London, 1969.
3. Arnold, Klaus, ed., *Johannes Trithemius—In Praise of Scribes (De Laude Scriptorum).* Lawrence, Kan., 1974.
4. Benet, William Rose. *The Readers Encyclopedia.* New York, 1965.
5. Berkowitz, David Sandler. *In Remembrance of Creation—Evolution of Art and Scholarship in the Medieval and Renaissance Bible.* Waltham, Mass., 1968.
6. Bishop, T. A. M. *English Caroline Minuscule.* Oxford, 1971.
7. Branner, Robert. *Manuscript Painting During the Reign of St. Louis—A Study of Styles.* Berkeley, 1977.
8. Brewer, E. Cobham. *Brewer's Readers Handbook.* London, 1911.
 ———. *The Historic Note-Book.* Philadelphia, 1891.

9. British Museum. *A Catalogue of the Lansdowne Manuscripts in the British Museum.* London, 1819.

10. Brown, Carleton. *Religious Lyrics of the Fifteenth Century.* Reprint No. 179, 1952.

11. Bryant, Arthur. *The Age of Chivalry.* New York, 1963.
 ———. *Makers of England.* New York and London, 1962.
 ———. *The Medieval Foundation of England.* New York, 1967.

12. Cockerell, Sydney Carlyle. *Two East Anglian Psalters—The Ormesby Psalter—The Bromholm Psalter.* Oxford, 1926. R. Pal. 8.6308.

13. *Columbia-Viking Desk Encyclopedia.* New York, 1953.

14. Coulton, G. G. *Five Centuries of Religion.* London, 1929 (Excerpted in the *History of Popular Culture,* edited by Norman F. Cantor and Michael S. Werthman. New York and London, 1968.)
 ———. *The Meaning of Medieval Moneys.* Historical Association Leaflet No. 95, London, 1934. S. Hist. 1 1.8 (Radcliffe Camera).

15. Cutts, Rev. Edward L. *Scenes and Characters of the Middle Ages.* London, 1872.

16. D'Ancona, P., and E. Aeschlimann. *The Art of Illumination—An Anthology of Manuscripts from the Sixth to the Sixteenth Century.* London, 1969.

17. Day, Lewis F. *Alphabets Old and New.* London, 1910.

18. de Breffny, Brian, ed. *The Irish World—The Art and Culture of the Irish People.* New York, 1977.

19. Degering, Hermann. *Lettering.* London, 1929.

20. De Roover, Florence Edler. "The Medieval Library," chapter XVIII in Thompson, James Westfall, *The Medieval Library.* New York, 1957. R 5.576.

21. Diringer, David. *Alphabet Exhibition.* Booklet sponsored and arranged by Staples Press, London, 1953.
 ———. *The Illuminated Book—Its History and Production.* London, 1967.

22. Disraeli, I. *Curiosities of Literature.* 3 vols. Boston, 1834.

23. Donnelley, R. R. & Sons, Inc. (Lakeside Press). *The Trajan Inscription in Chicago.* Chicago.

24. Dowley, Tim. *Eerdman's Handbook to the History of Christianity.* Berkhamsted, 1977.

25. Duckett, Eleanor. *The Wandering Saints of the Early Middle Ages.* New York, 1959.
 ———. *The Gateway to the Middle Ages—Monasticism.* Ann Arbor, 1961.

26. Eccles, Mark. *The Macro Plays; The Castle of Perseverence; Wisdom; Mankind.* London, 1969.

27. *The Encyclopedia Britannica.* Chicago and London, 1960.

28. Evans, Joan, ed. *The Flowering of the Middle Ages.* New York and London, 1966.
 ———. *Life in Medieval France.* London and New York, 1969.

29. Fairbank, Alfred. *A Book of Scripts.* Harmondsworth, Middlesex, 1949.
 ———. writing in *Lettering* by Hermann Degering. London, 1929.
 ———. *The Story of Handwriting: Origins and Development.* London, 1970.

30. Ferguson, George. *Signs and Symbols in Christian Art.* New York, 1959.

31. Gascoigne, Bamber. *The Christians.* New York, 1977.

32. Gray, Nicolete. *Lettering as Drawing.* London and New York, 1971.

33. Heer, Friedrich. *Charlemagne and His World.* New York, 1975.

34. Henry, Françoise. *The Book of Kells.* London, 1974.
 ———. *Irish Art.* 3 vols. Ithaca, N.Y., 1965.

35. Hewitt, Graily. *Lettering for Students and Craftsmen.* London, 1930.

36. Hill, G. F. *The Development of Arabic Numerals in Europe.* Oxford, 1915. R. Pal. 16.63.

37. Holweck, F. G. *A Biographical Dictionary of the Saints—With a General Introduction on Hagiology.* St. Louis and London, 1924.

38. *Horizon Magazine,* editors of, Norman Kotker, ed., and Morris Bishop. *The Horizon Book of the Middle Ages.* New York, 1968.
 ———, Marshall B. Davidson, ed., *The Horizon Book of Lost Worlds.* New York, 1962.
 ———, and Marshall B. Davidson and Roland H. Bainton. *The Horizon History of Christianity.* New York, 1964.
 ———, and Richard Winston. *Charlemagne.* New York, 1968.

39. Hubert, J., J. Porche, and W. F. Volbach. *Europe of the Invasions*. New York, 1969.

40. Hull, E. *Early Christian Ireland*. 1905.

41. Hume, David. *The History of England, from the Invasion of Julius Caesar, to the Revolution, in 1688* Albany, 1816.

42. Hyde, Robert C. *A Dictionary for Calligraphers*. Los Angeles and Minneapolis, 1977.

43. Jennings, Margaret. *Tutivillus—The Literary Career of the Recording Demon*, in *Studies in Philology*. Vol. LXXIV, No. 5. Chapel Hill, N.C., 1977.

44. John, James J. "Latin Paleography," in James M. Powell's *Medieval Studies—An Introduction*. Syracuse, N.Y., 1976.

45. Johnson, A. F. "The Classification of Gothic Types," in *The Library—Transactions of the Bibliographical Society*. Vol. IX, Oxford, 1929. A 7.237.

46. Johnston, Edward. *Manuscript & Inscriptional Letters—For Schools & Classes & For the Use of Craftsmen*. London, 1911 (facsimile, New York)
———. *Writing & Illuminating & Lettering*. 32nd ed. London, 1975.

47. Ker, N. R. *English Manuscripts in the Century After the Norman Conquest*. Oxford, 1960. R. Pal. 16.85.

48. Kraus, H. P. *Monumenta Codicum Manu Scriptorum*. New York, 1974.

49. Latham, R. E. *Revised Medieval Latin Word-List from British and Irish Sources*. Oxford, 1965.

50. Lindsay, W. M. *Early Irish Minuscule Script*. St. Andrews University Publications, No. VI, Oxford, 1910. R. Pal. 16.87.
———. *Palaeographia Latina*. Parts I & II, St. Andrews University Publications No. XIV (Oxford, 1922) and XVI (London, 1923). R. Pal. 16.15.

51. Longnon, Jean, and Raymond Carzelles, eds. *The Très Riches Heures of Jean, Duke of Berry*. New York, 1969.

52. Lowe, Elias Avery. *Codices Latini Antiquiores*. Vols. I, II, V and Supplement. Oxford. R. Pal. 4.43.
———. *English Uncial*. Oxford, 1960. R. Pal. 4.86.
———. *Handwriting*. Rome, 1969.
———. Ludwig Bieler, ed., *Palaeographical Papers 1907–1965*. 2 vols. Oxford, 1972.
———. *The "Script of Luxeuil"—A Title Vindicated*, in *Revue Bénédictine*, 1953.

53. Marks, Claude. *Pilgrims, Heretics and Lovers—A Medieval Journey*. New York, 1975.

54. Mayr-Harting, Henry. *The Coming of Christianity to England*. New York, 1972.

55. Menninger, Karl. *Number Words and Number Symbols—A Cultural History of Numbers*. Cambridge, Mass., and London, 1969.

56. Miner, Dorothy E., Victor I Carlson, and P. W. Filby. *Two Thousand Years of Calligraphy—A Three-Part Exhibition Organized by the Baltimore Museum of Art, Peabody Institute Library, and Walters Art Gallery*. Totowa, N.J., 1972.
———. *Illuminated Books of the Middle Ages and Renaissance*. Baltimore, 1949.

57. Mitchell, G. Frank, Peter Harbison, Liam de Paor, Maire de Paor, and Roger A. Staley. *Treasures of Irish Art—1500 B.C.-1500 A.D.* New York, 1977.

58. Morison, Stanley. *"Black-Letter" Text*. Cambridge, Mass., 1942. R. Pal. 4.121.
———. *Notes on the Development of Latin Script from Early to Modern Times*. Cambridge, 1949. R. Pal. 4.121a.
———. and Nicolas Barker (Editor), *Politics and Script: Aspects of Authority and Freedom in the Development of Graeco-Latin Script from the Sixth Century B.C. to the Twentieth Century A.D.*, The Lyell Lectures, 1957. Oxford, 1972.

59. Mutherich, Florentine, and Joachim E. Gaehde. *Carolingian Painting*. New York, 1976.

60. Nesbitt, Alexander. *Decorative Alphabets and Initials*. New York, 1959.
———. *The History and Technique of Lettering*. New York, 1950.

61. Ogg, Oscar. *The 26 Letters*. New York, 1948.

62. *Oxford English Dictionary*. Oxford, 1971.

63. Parkes, M. B. *English Cursive Book Hands 1250-1500*. Oxford, 1969.

64. Phyfe, William Henry P. *Five Thousand Facts and Fancies—A Cyclopaedia of Important, Curious, Quaint, and Unique Information in History, Literature, Science, Art and Nature*. New York and London, 1901.

65. Randall, Lilian M. C. *Images in the Margins of Gothic Manuscripts.* Berkeley and Los Angeles, 1966.

66. Reddall, Henry Frederic. *Fact, Fancy, and Fable: A New Handbook for Ready Reference on Subjects Commonly Omitted from Cyclopaedias.* Chicago, 1889.

67. Rhodes, Henry, and Luke Meredith, John Harris and Thomas Newborough. *The Great Historical, Geographical and Poetical Dictionary; . . . ,* London, 1694.

68. Simon, Edith, *The Saints.* New York, 1968.

69. Steinberg, S. H. *Bibliographical Notes—A Hand-List of Specimens of Medieval Writing-Masters,* in *The Library,* Transactions of the Bibliographical Society, Series 4, Vol. XXIII, London, 1943. A 7.237.
———. *The Forma Scribendi of Hugo Spechtshart,* in *The Library,* Transactions of the Bibliographical Society, Series 4, Vol. XXI, London, 1941. A 7.237.
———. *Medieval Writing-Masters,* in *The Library,* Transactions of the Bibliographical Society, Series 4, Vol. XXII, London, 1942. A 7.237.

70. Tarr, John C. *Calligraphy in the Chancery Script.* San Leandro, Calif., 1973.

71. Temple, E. *Anglo-Saxon Manuscripts: 900-1066.* London, 1976.

72. Thomas, Alan G. *Great Books and Book Collectors.* New York, 1975.

73. Thomas, Marcel. *The Grandes Heures of Jean, Duke of Berry.* New York, 1971.

74. Thompson, Edward Maunde. *Calligraphy in the Middle Ages,* in *Bibliographica,* Vol. III, London, 1897. Per. 25805 d.15.
———. *Catalogue of Ancient Manuscripts in the British Museum,* Part II Latin. London, 1884. R. Pal. 6.1.
———. *Introduction to Greek and Latin Palaeography.* Oxford, 1912.

75. Thompson, S. Harrison. *Latin Bookhands of the Later Middle Ages: 1100-1500.* Cambridge, 1969.

76. Thorpe, James. *A Noble Heritage—The Ellesmere Manuscript of Chaucer's Canterbury Tales.* San Marino, 1974.
———. *The Gutenberg Bible—Landmark in Learning.* San Marino, 1975.

77. Tierney, Brian, and Sidney Painter. *Western Europe in the Middle Ages.* New York, 1970.

78. Toynbee, Arnold. *A Study of History.* Oxford and New York, 1972.

79. Trevelyan, G. M. *History of England.* New York and London, 1974.

80. Triggs, Oscar Lovell. *The Assembly of Gods of the Accord of Reason and Sensuality in the Fear of Death* by John Lydgate. London, 1895.

81. Tschichold, Jan. *Non-Arbitrary Proportions of Page and Type Area,* published in *Calligraphy and Palaeography—Essays Presented to Alfred Fairbank.* London, 1965.

82. Ullman, B. L. *Abecedaria and their Purpose,* in *Transactions of the Cambridge Bibliographical Society,* III, No. 3, 1961.
———. *Ancient Writing and Its Influence.* London, 1932. 257 e. 22.

83. Unstead, R. J. *The Story of Britain.* New York, 1969.

84. Unterkircher, Franz. *King René's Book of Love.* New York, 1975.

85. Van Moe, Emile A. *The Decorated Letter: From the VIIIth to the XIIth Century.* Paris, 1950.

86. Wellard, James. *The Search for the Etruscans.* New York, 1973.

87. Whiting, Bartlett Jere. *Proverbs, Sentences, and Proverbial Phrases—from English Writings Mainly Before 1500.* Cambridge, Mass., 1968.

88. Wolpe, Berthold. *Florilegium Alphabeticum; Alphabets in Medieval Manuscripts,* published in *Calligraphy and Palaeography; Essays Presented to Alfred Fairbank.* London, 1965.

Solving the riddle

The solution to the riddle in the caption to *Plate 50* is as follows: The country fellow first takes the wolf and the lamb across, lands the wolf, and brings back the lamb. He then crosses with the turnip-tops, lands them, and returns to fetch the lamb, which he then takes across [12].

PLATES BY SOVRCE

BALTIMORE: The Walters Art Gallery, MS. 10.17—Plate 42, MS. 10.18—Plates 43, 107.

BAMBERG: Staatsbibliothek Bamberg, MSC. Patr. 5 (B.II.5)—Plate 2.

BERLIN: Staatsbibliothek Preussischer Kulturbesitz, MS. Lat 2°—Plates 6, 52, 56–61, 127, 135.

BLOOMINGTON: The Lilly Library, Ricketts, MS. 240—Plate 130

CAMBRIDGE: Magdalene College, Cambridge University, PL 2981—Plates 47, 48, 66, 114, 117–122; Trinity College Library, MS. R.17.1—Plate 3.

CHICAGO: R. R. Donnelley & Sons, Inc., Trajan Column photograph—Plate 10.

COPENHAGEN: Det Kongelige Bibliotek, MS. 3384.8°—Plate 8.

DUBLIN: Trinity College, University of Dublin, MS. 58 (A.I.6)—Plates 23, 28, 91, 94, 98.

DURHAM: The Dean and Chapter Library, The College, MS. B.IV.6—Plates 18, 82.

EPERNAY: Bibliothèque municipale, MS. 1—Plate 12.

FLORENCE: Biblioteca Medicea Laurenziana, MS. Plut. 39.I—Plates 13, 75, 77, 78.

THE HAGUE: Koninklijke Bibliotheek, MS. 78.D.40—Plates 51, 112

LONDON: The British Museum, MS. Add. 29972—Plates 101, 102, MS. Cotton Nero D.IV—Plates 27, 31, 92, MS. Cotton Vespasian A.I.—Plates 19, 84, MS. Harley 208—Plates 38, 103, MS. Harley 3038— Plate 108.

MUNICH: Bayerische Staatsbibliothek, Cod. Germ. 32—Plates 130, 131, 136; Universitatsbibliothek München, MS. 4°, 810—Plate 138.

NEW YORK: The Pierpont Morgan Library, M.23—Plates 20, 81, M.429—Plate 1.

OXFORD: The Bodleian Library, MS. Arch Selden B.26—Plates 26, 94, MS. Ashmole 328—Plates 9, 144, 145, MS. Ashmole 764—Plates 69, 139, 140, MS. Ashmole 789)—Plates 65, 68, 133, 137, 142, 143, MS. Auct. D.II.19—Plates 25, 93, MS. Auct. E. Inf. 2 (SC.2427)—Plates 45, 109, 110, MS. Auct. T.II.26—Plates 16, 79, MS. Bodl. 426—Plates 30, 95, MS. Bodl. 596 (SC.2376)—Plates 62, 128, MS. Bodl. 717—Plates 15, 39, 40, 104–106, MS. Digby 55—Plate 70, MS. Digby 63—Plate 4, MS. Douce 140 (SC.21714)—Plates 22, 90, MS. Douce 366—Plates 50, 126, MS. Douce 368 (SC.21943)—Plates 44, 111, MS. Hatton 48—Plates 83, 85–88, MS. Lat. Bibl. c.8(P)—Plates 29, 96, MS. Laud Misc. 442—Plates 33, 97, MS. Laud Misc. 517—Plate 64, MS. Rawl. C.398—Plates 63, 129, MS. Rawl. G.167—Plate 24, MS. Rawl. Liturg. E.40—Plate 115.

PLATES BY SOURCE

PARIS: Archives Nationales, K 3 N° 10—Plate 34; Bibliothèque Nationale, MS. Nouv. Acq. Lat. 2243—Plates 36, 100, MS. Lat. 919—Plates 67, 141.

ROME: Biblioteca Apostolica Vaticana, MS. Basilicanus D. (Arch. S. Pietro D.182)—Plates 17, 21, 32, 81, 89, MS. Vergilius Romanus Cod. Lat. 3867—Plate 76, MS. Cod. Vaticanus Palatinus 1631 (P)—Plates 14, 73, 74, 77, MS. XL (38) (Vat. Reg. Lat. 317)—Plates 37, 102.

ST. GALL: Stiftsbibliothek St. Gallen, Cod. 913—Plate 5, Cod. 1394—Plate 11.

SAN MARINO: The Huntington Library, MS. EL 26.C.9—Plates 71, 134.

UPSALA: Universitetsbiblioteket Uppsala, Codex Argenteus Upsaliensis—Plate 41.

VERONA: Biblioteca Capitolare di Verona, Cod. XL (38)—Plates 35, 99, 102.

VIENNA: Kunsthistorisches Museum, Der. Hl. Gregor mit drei Schreibern (Elfenbeinplatte, Inv. Nr. 8399)—Frontispiece.

From original manuscript leaves and fragments in the author's collection, Plates 7, 46, 49, 53–55, 72, 113, 116, 123, 124, 132.

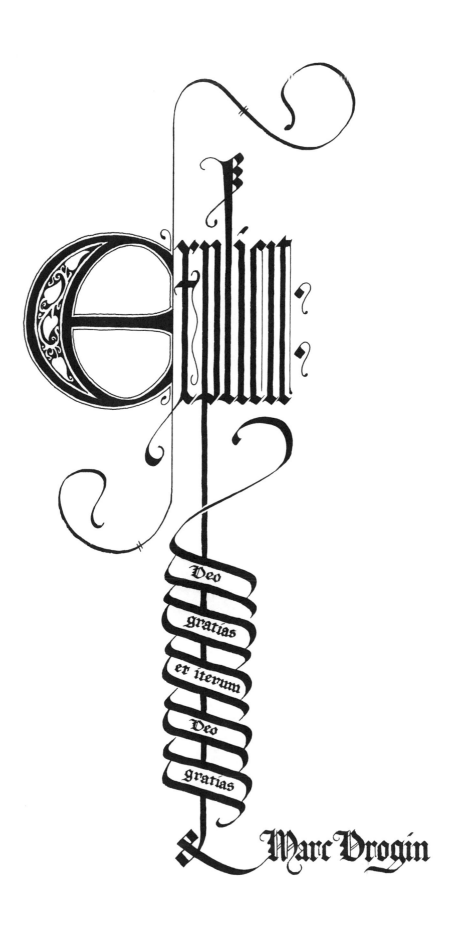

Explicit

Deo gratias et iterum Deo gratias

Marc Drogin

INDEX